MAY 2017

CHICAGO'S {FABULOUS FOUNTAINS

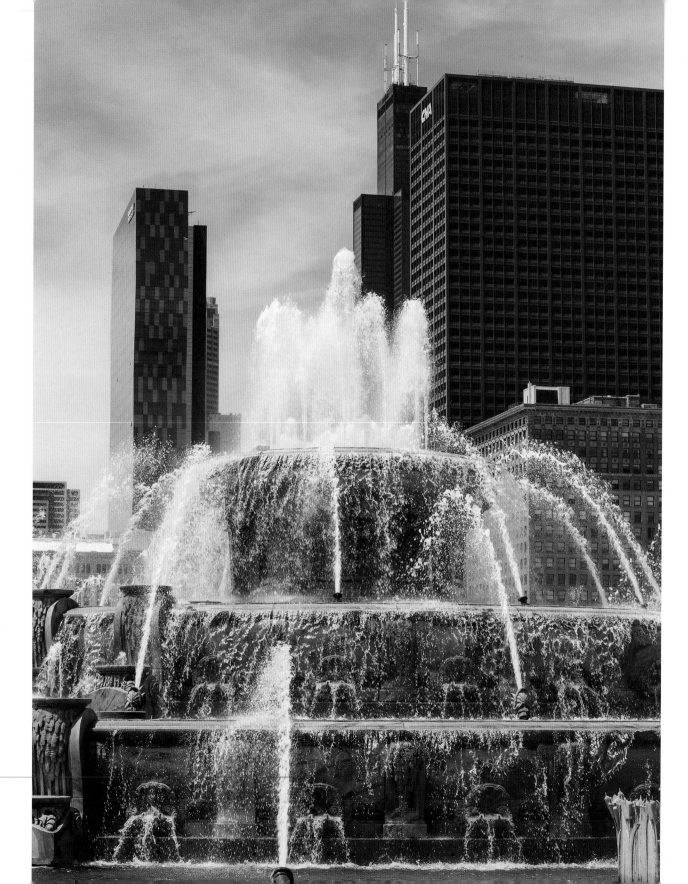

CHICAGO'S FABULOUS FOUNTAINS

GREG BORZO 〈 *PHOTOGRAPHS BY JULIA THIEL*

FOREWORD BY GEOFFREY BAER 〈 PREFACE BY DEBRA SHORE

Southern Illinois University Press 〈 Carbondale

Southern Illinois University Press
www.siupress.com

20 19 18 17 4 3 2 1

Jacket illustrations: front cover, Northern Trust Fountain at
 Monroe and Wells streets; *back cover (top),* fountain created
 by stone carver Walter S. Arnold to reflect the Richardsonian
 Romanesque style of the 1886 Ransom Cable House, 25
 East Erie Street (image used with permission of Mr. Arnold);
 and *(bottom),* Chicago Board of Trade Fountain, designed
 by Edward Windhorst, featuring a sleek aluminum art deco
 design, like its namesake building next door, at Jackson
 Boulevard and LaSalle Street, and inaugurated in 1998 to
 honor the board's 150th anniversary. All cover photographs
 by Julia Thiel.

Frontispiece, Buckingham Fountain "is not designed to furnish
 refreshment to man or beast; Loop office workers cannot
 swim in it in summer, nor skate upon it in winter; the four-
 teen thousand gallons of water tumbling down its basin ev-
 ery minute turn no mill wheels, produce no power," said the
 Chicago Daily News in 1927. "It's just a superlatively beautiful
 fragment of the stuff from which dreams are made."

Library of Congress Cataloging-in-Publication Data

Names: Borzo, Greg, author.
Title: Chicago's fabulous fountains / Greg Borzo ; photographs
 by Julia Thiel ; foreword by Geoffrey Baer ; preface by
 Debra Shore.
Description: Carbondale : Southern Illinois University Press,
 2017. | Includes bibliographical references and index.
Identifiers: LCCN 2016037236 | ISBN 9780809335794
 (hardback) | ISBN 9780809335800 (ebook)
Subjects: LCSH: Fountains–Illinois–Chicago. | BISAC: ART
 / Sculpture & Installation. | ARCHITECTURE / Regional. |
 PHOTOGRAPHY / Subjects & Themes / Architectural &
 Industrial. | PHOTOGRAPHY / Subjects & Themes / Regional
 (see also TRAVEL / Pictorials).
Classification: LCC NA9410.C4 B67 2007 |
 DDC 720.9773/11–dc23 LC record available at
 https://lccn.loc.gov/2016037236

Printed on recycled paper. ♻

This paper meets the requirements of ANSI/NISO Z39.48-1992
(Permanence of Paper) ∞

To my wife, Christine Bertrand, my best friend,
my biggest supporter, and the love of my life

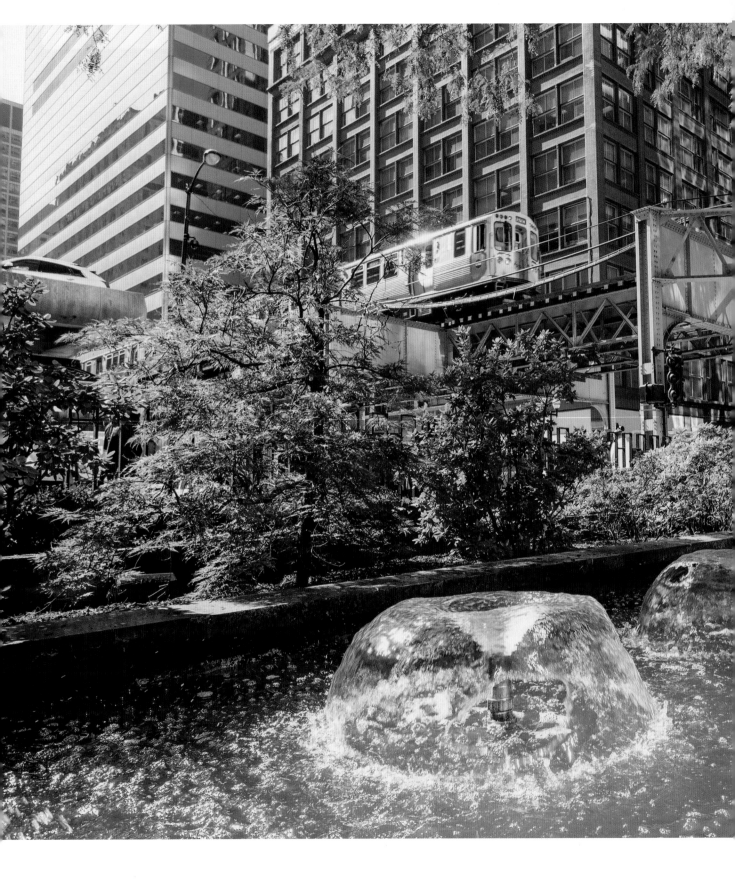

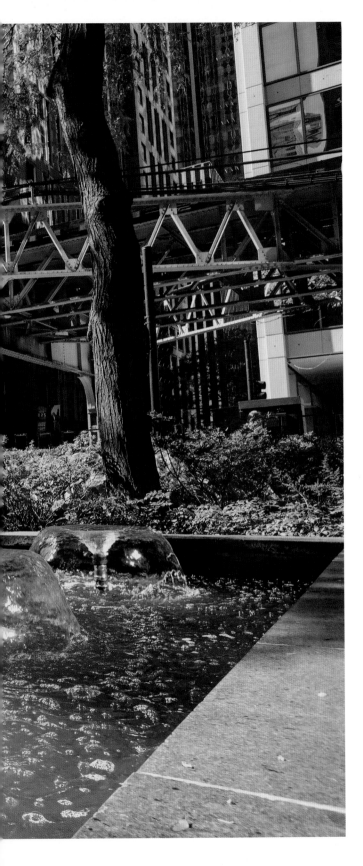

CONTENTS

"The ultimate test for a fountain is: If you walk by, do you say, I've just gotta watch this for a moment," said Mark Fuller, president of WET Design. That's certainly true of the bubbling Northern Trust Fountain at Monroe and Wells streets, with the Chicago "L" in the background. It's been attracting passersby since 1969.

ILLUSTRATIONS

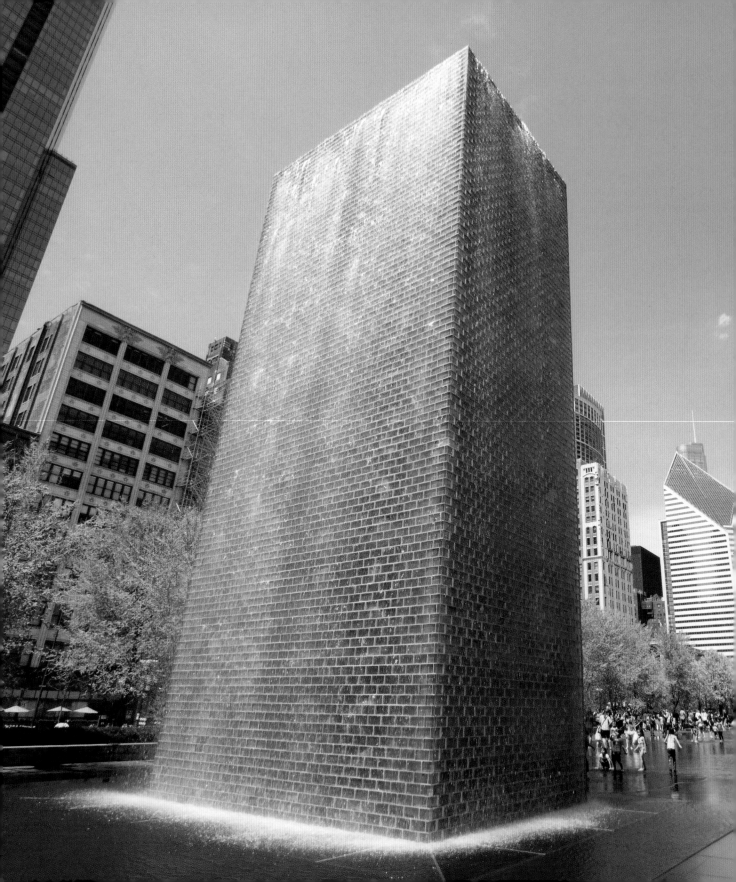

FOREWORD
Telling Fountain Stories

An artist, a gallery owner, and a TV producer walked into a bar . . .

No, this is not the start of a joke. The artist was Jaume Plensa, who created the wildly popular Crown Fountain in Millennium Park. I was the TV producer, and through my friendship with the gallery owner who represents Plensa, the three of us went out for drinks shortly after the fountain debuted in 2004. As we sat and talked, Plensa revealed something that surprised me. He said he had not expected that so many people would gleefully splash in the reflecting pool standing between the fountain's two tall glass-brick towers. He had imagined most people would simply sit or stand on either side of the pool and watch the spectacle as the video faces of a thousand ordinary Chicagoans took turns appearing on the towers, periodically puckering their lips to spit streams of water into the pool.

Is it possible that Chicagoans—residents of a river town with a glorious lakefront—are particularly drawn to water? As this book demonstrates, we certainly have a love affair with fountains. And this is the book fountain lovers have been waiting for. In these pages Greg Borzo reveals the stories behind tourist attractions like Buckingham Fountain (modeled on a fountain at Versailles, but in true Chicago fashion it's much bigger) as well as neighborhood

"What appealed to us from the start was Jaume [Plensa]'s clarity of vision and complete conviction of what he felt this fountain should be–a fountain for the people," said Lester Crown at the Crown Fountain's inauguration.

gems like Independence Square Fountain, which depicts kids playing with fireworks. (The water-and-light display, no longer operating, represents roman candles.)

In his other books, Borzo has demonstrated his obsession with digging for the telling details of the story, revealing fascinating facts about the Chicago "L," neighborhood lore best explored by bicycle, and the forgotten history of Chicago's cable cars (not electric trolleys but the earlier transit technology where railcars were propelled by latching on to a cable moving continuously under the tracks).

In *Chicago's Fabulous Fountains*, Borzo has done it again.

There's the story of the lovely Fountain Girl in Lincoln Park. She was stolen in 1958, leaving behind a stone base that remained empty until a donor stepped forward to restore the fountain. A copy of the fountain was located in Portland, Maine; a cast was made; and the little bronze girl returned to her Lincoln Park perch in 2007.

And there's the Fountain of Time, Lorado Taft's sprawling Hyde Park masterpiece restored from a crumbling concrete wreck in the late 1990s. It presents the procession of humanity through life, and if you look closely around the back you'll find the artist himself in the parade.

You've passed by some of our city's fountains innumerable times. Maybe once in a while you've stopped to relax to the soothing sounds of the cascading water, or surrendered to the urge to throw in a penny. But after reading this book, you'll see Chicago's fountains as new friends, each with a story to tell.

Geoffrey Baer, Program Host and Producer
WTTW Channel 11 Chicago

Geoffrey Baer

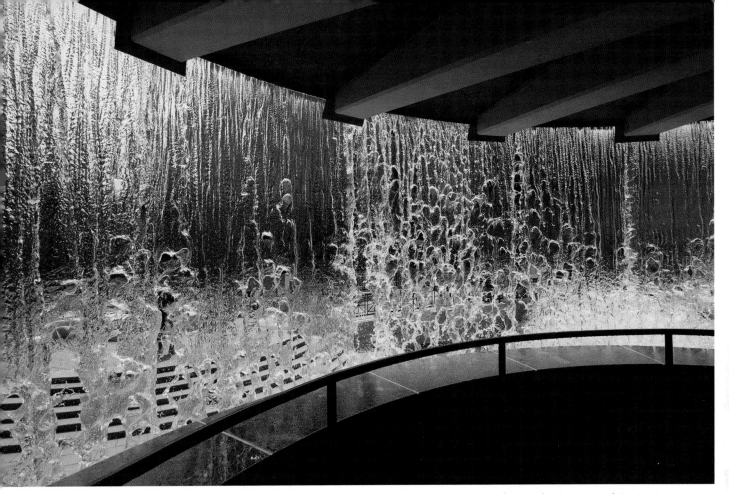

Chicago is a place with water, water, everywhere: its lakefront, its rivers–and its fountains! Here the Centennial Fountain on the north bank of the Chicago River at McClurg Court affords a striking view of the city through the aqueous blur of a water curtain.

PREFACE
Fountains Celebrate Water

Until Greg Borzo asked me to write a preface for this book, I did not fancy fountains. But water? Well, that's another matter. I treasure water in all its forms—as the rocks over which to pour some Scotch, as the burbling river I hike beside, as the steam powering engines. Many of our faith traditions use water in sacraments and rituals.

We begin and end our days with water. Water is fun, water is forceful, and water is certainly fickle.

Civilization can be viewed as humans' long struggle to tame, capture, and use water for their own purposes. It could be said that the manipulation of water—namely, the reversal of the Chicago River to protect the city's

drinking water supply—defines Chicago. By digging a twenty-six-mile-long channel to convey sewage away from Lake Michigan and provide a route for commercial barge traffic between the Great Lakes and the Mississippi River, Chicago launched one of the largest public works projects of all time. As a result, it became a great metropolis.

But we also control water through infrastructure for pleasure and public art. Fountains sit at the intersection of nature and culture, bringing to the surface what is mostly out of sight and out of mind: the rivers we have buried in concrete, the streams we have channeled and straightened. Free-flowing water carves grand canyons, bends into oxbows, and babbles over rocks. Conversely, water pressured into pipes and forced through the mouths of lions and over the backs of nymphs becomes a public display of nature dominated for our own wishes.

Fountains are playful and fantastical, utilitarian and sublime. Public fountains are truly democratic (lowercase *d*), inviting people from everywhere and anywhere to come, meet, talk, play, learn, reflect, wish, and find repose in the eternal sight and sound of splashing water. They are a means to record our history and to celebrate civic life. As public gathering places, they represent increasingly rare and endangered spaces in our atomized modern lives.

The Nicholas J. Melas Centennial Fountain on the north bank of the Chicago River acknowledges the one-hundredth anniversary of the founding of the Chicago Sanitary District, arguably the agency that has had the greatest effect on Chicago's waterways, both good and ill. Of course the agency, in seeking to mark its centennial, turned to water. Its fountain includes a popular water cannon that shoots an arc over the river every hour from May through October.

With this book, Borzo has undertaken a worthy project, and we are all in his debt. He invites us to dip into and learn about Chicago's history, neighborhoods, and character by getting to know better its outdoor public fountains, none of which charge an admission fee.

Chicago is the city in a garden—and gardens need water! Go forth, explore, enjoy, and celebrate water in our midst.

Debra Shore, Commissioner
Metropolitan Water Reclamation
District of Greater Chicago

Debra Shore

ACKNOWLEDGMENTS

Years ago, I thought Chicago's outdoor public fountains were few in number and not as compelling as other American fountains: the famous Prometheus Fountain at Rockefeller Center in New York City, Fountains of Bellagio in Las Vegas, Forsyth Park Fountain in Savannah. Therefore, this book was initially going to cover enticing fountains around the country and highlight only a few of Chicago's prominent water spectacles.

The more people I consulted, however—and the more we started looking around Chicago—the more we discovered the great variety and vibrancy of Chicago's water tossers. It was exciting to receive calls, texts, and images of fountains from this informal team of roving researchers. "I just saw one on my way home at Division and Ashland," Christine Bertrand said. "Have you ever noticed the one in Lincoln Central Park?" Frank Malone asked. Together, we found more than 125 fountains, many with fascinating stories to tell. Thank you, Fountain Finders.

Other friends and colleagues came up with stories about these fountains that would help carry the book along. For this, I'm grateful to Oliver Borzo, Charles and Joanne Gasperik, John Greenfield, Sarah Guerin, Philip Halpern, John Holden, Janet Hong, Michael Klaus, Chris Lynch, Sarah Mickler, Father Michael Pfleger, Dan Pogorzelski, Andrea Sherwood, Ken Spengler, Patrick Steffes, Andrew Tinich, Charlie Wojciechowski, and more—too many to list here. I may not have used each of your stories, but you primed the pump and helped me realize how fun and compelling fountain stories can be.

Meanwhile, the most enthusiastic and helpful person on this project was Julia Thiel, who volunteered to do the photography and provided inspiration throughout the process. She devoted countless hours to planning, shooting, and editing her photographs, and most of the contemporary images in this book are her work. Julia is extremely talented not only as a photographer but also as a graphic designer (see Yoolia Design). She created the map and other features that accompany this book. *Chicago's Fabulous Fountains* would not have been as successful without Julia's thoughtful and dedicated participation.

Several artists, architects, and fountain designers enthusiastically supported my research and taught me a lot about siting, designing, and building fountains. Chief among them was Edward Windhorst, a former staff architect at DeStefano and Partners. I call Ed Chicago's "Fountain Meister" because he designed more than fifteen Windy City fountains, including some of its most remarkable ones. Other artists, architects, and designers who generously shared their time, resources, expertise, and artistic views include Andrzej Dajnowski (Conservation of Sculpture and Objects Studio), Jerzy Kenar (Wooden Gallery), Joe Petry (Delta Fountains), John David Mooney (John David Mooney Foundation), Ron Weslow (formerly with the Chicago Transit Authority), and Hana Ishikawa and Ernest Wong (site design group, ltd.).

For my research, I read dozens of books and hundreds of articles about fountains. With the latter, the name that popped up the most frequently and provided the most insight was that of Blair Kamin, architecture critic par excellence for the *Chicago Tribune* since 1992. Long may he write!

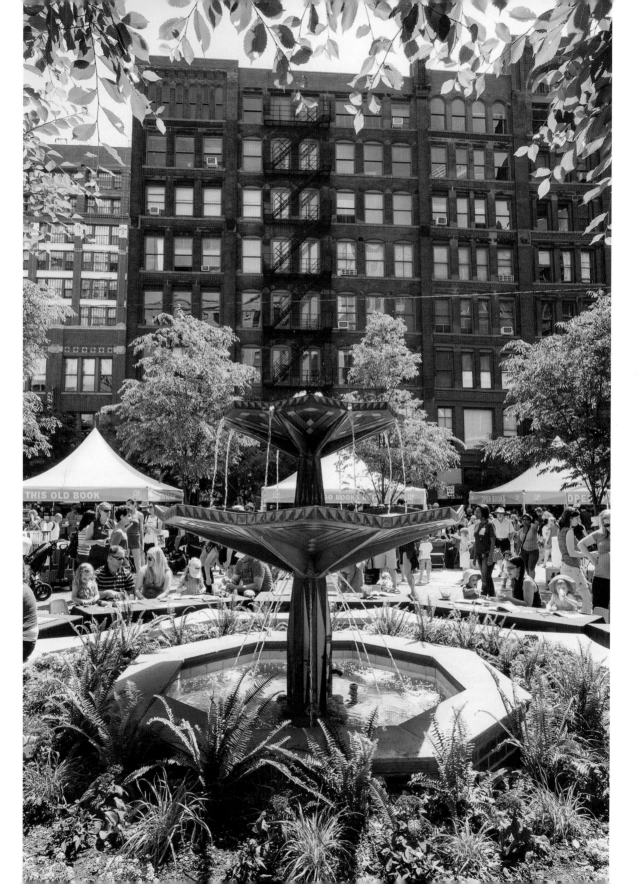

After the manuscript was completed, I turned to several readers and editors to help make my words do justice to the fountains they describe. My profound gratitude goes to Jeanette Borzo, Sherry Brenner, Jane Swanson-Nystrom, and Edward Windhorst, all of whom provided extensive editing—over and above the call of duty. Other readers who offered helpful feedback include Christine Bertrand, Roxanne Bertrand, Paul Borzo, Mary Bryant, Joseph Gustaitis, Janet Hong, Jacob Kaplan, Richard Lanyon, Patrick McBriarty, Chris Slivon, and Patrick Steffes.

As with each of my previous books, *Chicago's Fabulous Fountains* would not have come together without the detail-oriented, top-notch assistance of many librarians. My sincere thanks goes to Julie Lynch (Sulzer Regional Chicago Public Library); Lesley Martin (Chicago History Museum); Autumn Mather (Ryerson and Burnham Libraries, Art Institute of Chicago); Neil O'Shea (Niles Public Library); Tracy Seneca (Richard J. Daley Library, University of Illinois Chicago); and Morag Walsh and Johanna Russ (Special Collections, Chicago Public Library).

The Chicago Park District's website (www.chicagoparkdistrict.com), researched and written by Julia Bachrach, provides vital information about Chicago's fountains. And Jyoti Srivastava's striking photography, which can be viewed on her inspiring blog called *Public Art in Chicago* (www.publicartinchicago.com), is beautiful, meticulous, and comprehensive.

For expert opinions on architecture, history, religion, transit, politics, and urban planning I was able to turn to many friends and experts, including Rolff Achilles, Peter Alter, Krista August, Julia Bachrach, Sara Benson, Rich Cahan, Kevin Carroll, Vi Daley, Michael Fus, Benet Haller, Louise Howe, Gary Johnson, Ken Little, Nathan Mason, Dennis McClendon, Ward Miller, Bruce Moffat, John O'Neal, Debra Shore, Douglas Stotz, Molly Sullivan, Terry Tatum, Erma Tranter, Ron Weslow, and David Wilson, as well as members of the incredible team at Forgotten Chicago, including Jacob Kaplan, Daniel Pogorzelski, and Patrick Steffes. All of you rock!

Helpful in securing images were Julia Bachrach, Ben Holden-Crowther, Stephanie Franklin, John Graf, Heather Johnson, Russell Lewis, George Lightfoot, Michael Lyons, John David Mooney, Diane Joy Schmidt, Deborah Talamantez, René and Peter van der Krogt, and Bruce Verink. And, of course, Julia Thiel.

My newfound fountain friends in Kansas City (America's self-proclaimed City of Fountains) deserve loud applause for their unflagging support of fountains—and this book: Jocelyn Ball-Edson, Nyle Gordon, Megan Hewitt, Lou Joline, George Lightfoot, Ann McFerrin, Mark McHenry, Joanie Shields, and others, especially Heidi Downer at the Kansas City Parks and Recreation Department, who provided these contacts and coordinated their efforts. May your welcoming spirit as well as your enthusiastic support of fountains spread to Chicago and beyond.

I am deeply grateful to two longtime friends who share my love for Chicago: Geoffrey Baer, who wrote the foreword, and Debra Shore, who wrote the preface. Both of them embody a truly generous spirit—giving advice, sharing knowledge, and celebrating Chicago everywhere they go, every way they can! Chicago and I are indebted to both of them.

Of course, no one would be talking about fountains without all the donors and funders, artists and architects, designers and landscapers, and builders and engineers who collectively form fountains out of their ideas and dreams. Bravo and encore!

Finally, a shout-out to all the volunteers and staff members who keep Chicago's fountains flowing. Your hard work makes our city more enjoyable and attractive.

Throughout the entire process, Christine Bertrand helped in every way possible, provided steadfast support, and showed incredible patience.

To all of you I say, "Merci buckets."

Greg Borzo

The Printers Row Park Fountain at 700 South Dearborn Street is a magnet for the community–and the entire city– during the *Chicago Tribune* Printers Row Lit Fest every June.

CHICAGO'S }FABULOUS FOUNTAINS

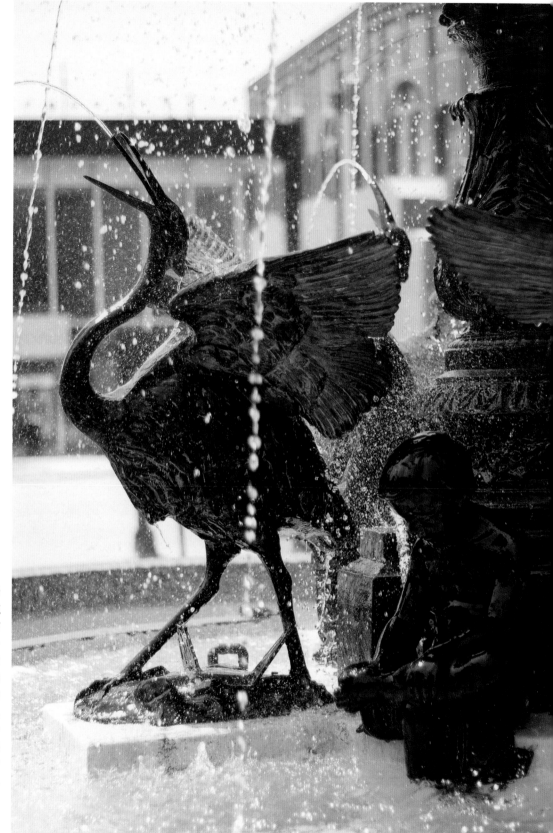

While Mayor Jane Byrne was choosing the features of her Children's Fountain, she decided on defenseless cranes rather than fierce griffins. The fountain, which she called "my favorite project, a work of the heart," was later bounced around town.

INTRODUCTION

Perhaps Mayor Jane Byrne should have gone with the griffins.

Sitting in her office at City Hall in 1982, Byrne was selecting the features of the ornate Children's Fountain she was planning for a traffic island at Wacker Drive and Wabash Avenue. She and Scott Howell, vice president of Robinson Iron, were assembling the four-tiered fountain piece by piece from a catalog, using acrylic sheets to overlay different animals and figures on the emerging design.

"How about griffins?" Howell asked.

"No, I just had a fight with a guy named Griffin," Byrne replied, referring to her chief of staff, William Griffin. "Let's go with cranes."

But griffins—fierce legendary creatures with the body of a lion and the head of an eagle—might have provided better protection than the timid cranes ever did. In what some consider a slap at Byrne, Mayor Richard M. Daley removed the twenty-foot-tall Children's Fountain in 2000 during the reconstruction of Wacker Drive. Declining to incorporate the $228,000 ($565,000 today) fountain into the new street design, Daley had the piece put in storage, where it languished for years. Most people understood that for Daley, the fountain represented Byrne, with whom he had feuded for years.

Byrne had made no secret about how important the Children's Fountain was to her. The cover of *My Chicago*, her 1992 memoir, featured Byrne standing in front of it. And in that book she called the fountain "my favorite project, a work of the heart" and "one of the two achievements that mean the most to me." (The other was *another* fountain, the Chicago Vietnam Veterans

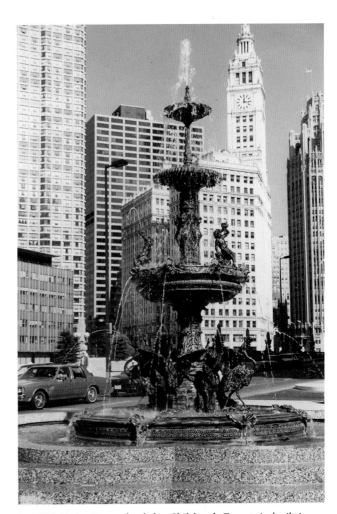

In 1982 Major Byrne had the Children's Fountain built in Heald Square, a large traffic island in Wacker Drive west of Wabash Avenue.

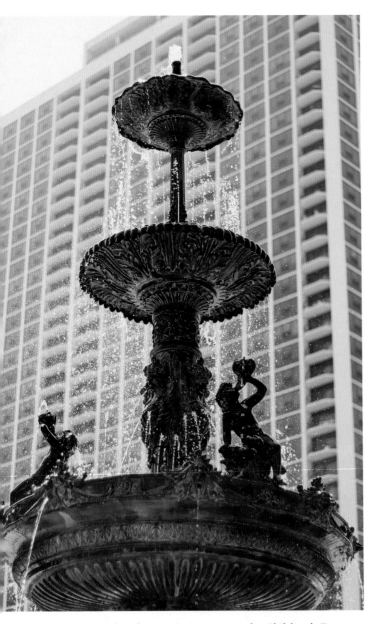

In 2005, after five years in storage, the Children's Fountain was installed in front of the Chicago History Museum. Today it's in shabby condition, missing parts, and appears to be rusting on its laurels!

Memorial Fountain, which Daley also bounced around.) Nevertheless, her Children's Fountain did not get much respect. It was poorly maintained under three successor mayors, and Daley, Byrne's fourth successor, administered the apparent coup de grâce after he took over City Hall.

But "Fightin' Jane" and sympathetic reporters did not let him get away with it. They pressed the issue and got the fountain reinstalled in 2005 near the Chicago History Museum at North Avenue and Clark Street. Who would have thought that a beautiful, well-intentioned fountain—one dedicated, no less, to "all children in Chicago who take from our past to make better our future"—could play a role in such Machiavellian mischief?

~~~~~~

As this story illustrates, Chicago's fountains have a lot to spout about. They overflow with stories about their design, character, and meaning—tales motivated by ego and rivalry, fame and fortune, love and social reform. These fountain stories reveal simple goals as well as lofty ideals; ethnic heritage as well as neighborhood identity; misguided creative forays as well as soaring artistic achievements.

Some fountain stories, on the other hand, are simply amusing. Television crews have been known to initiate rookie reporters by waiting for a windy day and pretending to take an assignment at Buckingham Fountain. They set up the reporter close to—and downwind of—the fountain and position their camera off to the side. While waiting for the top of the hour, they fiddle with their camera and have the reporter rehearse his lines. When the fountain's main jet shoots off on schedule, the unsuspecting reporter gets doused.

"It was pretty easy to pull off this prank because a new reporter depends on his crew to find his way around town, who to talk to . . . and where to stand," said Charlie Wojciechowski, a veteran reporter for NBC Channel 5. "Just a little hazing, all in fun."

~~~~~~

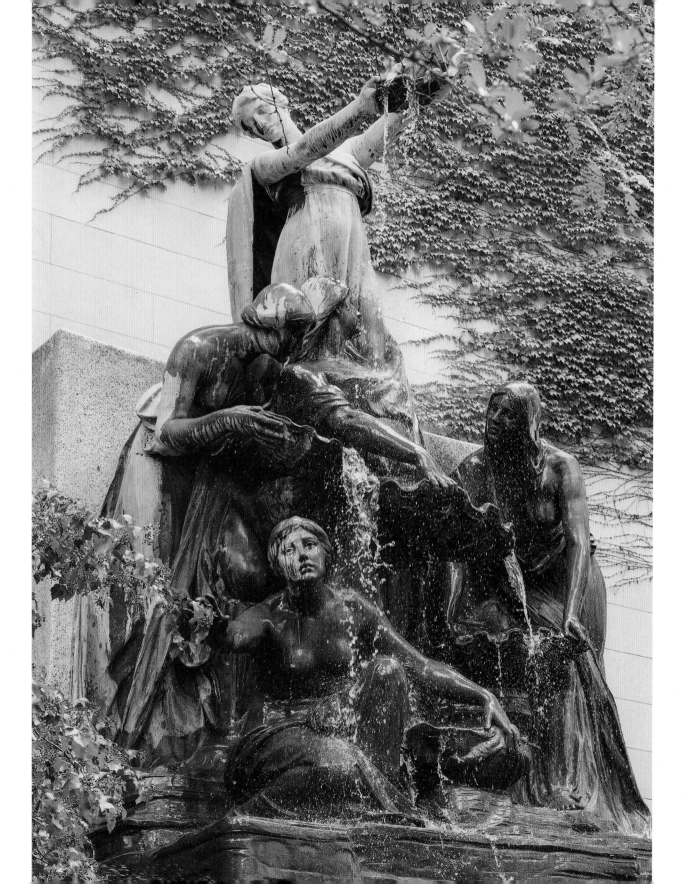

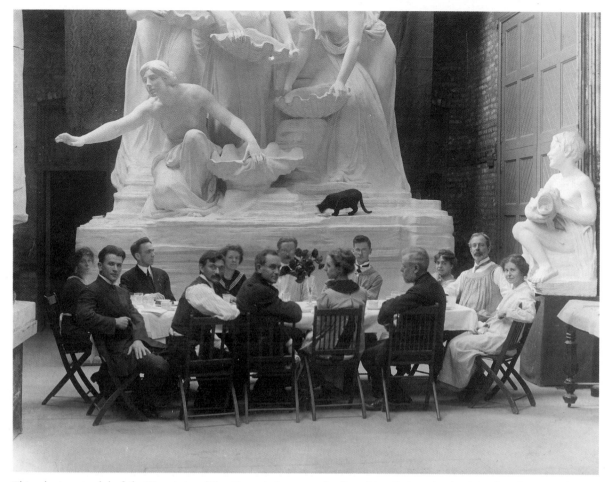

This plaster model of the Fountain of the Great Lakes was the first thing Robert Irwin saw when he visited Taft's Midway Studios in 1929 looking for work. (Did the black cat portend evil?) Years later the murderer gave himself up at the fountain, by then built on Michigan Avenue.

Chicago fountain stories can be deadly serious, too. Robert Irwin was a gifted sculptor and protégé of Lorado Taft, a leading sculptor who designed two of Chicago's greatest fountains. On Easter Sunday 1937, Irwin murdered three people in New York City.

Veronica Gedeon, one of his victims, was a model who posed for scandalous photographs in pulp magazines. While Irwin was on the lam, he and Gedeon were the

Previous page: The Fountain of the Great Lakes, one of Lorado Taft's masterpieces, adorns the South Garden of the Art Institute. Each of five maidens holds a shell that represents one of the Great Lakes.

subjects of front-page newspaper articles nationwide. "Slain Model's Diary Bares Love Secrets," screamed one headline.

With the law closing in on him, Irwin fled to Chicago, where he had lived while working for Taft. The "Mad Sculptor," as the tabloids called him, decided to sell his confession to a newspaper and use the $5,000 ($83,400 today) reward to hire an attorney. When Irwin called the *Chicago Herald-Examiner*, Harry Romanoff took the call.

"Can the reward go to anyone?" Irwin asked.

"Why, sure," Romanoff answered sympathetically, asking to discuss the matter in person.

"That can be arranged," Irwin said. "I'll meet your representative at two-thirty near the fountain at the south

Introduction

end of the Art Institute," referring to the Fountain of the Great Lakes.

"We knew right then that we had Irwin because he had been a disciple of Lorado Taft," and that was a Taft fountain, Romanoff recounted.

Why did the murderer choose that location to give himself up? Perhaps because Irwin felt close to Taft, his former mentor. (Taft had even arranged for his mother-in-law to lodge Irwin.) Or perhaps it was because Irwin liked the Fountain of the Great Lakes. After all, a full-scale plaster model of that sculpture was the first thing he saw when he, an unknown sculptor looking for work, had shown up unannounced at Taft's studio in 1929.

In the end, the *Herald-Examiner* milked the Irwin story for days before handing over the murderer to the police. Irwin used his reward to hire renowned defense attorney Samuel Leibowitz, who helped him avoid the electric chair. Still, the Mad Sculptor spent the rest of his life in a prison for the criminally insane.

~~~~~~

What is a fountain? Originally the word referred to a spring or other natural source of water. Today it refers to a built structure designed to hold and move water for aesthetic, pleasurable, or artistic purposes. Some water tossers highlight the structure, others the water, but all celebrate the sight and sound of rising and falling $H_2O$—in its infinite varieties.

Surprisingly, more than 125 outdoor public fountains grace Chicago and constitute a vital element of the city's built environment. Nevertheless, most of these aquatic spectacles are unappreciated, even unnoticed. The Windy City is famous for

- stunning architecture,
- world-class museums,
- impressive skyscrapers, and
- vibrant performing arts.

It's high time to shine a spotlight on Chicago's fountains, which are

- architecture in motion,
- museums without walls,
- "sky-sprayers," and
- effervescent performers, singing and dancing with a cast of metal and stone, air and light, water, weather, and wind.

These treasures—from the Aon fountains to the zellij fountains; from temperance fountains to the "boob" fountain; from Buckingham Fountain to the Shit Fountain—are more than decorative amenities. They are spirited pieces of art that bring life and pleasure to the big, hard city. They are dynamic, ever-changing—almost alive. They offer spectacular symphonies of sound. They attract, relax, refresh, and inspire people. They are one of the best implements in an urban planner's tool kit. And they express Chicago's culture, values, and priorities.

"Chicago is what it is thanks to water, and fountains can help us remember that," said John David Mooney, an acclaimed Chicago architect who has designed many fountains. "We have—and should celebrate—water, water, everywhere!"

A city can be measured by the fountains that dot its parks, plazas, and streets. Anyone who stops, looks, and listens to the splish, splash, and splosh of Chicago's water shows will discover that these works have much to say about the city's accomplishments and aspirations. Anyone who thirsts for a better understanding of *urbs in horto*—this city in a garden—can quench this thirst by exploring the city's fountains. These water wonders provide a portal to study Chicago and to make it more accessible.

Beyond their artistic and historical significance, Chicago's fountains build, sustain, and (so to speak) water community. By bringing people together, they offer the residents a way to interact with each other (and sometimes even with the water itself).

"Public spaces are the fabric that ties communities together, and fountains are an important part of creating and celebrating those public spaces," said Ernest Wong, principal at site design group, ltd., a landscape architecture and urban design firm that built many Chicago fountains.

Jaume Plensa also understands how fountains have the power to gather and rouse people. In 2004 he achieved praise worldwide for his spectacular Crown Fountain, which features two glass-brick towers that squirt water from video images of average Chicagoans. "My goal with this fountain was to celebrate the most fundamental element of a public space—people," he said while honoring the fountain's tenth anniversary.

Keith Patrick described how the Crown Fountain helps cultivate a sense of community: "Plensa wanted to restore the fountain to its rightful place. Not at the periphery but at the center of people's lives. A fountain to which people effortlessly gravitate in a space that is welcoming. A beacon that reaches out with its celebration of life."

~~~~~~

And there are lots of ways to celebrate life. Just ask Diane Joy Schmidt and Michele Fitzsimmons. Schmidt, already a well-established photographer in 1981, shot the nude or seminude Fitzsimmons all over Chicago for *The Chicago Exhibition,* a coffee-table book that set out to "elevate the ordinary to the humorous or startling."

The daring duo was determined to include photographs of Fitzsimmons at local landmarks, such as the lakefront, Maxwell Street, and the "L." They shot at Buckingham Fountain in the off-season, when there would be no water to deal with. After Fitzsimmons climbed atop the boarded-up fountain, police spotted her. "The cops chased us, and it got to be like a Woody Allen movie with us zigzagging around the park, and the cops chasing us in their squad car, jumping curbs, et cetera," said Schmidt, who is now an award-winning journalist and photojournalist in Albuquerque, New Mexico. "We got the shot and didn't get arrested, but the cop who caught us lectured us about what is and isn't art!"

In the preface to *The Chicago Exhibition,* Fitzsimmons mused about what made her do a book that cast her "buck naked" all over town. "Perhaps I did it for fun," she said. "Or to have a reason to climb Buckingham Fountain."

With constantly changing water, fountains constitute one of art's most dynamic forms. When water dances with air and light, and flows over metal and stone, it softens the city's hard edges. Take a walk on the wet side!

What would it be like to pose nude atop Buckingham Fountain? "I felt strong and free, and part of the fountain," model Michele Fitzsimmons told the *Tribune*, about her experience.

This same sense of audacity motivated artist Jerzy Kenar to build the **Shit Fountain** in front of his East Village home and studio at 1003 North Wolcott Avenue. This outlandish work of art features a conspicuous coil of bronze dog poop deposited on top of a short pedestal. "I hoped it would motivate dog owners to pick up after their pets," he said.

When the water's running, the bronze pile glistens like a real, fresh dropping. That did not stop Mayor Richard M. Daley and Father Michael Pfleger, the high-profile pastor of St. Sabina Church, from attending the 2005 unveiling of this "pile of shit."

In fact, Kenar is a world-class artist who usually busies himself designing religious sculptures and liturgical furnishings in wood and bronze. Some call the Shit Fountain his "Number Two Fountain" because it's his second, the first one being the Black History Fountain near St. Sabina. Kenar meant the Shit Fountain to be whimsical. "Only one little old lady didn't get the joke," he said. Indeed,

The Shit Fountain sits in front of the East Village residence and studio of artist Jerzy Kenar, better known for religious sculptures and liturgical furnishings.

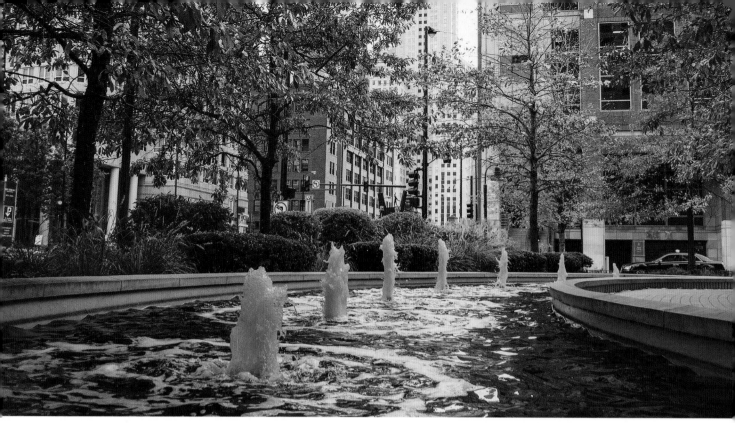

Only a few Chicago fountains, including this one at 400 North LaSalle Street, are dyed for holidays, social causes, or special events. Is Chicago missing the boat?

neighbors seem to have embraced the fountain. People frequently visit, drink from, and pose with it.

Balancing the Shit Fountain, in some measure, is the **Bathtub Fountain** in the rear courtyard of Salvage One at 1840 West Hubbard Street. In this crazy creation, water flows from overhead spigots, across rows of lunch trays, through pipe organs, and into two bathtubs propped against a vine-covered wall. Former employee Davide Nanni made this Rube Goldberg contraption in 2006 from "whatever materials were around at the time," said Marcus Ober, manager of the salvage warehouse and event venue. "The fountain is a popular backdrop for parties and photo shoots and actually attracts business."

Fountains are also fun to dye. The Daley Center Plaza Fountain makes a big splash out of dyeing its water emerald green for St. Patrick's Day and bright orange for Halloween. President Barack Obama carried this tradition to Washington, D.C., in 2009 when, for the first time, White House fountains gushed green on March 17.

The **400 North LaSalle Condominiums Fountain** is dyed green and orange annually, a practice property manager Diana Breting instituted in 2012. She wonders why other buildings don't follow suit because it's inexpensive to do and people enjoy the colors. (Breting uses food dye and needs less than a day to drain and refill the fountain.) "I'm thinking of coloring ours for additional occasions, such as red for the Blackhawks," she said.

But there's more than one way to color a fountain. In 2007 Buckingham Fountain turned blood red using colored lenses on its lights. The occasion, which earned the Chicago Park District $11,000, was a publicity stunt for *Dexter*, the television show about a bloodstain-pattern analyst who's also a serial killer. During the promotion, minions in lab coats handed out DVDs and other freebies.

A more established tradition is tossing in a coin while making a wish. In this case, all fountains lead to Rome, where the practice was popularized by the 1954 film *Three Coins in a Fountain*, featuring the Trevi Fountain. Nonetheless, the coin-tossing tradition originated in ancient times, when people had to leave an offering (or pay a fee) at natural springs to thank the gods (or the guards) for clean water.

Coins tossed into fountains represent society's collective wishes. The bottom of many Chicago fountains (especially the Burnham Fountain at Macy's on State Street) are sprinkled with pocket change. Most fountain owners say these coins get donated to charity. Still, thieves sometimes take a cut—unless they get caught wet-handed.

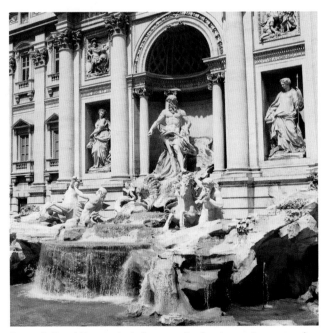

Rome's Trevi Fountain is famous for having coins tossed into it, but that practice is rare in Chicago. Midwesterners may be too practical to throw away money.

Thieves have also been caught black-handed. While Michael Klaus, a retired engineer, was a college student, chemistry majors would lace campus fountains with silver nitrate and then toss in some valuable coins. Invariably, fellow students (perhaps looking for beer money) grabbed the coins, only to find that their arm would turn black (from the silver nitrate). "Better living through chemistry," Klaus quipped. "Anyone who was baited by the coins became the talk of campus . . . until the next person would be suckered in."

~~~~~~~~~~

Some Chicago fountains are prominent, but most are off the beaten path—"nice works if you can find them." This book will help you navigate the fountain scene, to notice and better understand fountains you might pass frequently. It will also motivate you to discover new ones, many of which are hidden in plain sight.

There's a lot more to Chicago's fountains—from the big blasts to the little squirts—than meets the eye and ear. Chi-town's fountain designers have molded water into stunning shapes, orchestrated it to make a huge variety of sounds, and commanded it to refresh and renew anyone who happens by. History, art, and beauty pour from these water displays.

Check out Chicago's fabulous, free outdoor fountain museum. Visit early and often! Such outings will lead you to discover surprising stories of people and places; parks and plazas; churches and schools; restaurants and libraries; historic sites and neglected neighborhoods; boulevards and bike paths; artists and architects; authors and astronauts; skylines, shorelines, dance lines, headlines, and transit lines. Go ahead. Put fountains on your bucket list.

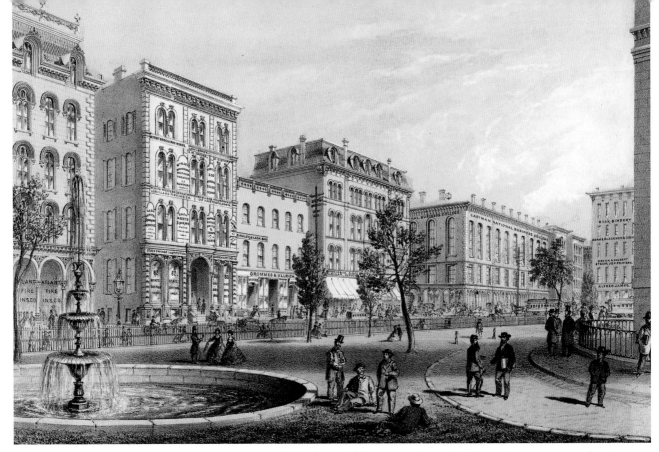

This 1866 lithograph of Courthouse Square at LaSalle and Randolph streets shows that fountains were part of early Chicagoans' attempts to beautify their city.

# 1. FIRST FOUNTAINS

Most of Chicago's earliest fountains have fallen prey to time, the elements, poor maintenance, or changing tastes. In many cases, photos and drawings are all that remain to bear witness to the beauty of old fountains—and to the fact that fountains have always been a part of the city's growth and development, design and identity.

A good example of the significance of fountains in the city's early history is the traditional-looking three-tiered fountain that stood in the center of Dearborn Park. Thought to be Chicago's first park, this green space was opened in 1838 at the present site of the Chicago Cultural Center. Moving ahead several years, a grander fountain appears in an 1866 lithograph of **Courthouse Square** at LaSalle and Randolph streets. The artist highlights this stately fountain, showing that Chicago, despite its new Union Stock Yard, was not just a place to butcher hogs but also a city aspiring to elegance.

The city's oldest surviving fountain, the **Francis M. Drexel Fountain**, dates to 1883. Ironically, it's named for a man who probably never set foot in town. But as with much of Chicago's development—from its roots until today—the history of this fountain flowed out of a real estate deal.

In the 1840s the Philadelphia-based Drexel Bank acquired through foreclosure a large tract of land south of Chicago. Drexel, who headed the bank, was born in Austria and as a young man lived in Italy, Switzerland, and France. His travels allowed him to study art but also to avoid the Austrian army's draft. Drexel took up painting and continued traveling, including to the United States. He developed an interest in finance and currency trading, opened a bank in Philadelphia, and went on to become one of the country's most successful bankers.

Even though Drexel never lived in Chicago, his sons Francis A. and Anthony did. Running Chicago's branch of the family business, they were deeply involved in financing the growth of the city. After their father died in 1863, the Drexel scions wanted to do something to honor him. Their bank still owned that tract of land south of Chicago, so they gave the city a strip of it for a street, with the understanding that it would be named Drexel. In 1880 the South Parks Commission (a precursor of the Chicago Park District) complied by changing the name of the street from Grove Parkway to Drexel Boulevard.

Glad to have a street named Drexel, the brothers decided to donate a fountain. In 1881 they commissioned German sculptor Henry Manger to sculpt a statue of their father for the fountain, which ended up costing $50,000 ($1.2 million today). Two years later, the elegant four-tiered waterworks was unveiled at Drexel Boulevard and 51st Street.

Manger's nine-foot-tall bronze statue of Francis M. Drexel leaning against a fencepost, wearing a bowtie and midlength coat, stands atop a thirty-five-foot-high base. Below him, a large vase that catches water is trimmed with thirteen stars representing the original colonies. Below that, four winged lions and four bronze bas-relief panels celebrating water decorate the memorial. On one panel, Neptune, Roman god of the sea, rides a dolphin and holds a trident. On the others, a boy fishes, a damsel draws water from a spring, and a maiden gathers flowers.

With sixty some jets and sprays, water spews everywhere from the stars, lions, and other ornaments. Then it dribbles off the scalloped shells, acanthus leaves, and

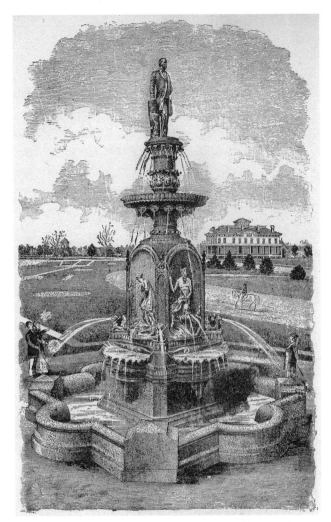

The Drexel Fountain, Chicago's oldest water tosser, dates to 1883. "Our works and our surroundings corrupt or refine our souls," said Charles Richmond Henderson in *The Social Spirit in America*, published in 1908.

other frills of this lavishly garnished fountain. A twenty-three-foot-wide granite basin near ground level catches the overflow. The overall effect is dainty Victorian.

As anticipated, this impressive yet graceful fountain on the wide, tree-lined Drexel Boulevard helped the area prosper. Henry Ives Cobb and John Root designed mansions built along the street, which became home to many of Chicago's wealthiest families.

Over the ensuing years, the fountain was neglected and fell into disrepair. It spent decades inoperable, somewhat

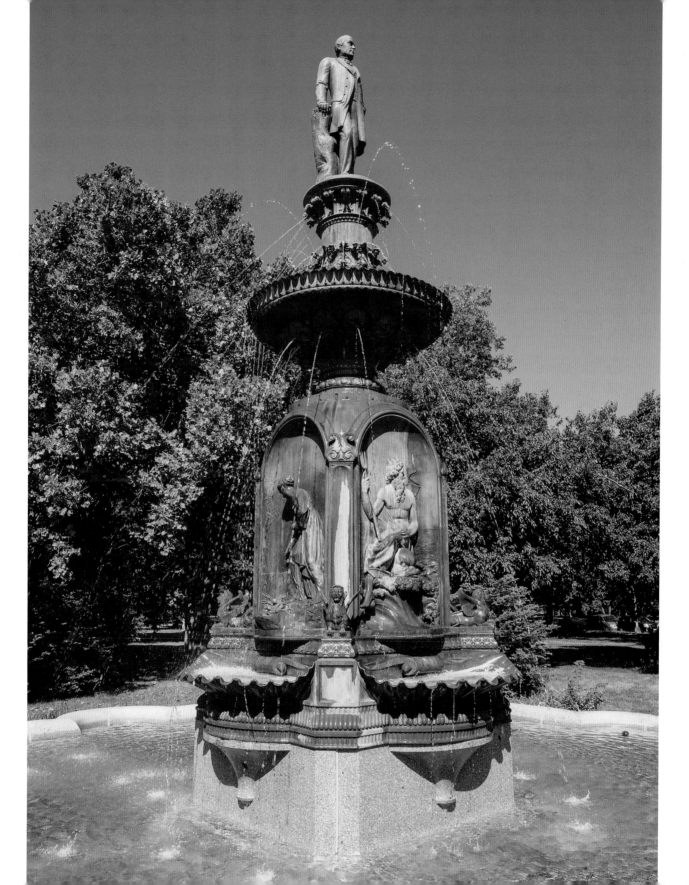

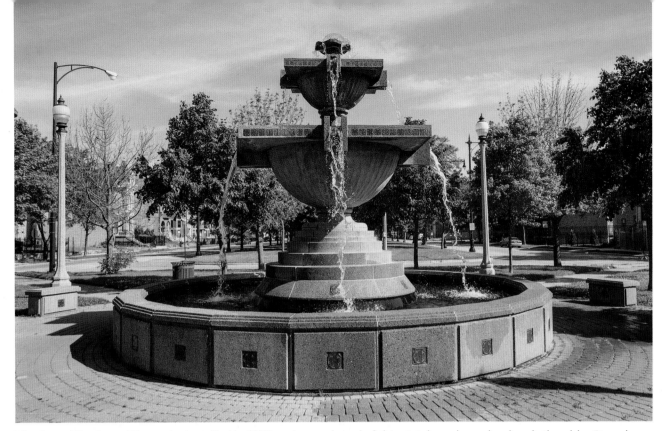

The Drexel Boulevard Fountain, installed in 1998 at the north end of this stately parkway, bookends the older Drexel Fountain at the south end.

forgotten. By the 1970s the neighborhood had declined and become crime infested. The area rebounded in the 1990s, and in 1999 a restoration of the fountain made it "bubble over with pride," as reporter Nancy Moffett put it.

"The fountain was derelict, so we had to disassemble it and send all the parts to a shop in Wisconsin for a complete overhaul," said Edward Windhorst, the architect who directed the restoration for DeStefano and Partners.

The project included new piping, plumbing, and lighting systems. Also, stolen pieces were refashioned. Previously, the water flowed into the sewer, so a new closed water recirculation system was added. (When this memorial was built, recycling fountain water was uncommon, which explains why water was used sparingly,

**The extravagant and newly restored Drexel Fountain reflects well on Chicago and presides over the renewal of a once-again vibrant community on the South Side.**

in trickles out of small spigots rather than gushing out of large spouts, as is common with newer waterworks.) Regrettably, the renovation was not whole for long. The day after the dedication, two restored bronze plaques were stolen and have never been recovered.

Today, the area around the fountain continues to improve, manifested not only by the renovation of the Drexel Fountain but also by the construction in 1998 of another fountain at the north end of Drexel Boulevard, where it intersects Oakwood Boulevard. The new fountain stands across the street from the former headquarters of El Rukns, a notorious 1980s street gang. It was named the **Thomas Dorsey Fountain** for the South Side musician considered to be the father of gospel music. That name did not stick, however, so the large concrete waterworks is known as the **Drexel Boulevard Fountain**.

Together, Chicago's oldest fountain, at the south end of Drexel Boulevard, and one of its newest, at the north

end, stand as bookends—testament to the resurgence of an attractive parkway and thriving community. They represent the power of fountains to help build, and then rebuild, a neighborhood.

~~~~~~~~

The oddity of Chicago's oldest fountain being named for someone who probably never set foot in Chicago is matched by its second oldest, **Storks at Play**. This flamboyant fountain contains none of its namesake storks!

The three large bronze birds, with wings spread, that spray water from their beaks are swans. So says Douglas Stotz, an ornithologist at the Field Museum of Natural History. After carefully considering the bird's features, he eliminated all the alternatives, including duck, crane, goose, and heron (as well as stork).

No one at the Field Museum, however, could identity the genus or species of the three bronze merboys (half boy, half fish) who frolic with large fish in their arms in the fountain's shallow granite basin. Tall bronze reeds and cattails protrude from the center of the forty-foot-diameter

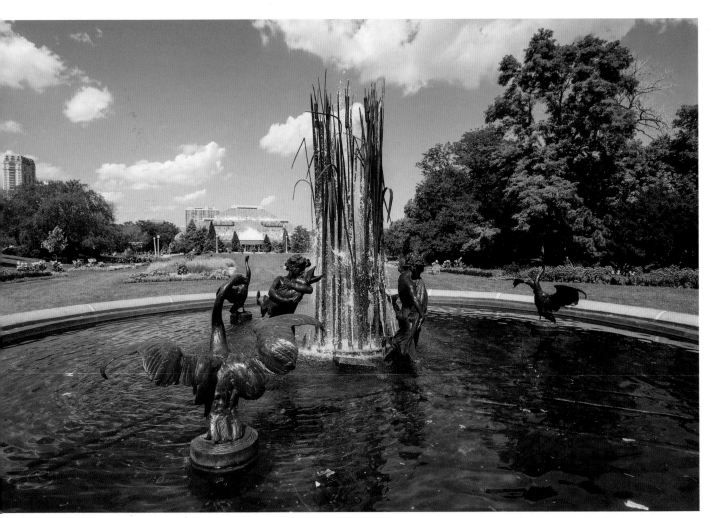

"If there's magic on this planet, it's contained in water," said anthropologist Loren Eiseley. His words aptly describe Storks at Play in Lincoln Park.

First Fountains

basin, and water sprays everywhere. The theme is playful, so much so that the public has occasionally waded in to join the fun. These fountain forays have compromised the work, and for a while a fence was put up to keep people out. In fact, the reeds and cattails are replicas, because the originals have been damaged or stolen.

Despite its prominence as the centerpiece of the stunning formal gardens in front of the Lincoln Park Conservatory, Storks at Play, also known as the **Eli Bates Fountain**, began somewhat as an afterthought. When lumber tycoon Bates died in 1881, he left $25,000 ($620,000 today) for a statue of Abraham Lincoln as well as $10,000 ($250,000 today) for a fountain. A selection committee launched a competition for the statue. After it deemed the submissions unworthy of such an important commission, the committee persuaded Augustus Saint-Gaudens (who had not submitted an entry) to take on the work.

Saint-Gaudens, on his way to becoming one of the country's most admired sculptors, threw himself into the statue, a magnificent piece that now anchors the south end of Lincoln Park. Meanwhile, he assigned the fountain to his assistant Frederick MacMonnies, who finished the work in 1887. Although the piece is attributed to both artists, experts agree the merboys and storks, er, swans, contain telltale signs of MacMonnies's touch.

Sculptor Lorado Taft said of MacMonnies, "For sheer dexterity and manipulation, there is no American sculptor to be compared with him."

But that style went a little too far for some. Shortly after the fountain was installed, critics objected that the merboys were naked. This prompted park officials to require "copper fig leaves be prepared by Mr. St. Gaudens . . . and put in place at once," according to the proceedings of Lincoln Park commissioners. The fig leaves were later removed.

Built downtown in time for the World's Columbian Exposition, the large Drake Fountain was a popular gathering place. It featured an eight-foot bronze statue of Christopher Columbus.

The remarkable **Drake Fountain**, now on a traffic island at South Chicago and Exchange avenues and 92nd Street, was built downtown as a drinking fountain to quench the thirst of those attending the World's Columbian Exposition of 1893.

This is one of the few Chicago fountains that's named for its benefactor. When John Drake moved to Chicago in 1855, he bought an interest in the Tremont House,

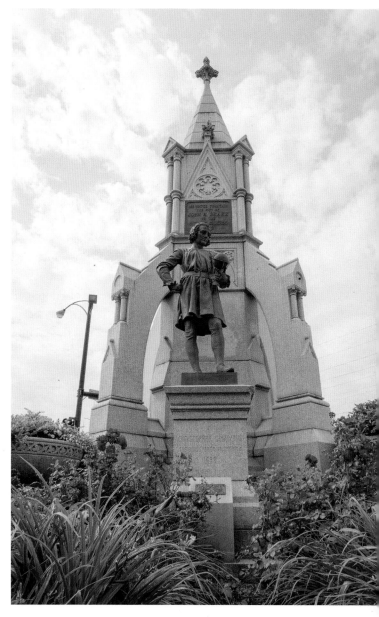

Chicago's leading hotel. Soon he owned it outright. Drake built and operated other elegant hotels, and set a high standard for hospitality in Chicago at a time when the city was still emerging from the mud. (His sons continued in his footsteps, opening the luxurious Drake and Blackstone hotels.)

In 1871 the Great Chicago Fire burned Drake's Tremont Hotel to the ground. The next day, while the fire was still raging, Drake bought the Michigan Avenue Hotel, taking a bold $1,000 ($20,000 today) gamble that the flames would not destroy it. The fire spared the hotel, and Drake quickly recouped his investment. Over time he became one of Chicago's most influential citizens. The hotelier counted among his friends generals Logan, Sheridan, and Sherman and presidents Lincoln, Grant, Hayes, Garfield, and Arthur.

When Drake decided to give the city a gift, the world's fair seemed a good time to maximize the benefits of his generosity. Being well practiced at serving people, he made his gift a useful but elegant drinking fountain at a cost of $15,000 ($400,000 today).

Many dignitaries attended the December 26, 1892, launch. Master of ceremonies Thomas Bryan applauded that Drake's gift was "not of the postmortem character," explaining, "the bestowment, during the life of a donor, of money for a great public use is to be specially commended, inspiring prompt execution of the beneficent design and enabling the donor to witness and share the blessings of his own benefaction."

And the blessings were plentiful. The Drake Fountain has a sixteen-square-foot base from which rise four flying buttresses built of coral-tinted granite from a famed quarry in Baveno, Italy. They meet in a central square column that holds a ribbed, church-like steeple crowned with an ornament thirty-five feet up in the air. Each corner of the stepped base is fitted with a four-foot-diameter basin that originally held faucets. A vault stored up to three tons of ice that cooled water as it passed through coiled pipes. During the few years this popular feature functioned, the structure was also known as the **Ice Water Fountain.**

In front of the edifice, atop a square Italian granite pedestal, stands an eight-foot bronze statue of Columbus sculpted by Richard Henry Park. The Great Discoverer holds a globe in one hand and a compass in the other.

Despite its beauty, the Drake Fountain was soon mired in controversy. People complained it attracted riffraff downtown. Others objected to the dirty conditions around the fountain. Its original location on Washington Street in a courtyard between City Hall and the County Building was unfortunate. Before the fountain was erected, this courtyard was used to park horses and buggies, or as the *Tribune* reported, "as a free barnyard . . . where the odor was unpleasant and the flies numerous." The fountain made the courtyard worse by attracting more carriages, resulting in more filth. "Every man who visited the business district in a buggy and was too stingy to patronize a livery station" used the courtyard and its fountain, according to the *Tribune* in 1894. In addition, theaters posted advertisements on the structure, making it "a sort of bureau of theatrical information" and "an unbearable nuisance."

In 1905, when the city began to build the present County Building at the site of the old one, it moved the Drake Fountain around the corner to LaSalle Street, a few doors north of Washington Street. But there it took up space on the sidewalk and caused people to congregate. By 1909 government officials had seen enough of the disparaged Drake Fountain. They announced plans to move it to, of all places, the far South Side.

By this time, Drake was dead so he could not object to the dishonor of having his gift, Chicago's most ornate fountain, relocated far away from the center of power. The Knights of Columbus did, however. This influential organization considered the threatened removal "an affront to Catholics" and launched a campaign to keep the fountain honoring its patron downtown, on the lakefront, or in another well-traveled location.

The Knights accused public works commissioner and South Chicago alderman John Hanberg of stealing the fountain. In the names of its 10,500 local members, the organization threatened political retribution. "The incident will serve to turn the Italian vote against the

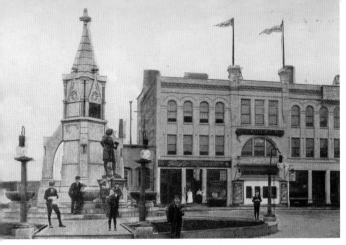

"Drake didn't give the fountain to South Chicago," the Knights of Columbus complained. "He gave it to the entire city. In the loop district, 10,000 persons would see it [but] only one may look at it in South Chicago." Nevertheless, the Drake Fountain was moved in 1909 to the far South Side, where it still stands.

Republicans [then holding the mayor's seat] unless the statue is returned to the heart of the city," said Thomas O'Shaughnessy, a Knights official. All to no avail. The fountain still crowds that South Side traffic island, far from its original home—even though it's one of only two fountains (along with Buckingham) to have been awarded Chicago Landmark status.

~~~~~~~~

The **Rosenberg Fountain** also debuted in time for the World's Columbian Exposition. Like the Drake Fountain, it provided drinking water to fairgoers traveling through downtown. And it, too, was funded by a wealthy businessman, albeit of the postmortem character.

Joseph Rosenberg lived most of his life in San Francisco, but he did not forget growing up in Chicago near Michigan Avenue and 16th Street. As a newspaper boy, Rosenberg often went thirsty because merchants along his routes refused to give him something to drink. When he died in 1891 he left $10,000 ($266,000 today) for a drinking fountain on a prominent corner in the heart of the city "in memory of many dry afternoons—and as a savior to those following in his footsteps."

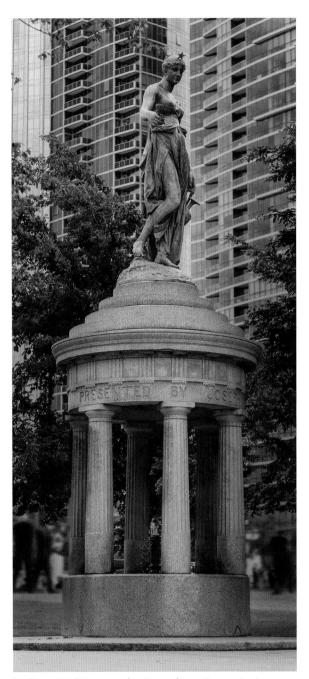

Hebe, standing atop the Rosenberg Fountain, is a mythological goddess of youth. And Joseph Rosenberg's thirst as a boy motivated him (years later) to commission this drinking fountain in the city of his youth. Therefore, his fountain is as close as it gets to a Chicago "Fountain of Youth."

Franz Machtl, a little-known German sculptor, crafted the eleven-foot-tall bronze statue of the goddess Hebe that stands atop the fountain's sixteen-foot-tall, ten-foot-diameter base. Fluted Doric columns made of granite from Baveno, Italy, ring the base, which was the work of Chicago architects Augustus Bauer and Henry Hill. The ensemble looks like a miniature Greek temple.

In Greek mythology, Hebe is a goddess of youth and a cupbearer to the gods, although she served ambrosia and nectar rather than mere water. In this statue she carries a pitcher and goblet befitting her role. One myth holds that Apollo dismissed Hebe after she indecently exposed her breasts while serving the gods. Machtl initially portrayed Hebe topless, but the executors of Rosenberg's will selected a safer design "out of deference to public taste." Dubbed "Hebe the Second" by the *Chicago Times*, the statue depicts the goddess wearing a clinging diaphanous gown and exposing only one breast.

The fountain was unveiled in 1893 at Michigan Avenue and Park Row (now 11th Street) across from the Illinois Central railroad station. Originally, it housed an elaborate illuminated drinking apparatus with metal drinking cups chained to the base. Today all that remains of the water portion of this fountain is a pipe in the middle that spurts water upward. It would sadden Rosenberg if he were to walk by and not be able to quench his thirst.

Rosenberg should not be confused with Julius Rosenwald, a better-known Chicago philanthropist who ran Sears, Roebuck, and Company and helped create the Museum of Science and Industry. Rather, Rosenberg was the nephew of California real estate investor Michael Reese, who funded Michael Reese Hospital. In addition to paying for his fountain, Rosenberg followed his uncle's example and helped fund the hospital.

Ironically, Rosenberg's small fountain has survived longer than the monumental hospital that he and his family did so much to support. Now that the hospital has been mostly demolished, the Rosenberg Fountain provides a treasured reminder of the generosity and goodwill of Rosenberg and his family.

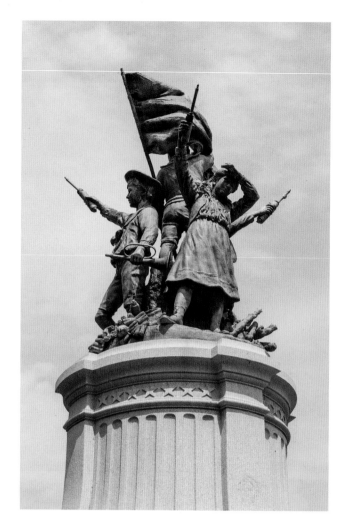

The **Independence Square Fountain**, at Douglas and Independence boulevards, features four gleeful children playing with roman candles—not exactly politically correct by today's standards.

The nostalgic, Norman Rockwell–like motif of what is also called the **Fourth of July Fountain** resulted from a 1901 design competition that Charles Mulligan won. On July 4 of the following year, the $18,000 ($517,000 today) fountain was installed with an ostentatious event that reportedly attracted three thousand people, many of whom represented the Daughters of the American Revolution and the Grand Army of the Republic.

*Left*: Kids playing with fireworks? "By a clever electrical device, alternating red, white, and blue lights will be displayed at the ends of the roman candles" that spew water from the hands of the children on top of the Independence Square Fountain, said the *Inter Ocean* in 1902. *Above*: A forty-five-gun salute, one for each state in the Union in 1902, helped inaugurate the Independence Square Fountain. Today the fountain is in a sad state of disrepair.

During the ceremony, seven hundred school children sang "Columbia, the Gem of the Ocean," and several dignitaries delivered orations. "We're not here for mere pleasure," said Governor Richard Yates. "We're here for the performance of a sacred duty. Every true American has considered it his religious duty to battle for an elevated and perfect civilization."

The *Chronicle* gushed over the monument: "When the flags and . . . bunting that draped the fountain were withdrawn, the water was turned on, and a spray fell upon the sweltering crowd like a cooling shower." The fountain was "one of the prettiest things of its kind in the city," the *Record Herald* opined.

The imposing fifteen-foot-high white granite base, shaped like the Liberty Bell, sits in a two-tiered, thirty-five-foot-diameter basin. When it operated, several jets shot water up and into the basin. Six-foot-tall bronze figures of two boys and two girls stand atop the base. The children play with a flag, a bugle, and the aforementioned fireworks, which originally spewed water illuminated red,

white, and blue. Piles of additional fireworks surround the children, and mortars poke out between their feet.

When this fountain opened, critics noted that it was erected across the street from the home of an official of the West Park Commission (a forerunner of the Chicago Park District). "While other parts of the park and boulevard system are neglected, thousands of dollars have been expended to beautify the premises in the neighborhood of William Lorimer's palatial residence at the expense of the taxpayers."

Today Independence Square Fountain is one of Chicago's most beleaguered monuments, victimized by vandalism as well as neglect. "The completely derelict condition of this landmark is absolutely deplorable," wrote esteemed architect John Vinci in 1982. The description still fits.

Originally four bronze bas-relief plaques on the base depicted intertwined flags and a shield, the signing of the Declaration of Independence, the dedication of the monument to "American Youth and Independence Day," and a mounted Native American facing a line of colonial troops—another image that would not be politically correct today.

In 1983 two of the 250-pound plaques went missing, but this misfortune was resolved five years later when Marsha Serlin, owner of United Scrap Metal in Cicero, happened to notice an employee about to cut up two large bronze pieces. "Stop! No way. This is valuable," she told her employee. Serlin called the Chicago Park District, which rushed over to examine the plaques. By the next morning, workers had already reattached them to the base of the fountain. The hurry was because that very morning the city was holding a ceremony to rename the fountain for the late Mayor Harold Washington (a name that didn't stick). Serlin declined the city's offer to reimburse her for the $1,000 ($2,000 today) she paid for the plaques, saying, "Consider them a gift." Today, the plaques are again missing.

The Independence Square Fountain and other waterworks along the boulevards might see better days, because Chicago's boulevard system recently earned a coveted listing on the National Register of Historic Places,

sites deemed worthy of preserving. "The boulevard fountains, themselves, have not been listed," said Terry Tatum, a preservation consultant who supervised the project during much of its five-year march to completion while he worked at the park district. "Rather, the fountains have been incorporated into the overall historic designation as contributing resources. Nonetheless this listing will help protect them."

~~~~~

Fountain Girl was built in 1893 for an exhibit sponsored by the Woman's Christian Temperance Union (WCTU) at the World's Columbian Exposition. WCTU, an influential national organization of pioneering women dedicated to social reform, women's rights, and the prohibition of alcoholic beverages, built Fountain Girl to encourage people to drink water.

The fountain features a bronze statue of a demure girl with outstretched arms holding a bowl from which water trickles. The barefoot girl wears a simple dress, as well as a reserved expression on her face. English artist George Wade sculpted the four-and-one-half-foot-tall statue, which stands on a stepped granite basin that originally served as a horse trough.

To help fund the sculpture, WCTU gathered more than $3,000 ($80,000 today) worth of small change from some thirty thousand children in more than fifty countries. It encouraged each child who contributed to take a temperance pledge, prompting the *Tribune* to refer to the bronze girl as "the representative of the young teetotalers" who had donated. Some called the waterworks the **Temperance Fountain**, others the **Willard Fountain** in honor of Frances Willard, an early WCTU leader.

During the 1893 unveiling at the fair, children sang the "Cold Water Song," popular with the temperance movement:

> Cold, cold water surrounds me now
> And all I've got is your hand
> Lord, can you hear me now?

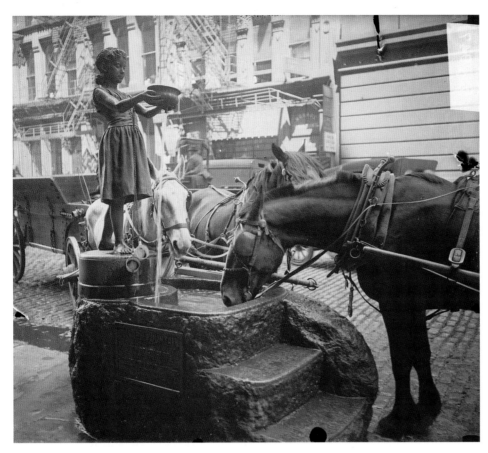

Left: Like many other nineteenth-century fountains, Fountain Girl provided water to man and beast while also being decorative and conveying a message, in this case temperance.

Below: Fountain Girl, which dates to 1893, was stolen in 1958 but rebuilt in 2007 due to a generous benefactor who had fond memories of the fountain from her childhood.

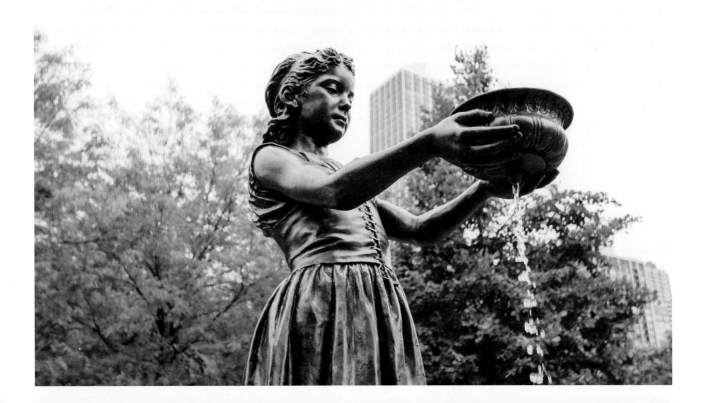

Two years after the fair, WCTU installed the fountain on the Monroe Street side of its Woman's Temple, a twelve-story skyscraper on the southwest corner of LaSalle and Monroe streets. By 1921 the future of the building (demolished in 1926) was in doubt, so WCTU moved Fountain Girl to Lincoln Park near North Avenue. In the 1930s the park district removed it during reconstruction of Lake Shore Drive but in the early 1940s reinstalled it in the park near the LaSalle Street underpass, east of the Chicago History Museum.

In 1958 the three-hundred-pound statue was stolen. Park officials hoped it would turn up in a scrapyard or someone's backyard, but it has never resurfaced. The original stone base was left intact, however, and that reminded many of Fountain Girl. In 2007 a local resident approached the park district about replacing the fountain. "She came to me and said, 'I want to bring it back because I remember playing there as a girl, and I loved the sculpture,'" recounted commissioner Cindy Mitchell.

Fortunately, three copies of the statue had been cast in 1893. A replica was created from one in Portland, Maine. It cost more than $68,000 to recast the statue and another $25,000 to repair the fountain's plumbing and return our shy heroine to her post.

Today, Fountain Girl's sweet silence belies her turbulent past. One can imagine, standing next to the retiring figure, children singing the temperance song, as they did at the bubbling beauty's coming-out party in 1893. What a shame the city was deprived of her soothing presence for more than half a century—but what a delight the fountain has been restored.

～～～～～

Just like its namesake, the statue in the **Christopher Columbus Fountain** traveled many miles and got lost along the way. It crossed the Atlantic, was displayed at the World's Columbian Exposition, adorned the front of a downtown office building, languished in storage, and finally found a new home as part of a fountain on the West Side.

In the early 1890s, the owners of the Columbus Memorial Building then being constructed at 31 North State Street commissioned a bronze statue of Columbus from Moses Ezekiel, an American sculptor living in Rome. Before the ten-ton statue was shipped to Chicago, Pope Leo XIII blessed it—possibly because it was cast from bronze melted down from sacred crucifixes, statuettes of Jesus, and vases, some of which purportedly dated back to the time of Columbus himself.

Ezekiel's nine-foot-tall statue of Columbus wearing armor arrived in time for the fair, where it was displayed in the Italian Pavilion. Afterward, the statue took its intended place in a niche above the arched entrance of the fifteen-story Columbus Building. It remained there until 1959, when the building was razed. Many parties, near and far, wanted the statue. The *Tribune* received "a pound of letters and endless telephone calls" about it. Suitors included Sons of Italy; Goodwill Industries; Columbus, Ohio; Columbus, Indiana; and the recently opened Disneyland.

The building's owner asked the Municipal Art League of Chicago to find a suitable home for the statue. Nevertheless, the sculpture ended up spending seven years ignominiously lying on its back in a lumberyard.

Finally, in the 1960s Illinois state representative Victor Arrigo led an effort to save the statue. Along with the Joint Civic Committee of Italian Americans (JCCIA) and other groups, Arrigo raised $25,000 ($202,000 today) to restore the statue. In 1966 it was made the centerpiece of a new thirty-foot-wide elliptical granite fountain, designed by Stephen Roman, in Vernon Park at 801 South Loomis Street. Several vibrant water jets frame Columbus, and features of the three walls surrounding the plaza represent wind, waves, and sails.

A year after Arrigo died in 1973, Vernon Park was renamed in his honor. The park and its handsome fountain shore up a longstanding Italian neighborhood that has been ravaged by the construction of the University of Illinois Chicago. Since 1952, JCCIA has sponsored Chicago's Columbus Day Parade, which boasts more than 150 floats and bands—and nearly as many politicians.

This statue was cast in Rome in 1892 from sacred objects. It decorated the front of Chicago's Columbus Building until that building was razed in 1959. In 1966 the Italian American community repurposed the statue for the Christopher Columbus Fountain in Arrigo Park.

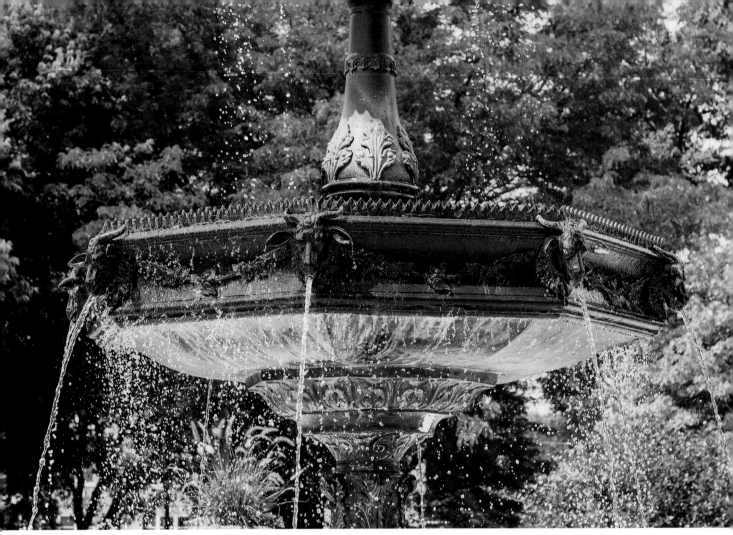

Gargoyles ring Wicker Park's Gurgoyle Fountain, a faithful 2002 replica of the original fountain from 1895.

Festivities begin with mass followed by the laying of a wreath at the Columbus Fountain.

~~~~~~~~~

Whoever came up with the name **Gurgoyle Fountain** was probably making a pun on "gargoyle," referring to the eight small but prominent goat faces that ring a tier, squirting water from their mouths. This stylish three-tiered iron fountain at 1425 North Damen Avenue in Wicker Park features foliage motifs and is capped with bronze finials. It stands in a large clover-shaped basin decked out with four cast-iron urns, each one fitted with a bronze water nozzle.

Installed in 2002, this copy is a faithful replica of the original Gurgoyle Fountain that was placed in the same spot in 1895. The original didn't last long, however. Landscape architect Jens Jensen apparently considered it a Victorian folly and removed it after thirteen years. Then superintendent of the West Parks, Jensen converted the basin into a children's wading pool, with a water spray in the center, and added pergolas around the basin.

Fast-forward to the late 1990s: the Chicago Park District began working with the Public Building Commission

First Fountains

to take out the wading pool and rebuild the original fountain. But how to make an accurate replica from only a few photos of that intricate piece?

Research revealed the fountain had been purchased from J. L. Mott Ironworks, later acquired by Robinson Iron. Robinson was able to locate Mott's catalogs and pattern books, as well as the actual molds that had been used to cast some of the sections of the original fountain. The beautiful restoration won a Chicago Landmark Award for Preservation Excellence from the Chicago Department of Planning and Development.

"This fountain is more than a pleasant little addition to the neighborhood," Mayor Daley said when the replica was inaugurated in 2002. "It's a symbol of what's happening in the neighborhood."

The neighborhood was indeed improving and is now considered one of the hippest communities in the country. The Wicker Park Garden Club and other groups look after the park and fountain. They clean, garden, and run events, including one to decorate the fountain for the holidays. Their work reflects the spirit of Charles Wicker, the alderman and legislator who in 1868 donated the land for the park. Northwest of the park's fieldhouse stands a delightful statue of Wicker with a broom in his hands. Despite his wealth and stature, the hardworking man was known to help out with menial tasks.

~~~~~~

The **Robert McCormick Fountain**, holding center-stage in the elegant Washington Square Park at 901 North Clark Street, is another award-winning replica of a historic fountain. And like the Gurgoyle Fountain, it's on the site of three consecutive waterworks. The first (circa 1890 to circa 1900) featured a Victorian design; the second (1906–75) consisted of a wide concrete bowl atop eight-foot-tall concrete columns standing in a thirty-foot-diameter basin at ground level; and the third (1999–) is a faithful replica of the second.

Early on, farmers watered their livestock at a spring here. With the hope of improving local property values, the American Land Company donated three acres to the

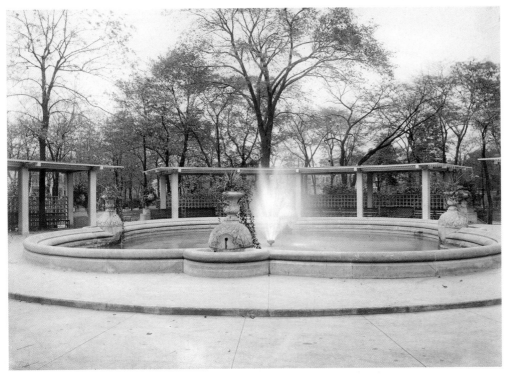

In 1908 the Park District replaced the 1895 Gurgoyle Fountain with a simple wading pool.

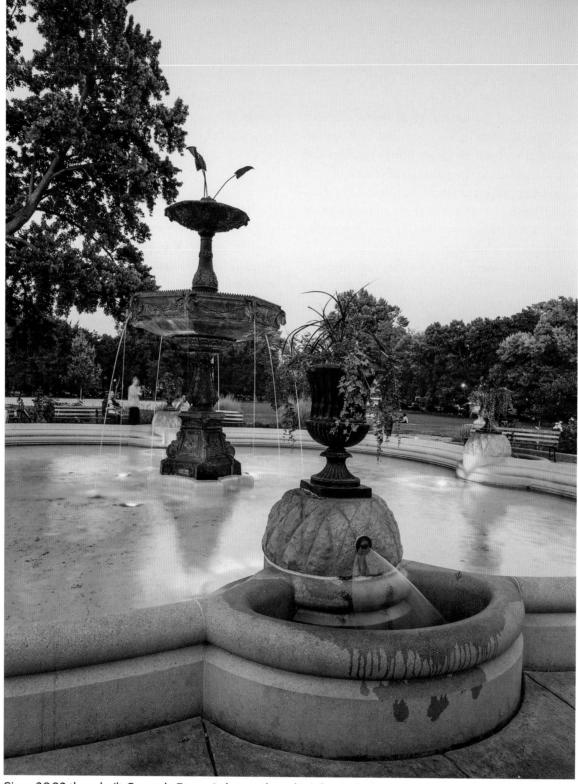

Since 2002 the rebuilt Gurgoyle Fountain has anchored Wicker Park, the park, which anchors Wicker Park, the neighborhood. Flowers, benches, trees, and, ultimately, shops and homes surround this water spectacle.

city for a park in 1842 and specified it be named Washington Square (probably for the posh park of the same name in Manhattan). It's Chicago's oldest existing park.

The city didn't begin improving Washington Square until 1869. By 1890 a Victorian fountain had been added at the center, where the diagonal sidewalks meet in one of the park's many distinctive features. After about ten years of what some considered high maintenance costs, the city gave up on the fountain and replaced it with flowerbeds. In 1906 Colonel Robert McCormick, an alderman and a future publisher of the *Tribune*, donated $600 ($16,000 today) toward a stone fountain in the middle of the sixty-square-foot planter at the center of the park. Jens Jensen designed it.

The park and neighborhood have been through many ups and downs. Known as "Bughouse Square" since the early 1900s, the park was a haven for spirited radicals and freethinkers who staged debates or delivered speeches. By midcentury these soapbox orators attracted thousands of people in several groups on Sunday afternoons. The debates were popular through the 1960s and attracted the likes of Carl Sandburg and Studs Terkel, the latter of whom had his ashes sprinkled in the park.

Over the years, the neighborhood declined, with flophouses popping up next to rundown mansions. The park turned seedy and became a hangout for prostitutes, some of whom reportedly fell victim to serial killer John Wayne Gacy. In 1959 ownership of the park was transferred to

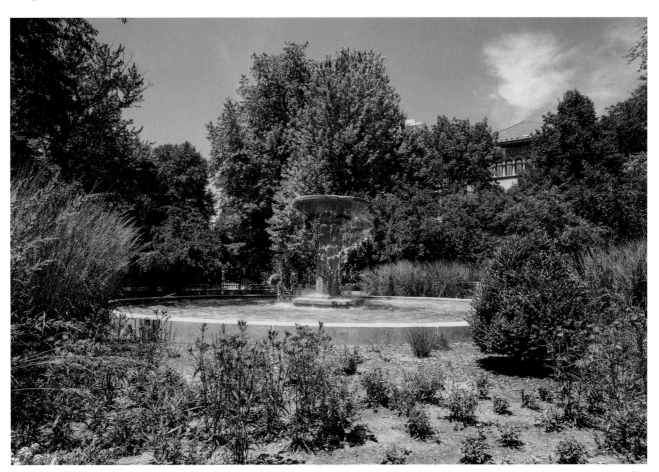

In 1906 a future *Tribune* publisher funded the Robert McCormick Fountain in Washington Square Park. It was removed in 1975, but in 1999 Edward Windhorst designed this replica from a few old photographs.

the park district, which removed the Robert McCormick Fountain in 1975.

By the 1990s the area was enjoying a revival, which prompted locals to propose renovating the park to its 1907 condition and rebuilding the fountain. "The murmur of falling water will help mitigate traffic noise and cool the garden in the hot summer," they said.

Edward Windhorst studied the history of the fountain and park and designed the new fountain on the basis of a few old photographs. It was installed in 1999, along with a limestone rim around the fountain's basin that mimics an old, one-foot-high limestone wall that still surrounds the park. In 2000 the project won a Chicago Landmark Award for Preservation Excellence from the Chicago Department of Planning and Development. Later, however, Windhorst was upset when the park district built a metal fence around the fountain—something not true to the park's 1907 design.

Today the fashionable park provides a chance to read and reflect, despite its busy urban surroundings. Once a year, in remembrance of Bughouse Square, the adjacent Newberry Library hosts an afternoon of debate, during which inspiration, revelation, and motivation flow from the speakers—as well as the fountain.

~~~~~~~~

Although it was not built until 1992, the **Burnham Fountain** *could* have been one of Chicago's oldest fountains because it was designed in the 1890s. And this four-tiered waterworks *could* have been built outside because it was designed to stand in what was then Holden Court. Instead, the fountain is inside Macy's State Street store (formerly Marshall Field's), because Field's enclosed Holden Court as it expanded.

Daniel Burnham, who in 1892 began designing Field's original buildings, conceived the stylish iron fountain as a meeting place, much like Field's clocks on State Street, under which people would later rendezvous. Somewhere along the way, however, the plans for this piece were lost and it was not built at the time, so it's also called the **Lost Fountain**.

As part of a store renovation started in 1992, architects were surprised to discover drawings in the store's archives for a fountain in Holden Court. Field's went ahead and built the long-lost gem—right where it had been originally designated.

Unfortunately, "lost" could apply to the drawings as well as to the fountain itself. Tony Jahn, a former Field's archivist, said the drawings may have been destroyed in the 1992 Loop flood, when 250 million gallons of water from the Chicago River inundated the underground facilities of many downtown buildings. Field's housed its architecture and design department in a subbasement when the flood hit. If the deluge swept away the records, at least the fountain was built before they were lost, Jahn noted. (In any event, a water burial would have been appropriate for fountain drawings.)

Years ago Holden Court bisected Field's, so to get from one section of the store to the other shoppers had to walk outside and cross the alleyway. As part of the renovation, however, Field's enclosed what had become a dismal space, creating a beautiful eleven-story atrium and installing its new fountain. Now, rather than leaving the store, shoppers can walk through the atrium and admire the bubbling waterworks built to the likeness and scale of Burnham's original plans.

Tossing a coin into Rome's Trevi Fountain supposedly guarantees a return to the Eternal City. Macy's must hope the same tenet applies here—that each of the many coins at the bottom of its Burnham Fountain guarantees a customer will return to its store.

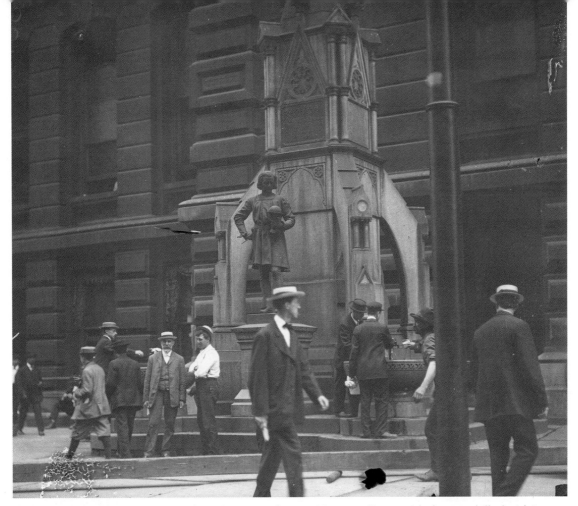

The Drake Fountain featured four large basins and several faucets that provided water chilled with ice stored in its interior. In 1908 the fountain stood near City Hall on the east side of LaSalle Street between Randolph and Washington streets.

# 2. DRINKING FOUNTAINS

The earliest fountains around the world tended to be utilitarian, communal affairs. The modern *drinking* fountain, however, is designed to allow an individual to grab a sip of water on the go. It hails from 1850s London, where the Metropolitan Free Drinking Fountain Association installed its first public drinking fountain in 1859. Soon hundreds of people a day were using it—and clamoring for more. Twenty years later, London boasted eight hundred such devices, some of which accommodated horses and dogs in addition to people. Many were elaborately decorated and served as monuments.

Chicago was quick to follow London's example. One of Chicago's first public drinking fountains was constructed in 1859 near the intersection of Randolph and Clark

Many early fountains were built to water people, horses, and dogs. Two such Illinois Humane Society Fountains still function near Michigan and Chicago avenues. In the early 1900s, sixty such fountains were sprinkled all over Chicago.

streets. Soon private entities, most notably the Illinois Humane Society, began building them, too. This secular organization was founded in 1869 to prevent cruelty to animals but expanded its mission to protect abused children. Both constituencies benefited from fresh, clean water.

In 1879 the society donated what was described as a "substantial and beautiful" drinking fountain to Garfield Park, but the work could also have been described as "strange and enormous." It was about twenty feet high and featured the figure of a man sitting in a pile of rock slabs, some of which were carved with faces. Reportedly

made of concrete, the fountain did not survive very many Chicago winters.

The society's typical fountain design, however, featured a faucet facing the sidewalk for people, a large trough extending into the street for horses, and a basin for dogs flaring out from the base, which was inscribed "Illinois Humane Society." The society had sprinkled nine such fountains around Chicago by 1877, and sixty by 1913. It also installed larger fountains exclusively for horses, including one in Lincoln Park that could water sixty horses at once.

Incredibly, two **Illinois Humane Society Fountains** remain and still function. One is at the northeast corner of Michigan and Chicago avenues; the other is nearby, just a few steps west of the Water Tower. Carriage horses that queue up along the square drink from the latter.

These iron fountains are more than one hundred years old, yet tens of thousands of people pass by them daily without any idea of their significance. If they knew, they might stop to admire the fountains' attractive Victorian style and quaint diminutive size. They might also take a photo—and, more important, a sip.

In the early 1960s, Charles Gasperik "liberated in the middle of the night" a humane society fountain. "At one time there were scores of these fountains all over town, but many were torn out for scrap, especially during World War I," he explained. "One near Clark and Lunt [streets] was put at risk when the store it stood in front of closed and there was no one left to protect it. So friends and I rescued it one night. In case the police came by, we had a story cooked up about taking it to the Art Institute."

Gasperik kept the relic in his garage until 1985, when he donated it to the Sulzer Regional Chicago Public Library with the hope it would be installed there. Years later, the city put the fountain in storage. Tentative plans call for it to be installed in the David R. Lee Animal Care Shelter at 2741 South Western Avenue.

~~~~~~~~~~

With the rebuilding of Chicago after the Great Fire of 1871, the development of department stores, and the growing wealth of the city, well-to-do people gained many places to find drinking water and other beverages. Still, working-class and poor people depended on free public drinking fountains. By the 1870s these devices had become an important means of promoting temperance and deterring people from quenching their thirst in saloons, according to historian Perry Duis.

The National Humane Alliance built at least four drinking fountains in Chicago. Meanwhile, the Women's Christian Temperance Union (WCTU) built many across the country—typically one per city. "Their erection served symbolic and promotional purposes as much as functional needs." (In Chicago the WCTU built Fountain Girl.)

At the time of the World's Columbian Exposition, the city was not only drawing water from Lake Michigan but also dumping sewage into it. That practice gave Chicago's water an unhealthy reputation, so the fair's organizers had to provide water from somewhere other than the lake. They tapped Wisconsin springs and supplemented that supply by purifying water at the fair. To dispense this water, they installed drinking fountains around the grounds, which helped popularize the concept.

After the fair, Chicago got more drinking fountains. Most were Illinois Humane Society models, which the prominent Municipal Art League in 1901 called "plain and inartistic." This prompted the League to lobby for more fountains that "are not only useful . . . but beautiful and pleasing to the observer."

Many drinking fountains at this time, including Fountain Girl and the Drake and the Rosenberg fountains, shared a feature that would be questionable by today's standards: metal cups chained to the structure for drinking. At first it wasn't known cup sharing made people sick, but that situation gradually changed. In 1909 a *Tribune* article under the headline "Danger in the Cup" said, "It's everywhere conceded the common drinking cup is a prolific means for the transmission of diseases." Soon "Ban the Cup" campaigns spread across the country, and in 1911 Illinois prohibited what had become known as the "death cup." The practice continued elsewhere, including Paris, where shared cups were not outlawed until 1952.

The waterspout, or "bubbler" as it's called in Wisconsin, replaced the shared cup. "You drink directly from the ever-changing jet of water—always clean, pure, fresh and wholesome," read a 1911 advertisement from J. L. Mott Ironworks. Still, some designs shot water straight up, which allowed users to touch the waterspout with their lips. In the 1920s manufacturers settled on the current design, which shoots water up at an angle and includes a metal guard over the spigot to prevent people from putting their lips on it.

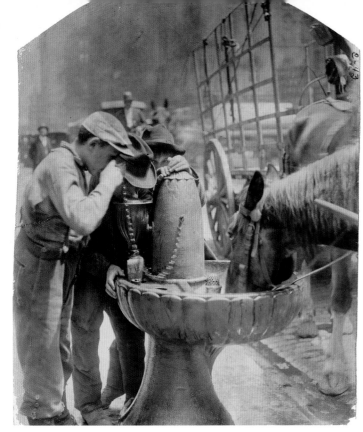

Chicago's earliest drinking fountains provided metal cups chained to the structure for drinking, as seen in this undated image. This practice died out in the early 1900s after the health hazard of shared cups was realized.

～～～～～～～

Throughout the early part of the twentieth century, the public demanded more drinking fountains, especially as the national debate about prohibition intensified. "One of the shames of our boasted civilization is the impossibility of obtaining a thirst quencher outside a saloon," opined the *Chicago Post* in 1905. "If you are really to preach temperance, erect many drinking fountains. Else keep silent."

The lack of public drinking fountains during a heat wave in June 1908 caused an uproar. "City Fountains Mere Mockeries," read a *Tribune* headline. "Eleven Deaths Caused by Heat in Chicago," read another over an article that described the city's "scorching thoroughfares" without water for the thirsty.

Private individuals, businesses, settlement houses, and churches tried to fill the void. The *Tribune* donated four "artistically pleasing as well as essentially useful" drinking fountains to the city. Many organizations, including the McDowell Settlement House and Belden Avenue Baptist Church, installed fountains in front of their buildings. Drinking fountains were never segregated in Chicago, as they were in southern states under Jim Crow laws.

During the Depression, several thousand drinking fountains were added to Chicago's parks as public work projects. In 1932 the Woodlawn Laundry Company launched, with much fanfare, its **Magic Fountain** at 1221 East 63rd Street. The chilled "triple filtered" drinking

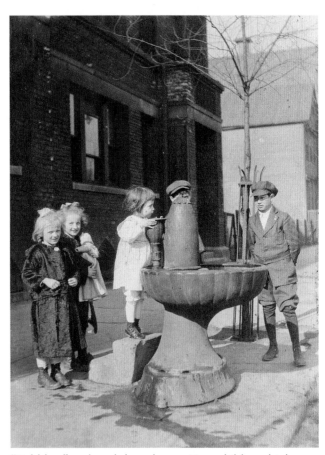

"Bubblers" replaced shared cups. Here children drink from an Illinois Humane Society Fountain in front of the McDowell Settlement House at 4630 S. McDowell Street circa 1901.

fountain attracted ample attention, even though it dispensed mere tap water (presaging the sale of cheap tap water as expensive bottled water). The popular Magic Fountain's namesake feature was an "amazing electric-eye," a light beam that turned the water on whenever someone approached.

When David Wallach died in 1894, he left $5,000 ($138,000 today) for a drinking fountain, but it went unbuilt. In 1937 the city sued Wallach's heirs to resolve issues surrounding his will. The heirs agreed to hand over the $5,000 as long as they could keep the $9,000 ($150,000 today) in accumulated interest. The handsome **David Wallach Fountain** was finally erected in 1939 at Promontory Point along the Lakefront Path.

Sculptors Elizabeth and Frederick Hibbard built the polished-marble hexagonal fountain, which includes drinking spigots for adults and children and a basin for dogs. The poised, wide-eyed fawn curled up atop the sculpture was modeled on one in Lincoln Park Zoo. The graceful fawn (once stolen but later recovered) was the work of Elizabeth, a former assistant of Lorado Taft. When she died in 1950, a *Tribune* critic said her work was "stamped with fancy, imagination and beauty . . . light in touch and perfect in craftsmanship."

Despite such accolades, Wallach might have been disappointed with his fountain. Not only was it slow in coming, but also it was built near 55th Street rather than between 23rd and 33rd streets, as he had stipulated. Furthermore, Wallach loved horses and wanted his fountain to water them. But horses, so common in Chicago in 1894, were scarce by the time his gift finally materialized forty-five years later.

~~~~~~~

Frederick Hibbard also designed two **World War II Memorial Drinking Fountains**. An octagonal one made of red polished granite was installed in 1945 in Ogden

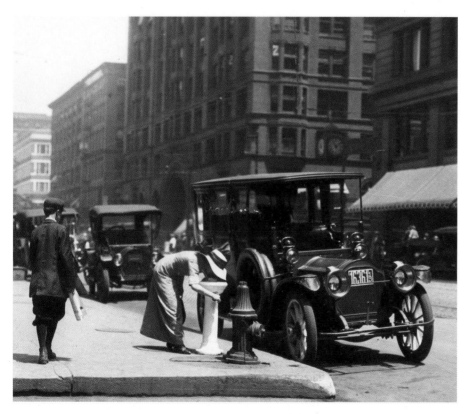

Before bottled water was ubiquitous, public drinking fountains, such as this one on State Street circa 1915, were common—and better maintained than they are today.

Park (6500 South Racine Avenue), west of the fieldhouse. The other was made of marble and installed in 1947 in Trumbull Park (2400 East 105th Street), north of the fieldhouse. Both were funded by contributions from local residents and dedicated to community members who had served during the war.

The similar **William Niesen Memorial Fountain** can be found near the south end of Lincoln Park between the baseball fields west of Cannon Drive. The Old Timers' Baseball Association funded this large, granite piece in 1955, naming it for a president of their association and Lincoln Park superintendent.

One of Chicago's most unusual waterworks, the **Viennese Drinking Fountain**, stands on Pearson Street east of Michigan Avenue. It's not clear how to drink from this odd-looking piece, even though it is dedicated to the thirsty. It would be easy to dismiss this peculiar fountain, but it was sculpted by Austrian artist Hans Muhr. He's known for studying the force and motion of water on motionless rock, particularly for the benefit of urban dwellers, who can be detached from natural cycles.

Vienna gave this piece to Chicago in 1998 as part of the Sister Cities program. Muhr designed dozens of water fountains—including variations of this model—for such major cities as Berlin, Stockholm, Budapest, and Hong Kong. "My work," he said, "is to serve mankind, improve its life, protect the environment, and pose water again where it belongs—in the center of life."

Chicago is also home to many playful drinking fountains. The **Turtle Fountain** in upscale Goudy Square Park (1255 North Astor Street) has been charming the young and youthful since 1991. Stone carver Walter S. Arnold sculpted the piece, which features a cute three-foot-tall limestone turtle standing on its hind legs and leaning over the basin. Incised carvings of fish ring the basin's exterior. Two bronze drinking spouts, one of a frog and the other of a fish, were perched at two corners of the triangular basin, with the turtle looking in from the third corner. The frog

The cute Turtle Fountain, built in 1991, is the work of Walter Arnold. It no longer functions but still delights children playing in Goudy Square Park.

From 1988 to 2006, George Suyeoka designed three drinking fountains for the Lincoln Park Zoo that, quite fittingly, celebrate zoo animals. The Lion Fountain shows his penchant for realism and detail.

went missing years ago, and recently the fish followed. Considering that the turtle is a symbol of longevity, it's a shame this fountain no longer works.

Meanwhile, Lincoln Park Zoo sports three blithe drinking fountains decorated with small, realistic-looking animals in bronze sculpted by illustrator and commercial artist George Suyeoka. These delightful creations, which serve as watering holes for the small bronze animals—as well as for the human visitors—are hard to find but quick to please. Look for **Lion Fountain** (2006), with a lion pride, west of the Kovler Lion House; **Elephant Drinking Fountain** (1992), with ivory-tusked mother and child, south of Park Place Café; and **For the Young at Heart** (1988) in the Pritzker Family Children's Zoo. The last holds a variety of small animals commonly found in Illinois: rabbit, deer, fox, raccoon, squirrel, and owl.

Also tucked away in Lincoln Park Zoo is **Dream Lady**, one of Chicago's most enchanting monuments. It holds two scalloped, flower-like drinking fountains, and three lovely bronze figures crown an elegant pink granite base. It sits in front of a water wall that was added in 2015.

A boy and girl sitting on the base slip into slumber as Dream Lady, an angel with open wings, floats above them, dangling sleep-inducing poppies over the innocent children.

This work is also called the **Eugene Field Memorial.** Field was best known for writing whimsical children's poems as well as "Sharps and Flats," a humorous *Chicago Morning News* column. After he died in 1895, newspaper editors organized a drive to commission a memorial to

their fellow journalist. Nothing came of this effort. Years later friends and colleagues tried again, this time led by Charles Dawes, who became a U.S. vice president. The B. F. Ferguson Monument Fund and Lincoln Park's Board of Commissioners contributed, as did schoolchildren, who emptied their piggybanks of a reported $3,920.25 ($56,139.49 today). Ultimately, it took a quarter century to raise $35,000 ($500,000 today) for the monument, which was unveiled in 1922 by two of the poet's grandchildren.

The eleven-foot-tall sculpture has not always been well cared for. Its charming drinking fountains have not worked for decades; old photographs show that the poppies were missing from the angel's hand in the 1950s; and in 1948 the sculpture was moved, some would say demoted, from a prominent location to its more secluded spot northeast of the Brach Primate House.

Today, however, Dream Lady shines due to a beautifully executed 2015 restoration. Its new surroundings are sure to charm anyone drawn in for a break from the lions and tigers and bears! One might fall asleep on a bench in this tranquil nook—even without the aid of soporific poppies.

Excerpts from two popular Field poems, "Wynken Blynken and Nod" and "The Sugar-Plum Tree," adorn the sculpture's base. The bas-relief panel above the south drinking fountain depicts a girl riding a horse from "The Fly-Away Horse," and the panel above the north drinking fountain depicts a boy from "Seein' Things." The latter reads,

> Mother tells me "Happy Dreams" an' takes away the light,
> An' leaves me lyin' all alone an' seein' things at night!

The angel hovering over the children is a figure from Field's poem "The Rock-a-By Lady." This angel of sleep

Dream Lady tops the memorial to journalist and children's poet Eugene Field. Two drinking fountains oriented toward children flank the memorial, but they have not functioned for years.

Drinking Fountains

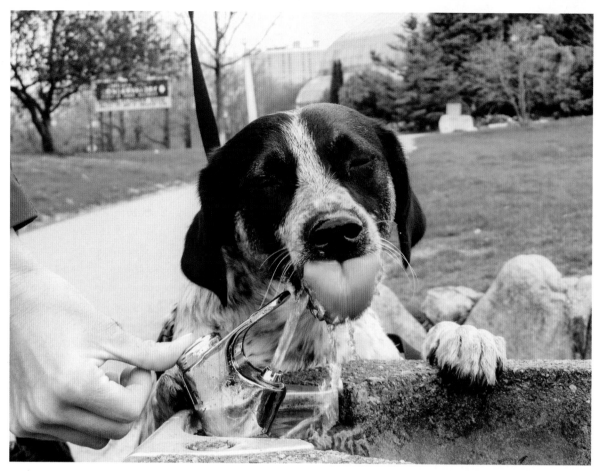

In the 1990s the Chicago Park District had about one thousand drinking fountains running day and night, each one sending more than one thousand gallons of water a day down the drain. To conserve water, these fountains were retrofitted with push-button faucets.

"comes stealing, comes creeping" from Hushaby Street . . . and "bringeth her poppies to you, my sweet."

Because opium is derived from poppies, this flower has been used to represent slumber, sometimes even a dreamy state that leads to death. (Think of the danger Dorothy encountered on the Yellow Brick Road.) This association between poppies and eternal sleep might explain why, over the years, there seems to have been discomfort or denial about Dream Lady's poppies. For example, a newspaper article says the angel is "sprinkling the sand of dreams" into the children's eyes. And a 1959 letter from Chicago Park District superintendent George Donoghue says, "The angel-like figure was holding a lantern." Alas, Field probably used the poppies' sleep-death imagery intentionally

because only one of his seven siblings survived infancy, and only five of his eight children reached maturity.

Harder to find than Dream Lady is the **Jim Northcutt Memorial Drinking Fountain** at about 2521 North Stockton Drive, south of a gazebo and west of the North Pond. This memorial amounts to a common, concrete drinking fountain with a small plaque that reads, "All you who are thirsty, come to the water! Isaiah 55:1. In memory of Jim Northcutt, 1929–1988."

Northcutt served in the Korean War, graduated from the University of Cincinnati, and worked at the Chicago

Transit Authority, where in the 1960s he helped computerize operations. He ended up living on the street for twenty years, dragging a shopping cart around with him but typically refusing help. After he died, his family persuaded the city to name a drinking fountain in his memory a couple of blocks away from a bench he frequented.

"Everyone who drinks from this fountain should be refreshed, not just physically, but spiritually, too, as we all become more concerned about the homeless," said Robert Oldershaw, pastor of the nearby St. Clement Church, at the memorial's dedication in 1989.

Today, Northcutt, who was an annoyance to some, an enigma to others, is all but forgotten, except for this drinking fountain with its small, weathered plaque. Find it and drink to his memory.

~~~~~~~~

Due to Chicago's proximity to Lake Michigan's seemingly limitless supply of fresh water, the park district used to run drinking fountains continuously during the summer. Environmentalists challenged this practice and persuaded the park district to install on-off faucets.

Meanwhile, the number of Chicago's remaining outdoor public drinking fountains keeps dwindling. Many have fallen into a sorry state—dirty and poorly maintained. But Americans consume about fifty billion disposable bottles of water a year, and as bottled water becomes ubiquitous, public drinking fountains are increasingly neglected and broken.

Still, tap water is cheaper than bottled water and better for the environment. This realization portends a revival of public drinking fountains, which provide free, sustainable supplies of water. New laws mandate them in schools and public buildings. People are increasingly carrying reusable water bottles. And drinking fountains—from college campuses to airports—are beginning to include spigots designed for refilling reusable bottles. At the same time, new apps locate public drinking fountains, and online maps will soon incorporate this information.

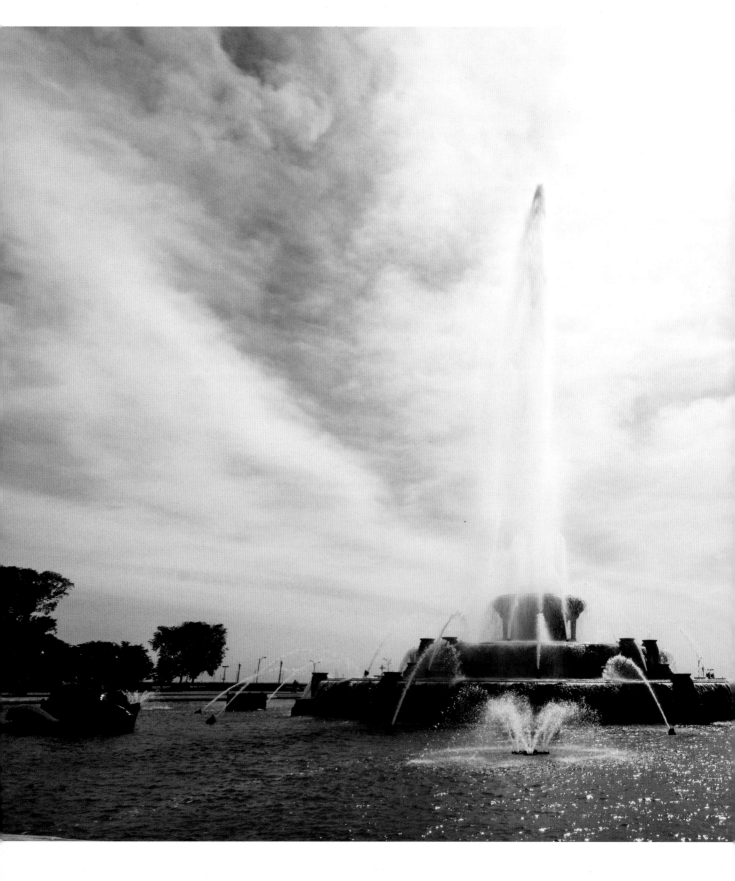

3. ICONIC FOUNTAINS

Although many Chicago fountains live in obscurity, a few are well known and stand up to other Chicago icons. Like the Willis Tower, they inspire civic pride. Like the Chicago Picasso, a monumental sculpture downtown that has been interpreted to represent a woman, baboon, or dog, they spark debate. Like Wrigley Field, they, well, provide shared experiences—a surprising one in 2016.

The iconic **Clarence Buckingham Memorial Fountain** is usually the first fountain that comes to mind. For many, this fountain's fountain generates a flood of memories of special moments: taking wedding pictures, showing out-of-towners around, enjoying the evening light show. The bubbly jets of this celebration of water shoot off like bottles of champagne.

It's easy, however, to take this icon for granted. It looks the same as it did on opening day in 1927, and it's been photographed a gazillion times (give or take). Yet how well do we know "Old Faithful by the Lake"? You might not have known these facts:

- Buckingham Fountain's design was inspired by the opulent Latona Fountain at the Palace of Versailles. (It's twice as big, however, as Latona. Therefore, it might have been dangerous to build such a magnificent fountain four hundred years ago. After Louis XIV, who reigned over Versailles,

"Buckingham Fountain enlarged Chicago's esthetic sense and has done it spiritual good," said the *Tribune* in 1927. "It's an expression of the lake, by which it is fed and which it extols. It is the lyric of the lake."

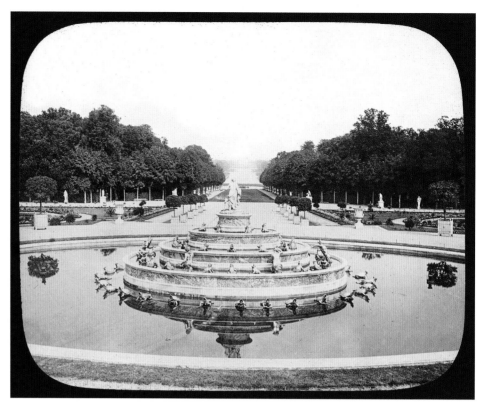

The Latona Fountain in the gardens of Versailles dates back to 1667. It inspired Edward Bennett when he designed Buckingham Fountain, which opened 250 years later.

visited the Chateau Vaux-le-Vicomte, he was so impressed with its fountains that he imprisoned his host, Nicolas Fouquet, for upstaging the king!)

- The fountain rests on approximately 860 wood piles, each sunk seventy-five feet through lakefront fill into the underlying soil. (These timber posts, which look like long telephone poles, have never been replaced because the moist underground conditions preserve the wood.)

- In some parts of the world, Buckingham is known as the Bundy Fountain. (*Married with Children*, the worldwide syndicated television sitcom about a family named Bundy, opens with a view of the fountain.)

- Buckingham Fountain uses its original pumps. (These three pumps kick out 515 horsepower to push water 150 feet high.)

- The fountain has remained intact all these years except for the theft of two fish-head sculptures.

(They were later recovered when a salvage shop tried to sell them, and the prospective buyer thought they looked familiar.)

- Buckingham Fountain is not controlled from Atlanta, as is commonly thought. (It was from 1983 to 1994 but is now run from a computer in an underground two-story control room, the tip of which is visible at the southeast corner of the fountain.)

- It is not named for Buckingham Palace in honor of the 1959 visit by Queen Elizabeth II, as tour guides have been overheard saying. (Queen's Landing along the lakefront near the fountain, however, derives its name from Elizabeth's visit.)

- The fountain is named for Clarence Buckingham, an arts benefactor and one-time president of Chicago's Northwestern Elevated Railroad. (He helped build what's now the Chicago "L" Brown Line.)

- Meanwhile, the pop band the Buckinghams is named after the fountain, according to Dennis Tufano, one of the singers of the top-selling group from Chicago. The nascent group was asked to take a name that sounded English "because the British Invasion was in full swing at the time [1965]," he said. "A security guard at the [radio] station heard the request and gave us a list with eight or ten names on it, and *the Buckinghams* stood out not only because it sounded British but also because there's a beautiful fountain [by that name] in Chicago. . . . This way, we didn't feel like we were selling out Chicago to take a British-sounding name."
- Early plans for Grant Park called for building the Field Museum of Natural History where Buckingham Fountain now holds court. (Instead, Aaron Montgomery Ward's campaign to keep a portion of the lakefront "forever open, clear and free of any buildings" pushed the museum farther south and created the need for a different centerpiece for Grant Park.)
- Park officials originally intended to build a modest $40,000 ($548,000 today) fountain here. (Instead, a donation twenty-five times that amount allowed for the majestic water spectacle.)
- The fountain did not receive landmark designation until 2000—after 170 other landmarks in the city had been so designated. (It was Chicago's first fountain to receive this status, which affords the highest level of protection.)

~~~~~~

Like a multitier wedding cake on a silver platter, Buckingham Fountain has three large bowls stacked one on top of the other. The top twenty-four-foot-diameter bowl nestles twenty-five feet aboveground on a fluted pedestal

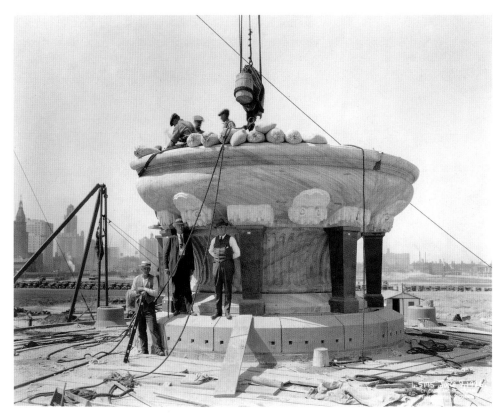

Despite its classical design, Buckingham Fountain incorporated modern lighting and advanced mechanical systems. It cost $750,000 ($10 million today) to build.

supported by eight square columns of red granite. The other bowls measure 60 and 103 feet in diameter, and all three are ornately carved and clad in pink Georgia marble.

The large quatrefoil-shaped ground-level basin (plainer, but also clad in pink Georgia marble) holds four pairs of twenty-foot-long mythical seahorses symbolizing the four states bordering Lake Michigan. French sculptor Marcel Loyau won the Prix National, one of France's highest honors, for designing these bronze creatures.

Kate Buckingham donated $750,000 ($10.3 million today) to build the memorial as a tribute to her late brother, Clarence. She had no children and was the sole heiress to her family's fortune, which was made in banking and grain elevators. She also donated $300,000 ($4.1 million today) for a maintenance fund.

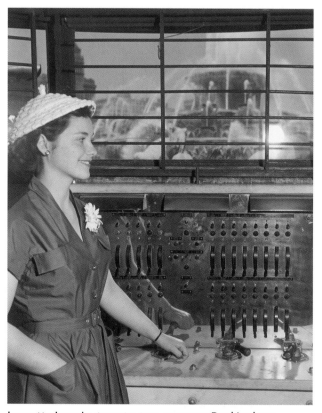

Jeanette Janvrin, twenty-two, poses at Buckingham Fountain's controls in 1953 after winning a contest in London to select the perfect secretary. As for the hat, that's another story!

Edward Bennett, coauthor of the 1909 *Plan of Chicago*, designed Buckingham Fountain. The exterior is classical, reflecting Bennett's training at the École des Beaux-Arts in Paris, but the mechanics and engineering were innovative. The structure was among the first monumental decorative fountains to use modern lighting and mechanical systems.

The fountain holds an astonishing 1.5 million gallons of water drawn directly from Lake Michigan (although chemically treated for health reasons). Water is added only to compensate for loss from evaporation and wind. One hundred thirty-four jets discharge water at fourteen thousand gallons per minute during major displays. Meanwhile, 820 lights illuminate the fountain, most spectacularly during light shows.

Originally, engineers operated the fountain manually, working buttons, levers, and hydraulic valves in the sunken control room. With all the controls within easy reach, they could see their handiwork through a panoramic window. These engineers must have been having too much fun varying the colors because "certain of their color combinations offended the sensitive souls of artists in the neighboring Art Institute," the *New York Times* reported in 1932. "It is planned to appoint a committee of artists to prepare color schemes to be faithfully followed by the uncultured hands . . . of mechanics more familiar with faucets than palettes." By 1980 control of the jets and colors was fully computerized.

Over its long life the grand dowager of the lakefront has needed a lot of work, comparable to facelifts, angioplasty, and hip replacement surgery. One of the more recent restorations, in 1995, cost $2.9 million ($4.6 million today). In 1996 four pavilions were added at the cost of $2.5 million ($3.2 million today). These pavilions house washrooms and restaurants. (Fortunately, the idea of making one of them a souvenir shop was rejected.) A 2009 restoration cost $12 million and was a big hit with the public, in part, because it added benches and replaced the plaza's dusty, crushed gravel surface with attractive red pavers. Still, a lot more work needs to be done. That 2009 restoration was only the first of three planned phases.

So much more than a pretty pile of stone and generously flowing water, Buckingham Fountain is one of Chicago's most important cultural centers. The popular gathering place has borne witness to everything from riots to skinny dipping. It has hosted demonstrations, footraces, bike rides, concerts, and weddings—everything from cancer walks to Lollapalooza.

As Chicago's best-known water wonder, Buckingham Fountain is the center of countless stories. In one recounted by Philip Halpern, Parker Hall III, head of an investment management firm, had an office on Michigan Avenue overlooking the fountain. To impress clients, he would pull the following ruse: About fifteen minutes before the hour, Hall would draw attention to the fountain, talk about its history, and say how wonderful it looks when it shoots off. Five minutes later, he'd remark again about the beauty of the fountain and say, "I have a contact in the mayor's office who owes me a favor."

Hall would then dial a bogus number and say, "Hi, Bill. How's your wife? Say, I've got some VIPs in my office. They would really like to see Buckingham Fountain shooting off. Could you call someone in operations . . . ?"

A few minutes later, the fountain would go off, right on schedule. Most of Hall's visitors fell for the charade.

What makes Buckingham Fountain so popular and monumental, so spectacular and mesmerizing? Perhaps its size. (It is one of the world's largest decorative fountains.) Perhaps tradition. (Three generations of parents have taken their children there on hot summer nights to cool off in the spray.) Perhaps its elegance and classical beauty. (The exuberant, exquisite water show is alive, dramatically lit, and decorated with extravagantly detailed aquatic motifs.)

But will Buckingham Fountain be able to keep its magical hold on the Windy City? Shortly after it opened, a columnist wrote, "the lyric of the lake . . . will never grow old or commonplace. Sunlight and shadow, mounting and waning breeze will ever renew and ever vary its spectacle and song." Nonetheless, the fountain has begun to feel more like a memory than a destination. The public no longer flocks to its light shows. Turning on Buckingham Fountain in May no longer heralds the arrival of spring. And other icons, such as Navy Pier and *Cloud Gate*, are bucking for its place as Chicago's top icon. As Buckingham Fountain approaches its 100th anniversary, many wonder how it will face the future.

A new water icon, **Crown Fountain,** is eclipsing the grand dame of Chicago water spectacles. While Buckingham is off the beaten path, Crown is right in the Loop. While Buckingham shuts down at night and in the winter, Crown is always on, in some fashion. While Buckingham is great to look at, Crown is fun to play in. Where else can one stand in a waterfall, get squirted by a human gargoyle, and walk—even waltz—on water?

As it was being built, Crown Fountain was one of Millennium Park's most contentious features. It cost $17 million, a staggering 750 percent over the amount initially budgeted for a water feature. As it took shape, critics called it too tall for the location. And because it combined several cutting-edge technologies that had never been combined, many doubted whether the mechanisms would even work. When costs spiraled out of hand in 2002, the project nearly failed. Instead, a new architectural firm set the work on a successful course. The challenges were many, varied, and enormous. At one point, Lester Crown, one of the funders, asked Jaume Plensa whether he could cut back the size, scope, and cost of the fountain. "Look, Lester, my piece is in the right scale of the city," the artist replied. "If you can scale down Chicago, I can scale down the fountain."

Planning for a park to recognize the new millennium began in 1997. When city officials approached the philanthropic Crown family about funding a water feature two years later, Millennium Park was developing into

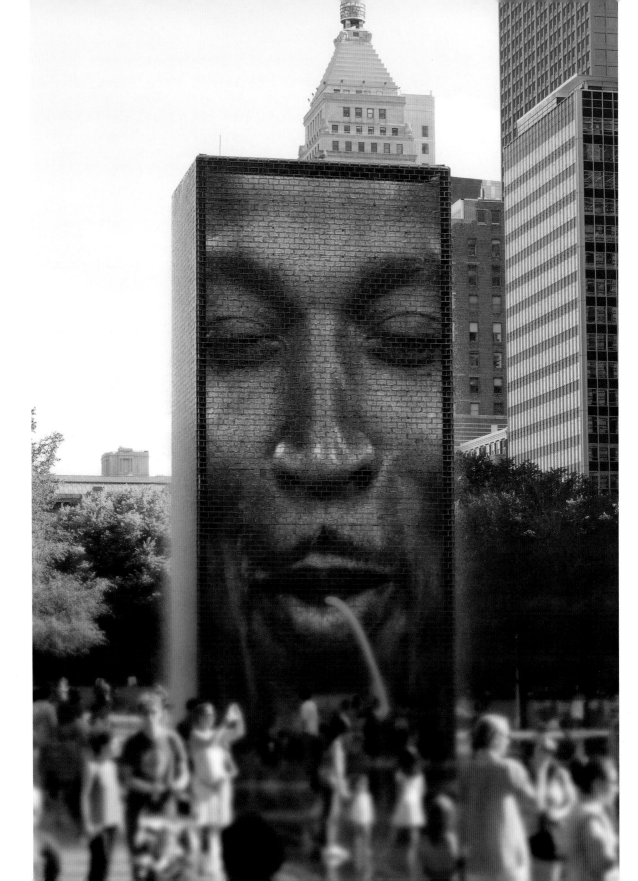

a highly anticipated, world-class project. Frank Gehry had agreed to design a pavilion, and Anish Kapoor was designing a large elliptical structure with a mirror-like surface that would become *Cloud Gate*, or *The Bean*. The expectations for a water feature were high. Nevertheless, the Crowns signed on.

The Crowns played an intimate role in the design and construction of their project. At one point they considered a flashy Las Vegas–style fountain but then decided something new would better suit a park celebrating the future. They drew up a long list of artists to consider for their water feature, but Jaume Plensa's name was not on it. The little-known Spanish sculptor had never done a major piece of public art in the United States and had limited experience with fountains.

Despite these factors, Plensa eventually became one of three finalists. Maya Lin, famous for her Vietnam Veterans Memorial in Washington, D.C., proposed a low, horizontally oriented fountain with slow moving water. Robert Venturi, coauthor of *Learning from Las Vegas,* proposed a 150-foot-tall virtual fountain—without water.

Choosing Plensa because they liked not only his provocative design but also his energy and commitment, the Crowns were swept away "by the singer as much as the song." It took four years and a large team of engineers and designers, led ultimately by the architecture firm Krueck and Sexton, to realize Plensa's vision. The School of the Art Institute and Columbia College worked on the video component.

Crown Fountain features two fifty-foot-tall glass-brick towers, each with more than one million LEDs. Talk about big screens!

Each tower projects the faces of one thousand everyday Chicagoans, facing off at opposite ends of a 232-foot-long, quarter-inch-deep pool paved with black granite. Every five minutes, the lips on the two faces pucker, and the

"The project was conceived as an open door that beckons passersby to enter," said Jaume Plensa, who designed Crown Fountain. It succeeds, drawing in countless people to splash in the water or watch others frolic.

mouths squirt a stream of water to the delight of kids who line up in anticipation of getting soaked.

The faces come from all segments and walks of life—wonderfully diverse in age, ethnicity, and skin color. Originally, Plensa considered changing the faces after a few years but in 2014 said, "These faces represent an archive of the city. As far as I'm concerned, this work is a finished piece."

Some have suggested the city could raise money by selling the right to have a face projected on the towers. Others have suggested the park set up a photo booth that would project images as they were shot. But Chicagoans are too protective of this treasure to let that happen. When the city installed obtrusive surveillance cameras on top of the towers in 2006, the public made such a fuss that the city removed them within days.

Why does Crown Fountain engage and inspire people as much as it does? Plensa put it best when he said, "The fountain is an homage to the people of Chicago. A city is made up of people, and my work is to celebrate them and to celebrate life." Indeed, the scale and prominence of the faces on the towers make all Chicagoans look and feel majestic. Plensa has declined lucrative offers to approve a similar fountain in another city.

~~~~~~~~

The splendid **Fountain of the Great Lakes** has been adorning the South Garden at the Art Institute since 1913. Lorado Taft, the city's preeminent sculptor, designed the fountain in response to chiding from Daniel Burnham regarding the World's Columbian Exposition, where Taft worked for Burnham. "Burnham was sorry none of us had made a fountain personifying the Great Lakes," Taft said. "I recognized at once the beauty of the suggestion."

At fourteen feet wide and twenty-three feet tall, this imposing neoclassical sculpture depicts five graceful damsels in bronze on a granite base. Each maiden holds a large shell signifying one of the Great Lakes, and water flows from one shell to the next, reflecting the way it flows through the lakes themselves. The figure holding

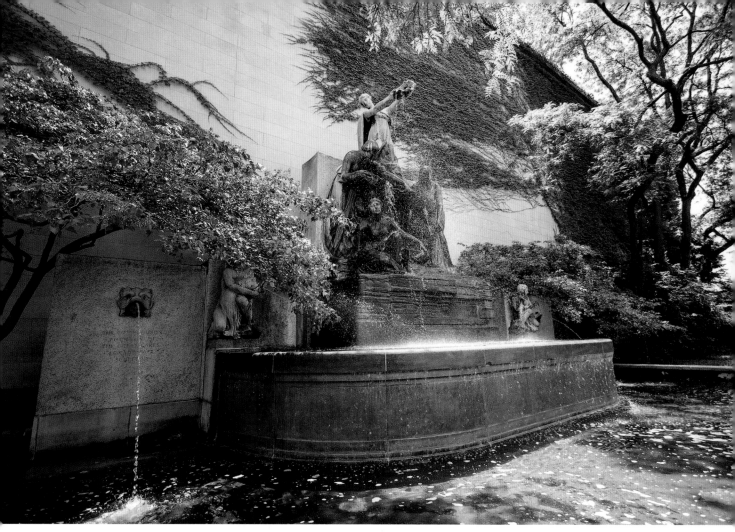

Most Chicagoans are unfamiliar with Lorado Taft's Fountain of the Great Lakes, even though this masterpiece sits only a few yards from busy Michigan Avenue.

the last shell, representing Lake Ontario, looks off into the distance as the water flowing from her shell enters the basin, which represents the St. Lawrence Seaway.

Taft studied sculpture in Paris for five years at the École des Beaux-Arts, then the most prestigious design school in the world. There Taft and many other Chicago-based architects became devotees of neoclassicism, the revival of art and architecture from ancient Greece and Rome. He returned to Chicago in 1886, began teaching at the School of the Art Institute, and gained recognition for sculptural work at the World's Columbian Exposition.

Taft believed art should be a part of everyday life, not an abstract, theoretical pursuit. "I cannot think of art as a mere adornment of life, a frill on human existence, but as life itself," he said. Throughout his career he worked to engage the public in art. "While our public needed sculpture," he lamented, "it did not know it and never should guess it unless someone showed it what it wanted." He tried to do just that, all the while building his career and reputation.

After lumber merchant Benjamin Ferguson died in 1905 and left $1 million for public monuments in Chicago,

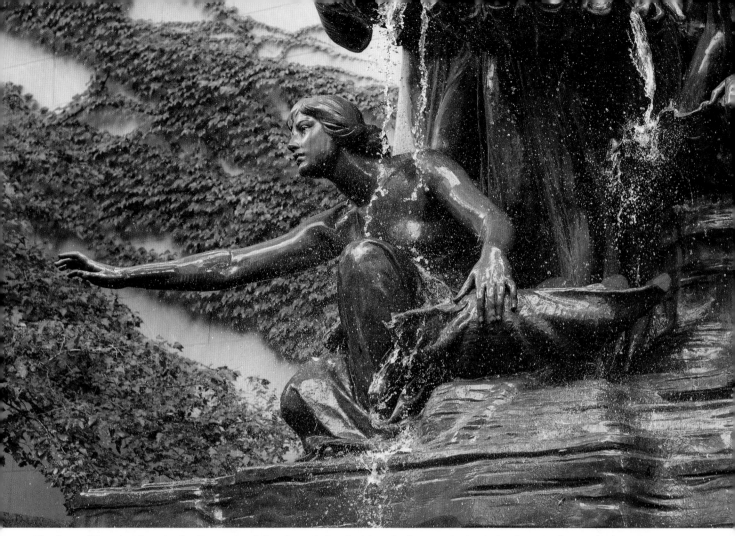

The last of five maidens in the Fountain of the Great Lakes holds a shell representing Lake Ontario, from which water flows away toward the ocean. "The figure reaches wistfully after [the water] as though questioning whether she has been neglectful of her charge," Taft said.

Taft positioned himself for a commission. He added to his impressive works in progress, generated favorable publicity by giving lectures and writing articles, and courted friends in high places, particularly at the Art Institute, whose trustees administered the fund.

At the same time, Taft started working on the Fountain of the Great Lakes. For that, he was inspired by the Greek myth of Danaides, in which forty-nine sisters kill their husbands on their wedding night. As punishment, the sisters were condemned for eternity to the futile task of transporting water in vessels full of holes.

In 1906 Taft moved his studio from the Loop to a barn near the Midway Plaisance, a mile-long parkway connecting Jackson and Washington Parks. Here he created Midway Studios, an artist community, complete with workspace, kitchen, dining room, and dormitory. And here Taft trained and mentored countless students and aspiring artists. (Midway Studios is now at 6016 South Ingleside Avenue.)

In 1907 Taft won the Ferguson Monument Fund's first grant: $38,000 ($975,000 today) for his Fountain of the Great Lakes to be completed in three years. But Aaron

Montgomery Ward, who opposed development along the lakefront, delayed the placement of Taft's piece there. At last, in 1913, Taft was allowed to erect his work outside the Art Institute's south wall.

The fountain was a hit. Nevertheless, one critic said the placid depiction of the Great Lakes did not match the Great Lakes that Chicago knew, lakes that could sink ships. And the Women's Christian Temperance Union objected that three of the maidens were bare-breasted,

although the more tolerant Mayor Carter Harrison Jr. proclaimed the work "acceptable" in that regard.

Jumping forward to 1963, the fountain was moved around the corner against the western façade of the Morton Wing. Some objected that the fountain had been removed from an ornate setting and placed against a flat, boring wall. Others pointed out the western light of the new location was not the same as the southern light for which Taft had designed the sculpture. The

Originally the Fountain of the Great Lakes adorned the south side of the Art Institute's main building. In 1963 it was moved around the corner against the plain west wall of the Morton Wing–a move some say compromised the fountain's design, the donor's directive, and the artist's intent.

Iconic Fountains

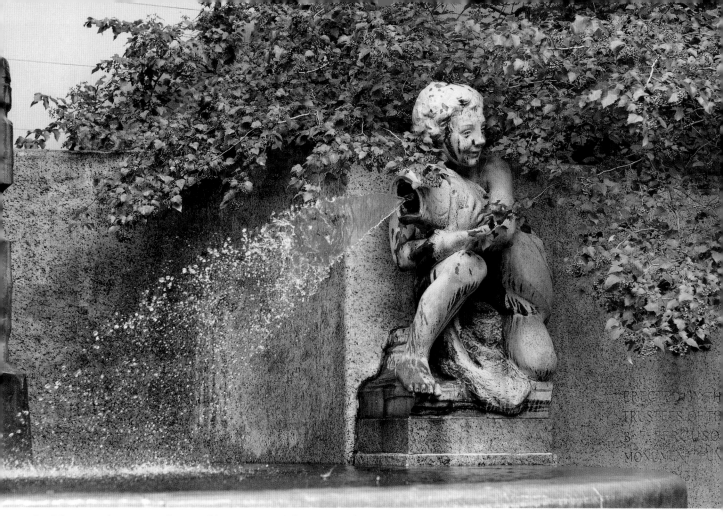

Playfulness and joy spring from Taft's Fountain of the Great Lakes. Chicago's leading sculptor, Taft lectured widely and wrote profusely in an effort to engage the public in fine art.

Chicago Heritage Committee wrote, "The relocation of this fountain raises a question of morality as well as of taste." Another critic wrote, "The re-siting showed not just indifference toward artist and patron, but insult."

The most serious objection to the move was the claim that the Art Institute was trying to hide a bronze plaque on the back of the fountain that, once placed against a wall, became impossible to read. The plaque says the money in the Ferguson Monument Fund was to be "entirely and exclusively used and expended . . . in the erection and maintenance of enduring statuary and monuments, in whole or in part of stone, granite, or bronze, in the parks, along the boulevards or in other public places within Chicago." Critics say Art Institute trustees strayed from this requirement in 1958 when they authorized $1.6 million ($13.3 million today) from the fund to construct an office wing at the Art Institute.

~~~~~~~~

Despite the controversy created by moving the fountain, the serene setting of its home in the South Garden is stunning. Architect Dan Kiley designed the intimately scaled sunken garden in 1962, complete with the **South Garden Fountain** consisting of a large, shallow, rectangular pool with thirty-two short water spigots that create a gentle,

bubbling sound. Crabapple trees flank the waterworks, also called the **Dan Kiley Fountain**, and twenty-eight low-hanging cockspur hawthorn trees create a canopy over the area that seems to hug the ground. Broad-edged planters around the trees provide plenty of seating. And three rows of tall honey locust trees along the sidewalk insulate the garden from the hubbub of Michigan Avenue.

The large but low South Garden Fountain sits unobtrusively at the foot of Taft's masterpiece, making the site a rare example of two Chicago waterworks in close proximity. The *Tribune* called Kiley one of the nation's greatest landscape architects, writing, "He led a challenge to conventional landscape design that . . . created static vistas meant to be seen from afar and, instead, immersed people in a dynamic merger of architecture and landscape."

Even though these two waterworks were built almost half a century apart and are quite different, they mesh beautifully. Peace and harmony rule in this sun-dappled fountain garden.

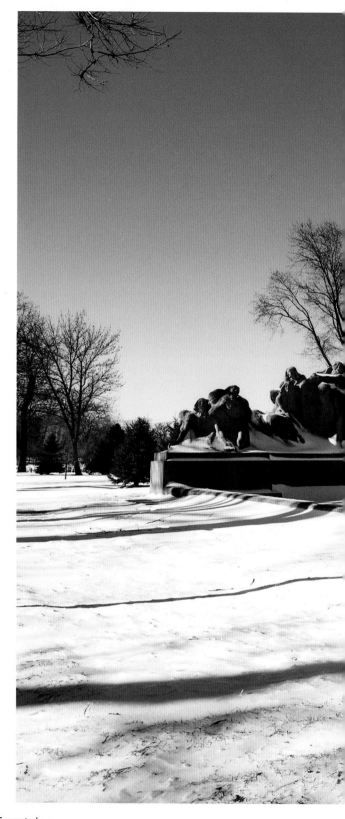

Taft created another iconic fountain, the colossal **Fountain of Time** installed in 1922 at the west end of the Midway Plaisance. This grim work depicts a 120-foot, wavelike procession of some one hundred people passing in review before an ominous, hooded figure representing Father Time. A large but shallow reflecting pool designed by Howard Van Doren Shaw separates the people from the sixteen-foot-tall figure Father Time.

Henry Austin Dobson's poem "Paradox of Time" inspired this work. The poem includes this line: "Time goes, you say? Ah, no. Alas, Time stays; we go." The dismal figures that pass in front of towering Time start at one end with babies and children and move on with young lovers

Taft's Fountain of Time was less successful than many of his other works. It demonstrates his strong interest in classical art and allegorical themes, but it's difficult to maintain.

Iconic Fountains

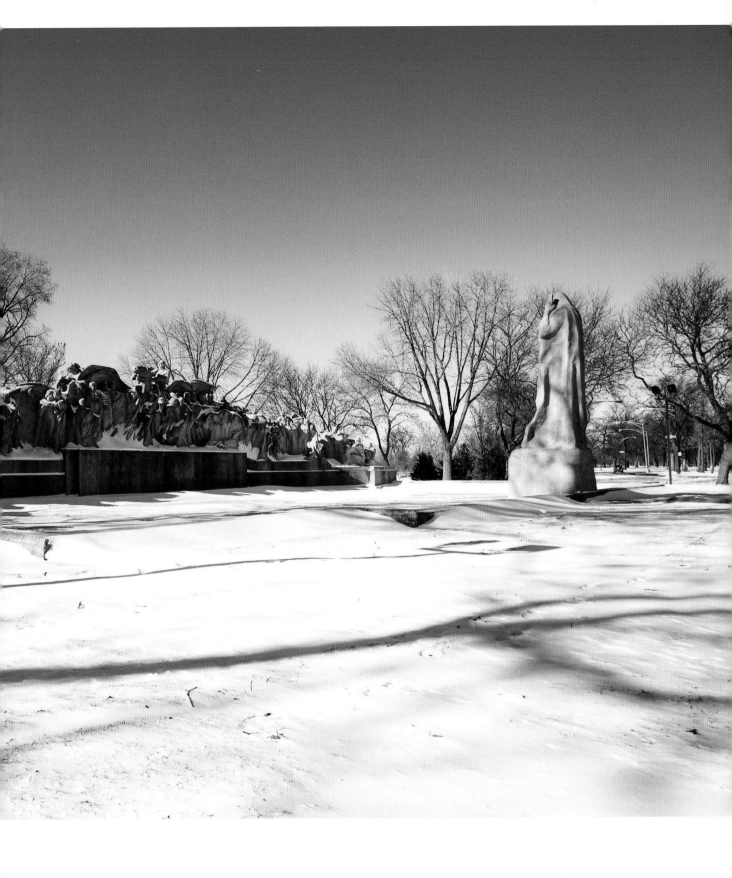

and families, followed by a priest and a poet. A conquering soldier on horseback surrounded by soldiers and refugees dominates the twenty-five-foot-high center of the piece, where three young girls modeled on Taft's daughters huddle under cloaks. The procession ends with an old man facing death, his arms outstretched. The backside is covered with figures, too, and Taft placed a portrait of himself there, wearing an artist's smock in a thoughtful, positive characterization.

This haunting piece has been called "a masterpiece" but has also been compared to "a row of false teeth smiling across the end of the Midway" and described as "an atrocity . . . better suited to a cemetery than a public pleasure ground." In fact, stern Father Time brings to mind Eternal Silence, another Taft sculpture that marks the resting place of Dexter Graves in Graceland Cemetery.

In 1913 Art Institute trustees awarded Taft $50,000 ($1.2 million today) from the Ferguson Monument Fund to start working on the Fountain of Time. The money, allocated over five years, covered the cost of creating a full-size plaster model, a sign that the trustees had doubts about the ambitious plan.

Incongruously, the fountain commemorates the Treaty of Ghent, which concluded the War of 1812. Having nothing to do with the nature of the piece, this subject was a pretext for tapping the Ferguson Monument Fund, which stipulated that works had to commemorate "worthy men or women of America or important events of American history."

Taft and his collaborators did most of the work on the fountain at the nearby Midway Studios. It took five years to complete the plaster model. By then enthusiasm for the enormous piece had waned. Administrators of the Ferguson Monument Fund declined to commission the finished piece in granite, marble, or bronze, which would have cost a fortune and taken many years to complete. Instead, Taft employed a new and relatively inexpensive type of architectural concrete developed by John Earley. Earley's polychrome process involved adding ground stone to enhance the color and texture of concrete, thereby creating a pebblelike finish. Polychrome concrete was

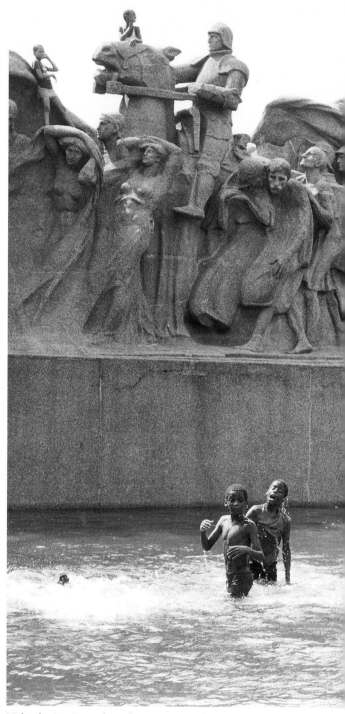

Kids playing in and on the Fountain of Time in this undated photo seem oblivious of its fragile state—or its dark theme.

Iconic Fountains

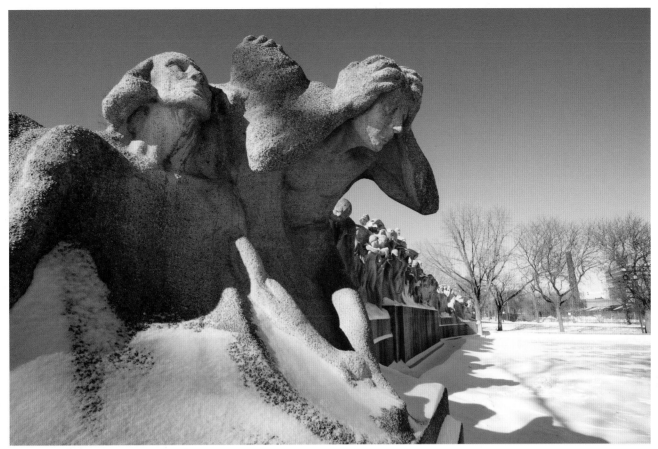

The Fountain of Time's pitiful procession of humanity ends with elderly people facing death.

also pourable, which allowed Taft to create his hollow, steel-reinforced concrete figures using a mold. The finished mold included hundreds of sections and forty-five hundred pieces, making it the largest piece-mold casting until then. The time tableau was finally installed in 1922.

Of course, Earley's material was far less durable than metal or stone. Weather and pollution have ravaged the structure. In the 1930s the park district determined that the Fountain of Time already needed repairs. Over the ensuing decades, expensive, periodic restoration projects have failed to fix the piece's underlying problems. They have simply bought more time.

Some of the repair work has made things worse, according to Andrzej Dajnowski, a preservationist who has worked extensively on the piece and heads the Conservation of Sculpture and Objects Studio in Forest Park, Illinois. The sculpture has been sandblasted, which stripped

off details and its protective coating. And workers have patched the sculpture with mixtures that didn't match the color or consistency of the original concrete, thereby causing the sculpture to crack even more with each freeze-thaw cycle.

By the 1980s the Fountain of Time was in such terrible shape that for several winters it was covered with plastic tarps to prevent more damage. In the late 1990s the park district and the Ferguson Monument Fund launched a massive restoration. Dajnowski led that project and was determined to get the right mixture to patch the cracks and repair broken parts. He ordered samples of aggregate from all over the country and tested each mixture without success. One day, he noticed fishermen digging for worms in sandy soil near the fountain. That gave him the idea of using local aggregate. "The answer had been right under my feet the whole time," Dajnowski said.

Despite the millions of dollars spent on this sculpture, it continues to deteriorate. Details have been lost, faces blurred. The pool leaks, and leaves often clog the drains and damage the plumbing. Moisture builds up inside, causing deterioration, despite a ventilation system designed to reduce the humidity. Dajnowski wonders about its future. He'd like to cover it with a translucent roof to protect it from the elements, as was done with *Four Seasons*, the Marc Chagall mosaic next to the Exelon Plaza Fountain. Others have suggested moving the piece indoors, sealing it with a protective plastic coating—or bulldozing it. Still, it speaks to many and attracts a steady stream, well, trickle, of visitors.

A footnote: Even though the Fountain of Time doesn't include running water, it's called a "fountain" because originally it incorporated water sprays. Old photographs show jets spraying water into the pool from both sides. Taft himself wrote, "I thought of the figure of time with waves circulating around it. But I decided . . . to have the figures come out of a veil of mist, pass before Father Time, and disappear again in the mist." Those sprayers were still in place decades later, according to an art critic who wrote that "two spindly water pipes squirt out a trickle."

Despite the current lack of sprays, water is still a critical element of this fountain. The water in the pool adds beauty and dimension, reflects the figures and sky, and represents the flow and fluidity of life. The fountain's wave of humanity seems to emerge from the pool—much as our ancestors emerged from shallow water eons ago.

～～～～～～

And now for an iconic fountain that does make a big splash. For ten minutes on the hour, the **Water Cannon** of the **Nicholas J. Melas Centennial Fountain** on the

Built in 1989, the Centennial Fountain's Water Cannon along the Chicago River was a glorious addition to what was then an undervalued waterway. Some compare this water arc to the Gateway Arch in St. Louis–like Chicago, another nineteenth-century gateway to the West.

Iconic Fountains

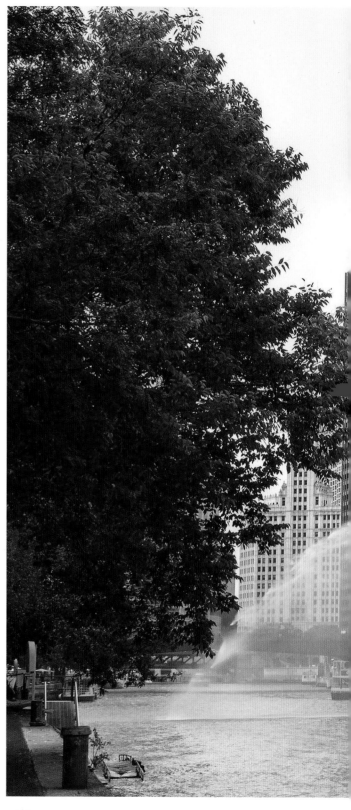

north bank of the Chicago River at McClurg Court shoots two thousand gallons of river water a minute across the waterway.

The eight-story, two-hundred-foot-wide water arc has become a Chicago favorite. It brings smiles to the growing number of pedestrians who stroll along the river. Most boaters wait for the cannon to stop, but others brave the spray while onlookers watch them get wet. If wind velocity and direction threatens to soak people along the banks, computerized controls turn off the cannon.

But the arc is only one part of a glorious water spectacle the Metropolitan Water Reclamation District of Greater Chicago built in 1989 to commemorate its hundredth anniversary. The project includes the lesser-known yet stunning Centennial Fountain at the base of the Water Cannon. Cascades of recirculating river water, illuminated by underwater spotlights, flow down the two stepped sides of granite into a 125-foot-wide semicircular basin. This creates something akin to a water amphitheater. Visitors can even walk behind a curtain of falling water and view Chicago's skyline through an aqueous blur.

Over its one hundred years, the water district reversed the flow of the Chicago River away from Lake Michigan, built massive sewer treatment plants, and began constructing the huge Deep Tunnel to capture storm water and sewage overflow. Despite these accomplishments, this fountain was controversial. Critics asked how the district—created to serve pragmatic needs—could justify spending $3.5 million ($7 million today) of taxpayers' money on sentiment and beautification? Ultimately, private funds were raised to build the water marvel.

Two women championed the project: Commissioner Gloria Majewski headed the centennial observance committee and called it "public art at its best." But Commissioner Joanne Alter is considered the fountain's fairy godmother.

When Alter started at the district, the commissioner's position was treated as a part-time patronage job. She got the position by complaining to Mayor Richard J. Daley that his Democratic Party machine was overlooking women. "'Okay,' Daley said, and immediately slated her

for commissioner," according to Jonathan Alter, Joanne's son and an accomplished journalist. "But she took the job seriously and became a watchdog and reformer." This brought out gender discrimination, Jonathan said. "A fellow commissioner called her 'one of the brainless, braless broads who was ruining America.'"

Such attitudes did not deter Alter. She championed conservation, the environment—and the fountain. "The fountain gave her more pleasure than anything else in her eighteen years as commissioner," Jonathan said. Many people thought it should be named for her. Instead, in 1993 the commissioners named it for Melas, who served as a commissioner for thirty years, eighteen as president of the board.

"It was an injustice," Jonathan said, "because Melas was not an early supporter of the fountain. She [Joanne] was bemused at the dedication that some of the commissioners clapping the loudest had opposed the fountain, calling it 'trivial' and 'an unaffordable luxury.'"

The commissioners later created a plaza honoring Alter on the south side of the river, near where the water arc lands. A plaque calls her an "ardent environmentalist" and reads, "Alter's vision for improvement in the Chicago River led to the revitalization of the entire river system."

The fountain also played a role in local politics. In 1988 former alderman Edward R. Vrdolyak ran against Aurelia Pucinski for clerk of the Circuit Court of Cook County. Vrdolyak ran radio ads criticizing Pucinski for supporting the fountain while she was a commissioner, remembers reporter John Holden. "'Tut! Tut! What a waste,' Fast Eddie's ads sneered," Holden said (using a popular nickname for the colorful Chicago politician, who later ended up doing time for mail and wire fraud). Mocking the fountain might have been a political miscalculation on Vrdolyak's part, as Pucinski beat him handily in the election.

Alter was a friend of and inspiration to Dirk Lohan, the architect who designed the fountain. Lohan is a principal at Lohan Anderson (and Ludwig Mies van der Rohe's grandson). Originally, he suggested a water cannon on each side of the river, but that proved to be too expensive.

The Water Cannon is prominent, but many don't notice the magnificent Centennial Fountain at its source, representing Chicago's subcontinental divide.

He also wanted the cannon to run continuously, as it did for a short test period, but the tour boat operators objected to their passengers getting wet.

Describing the Centennial Fountain along the river-bank, Lohan said, "I wanted to symbolize the natural phenomenon of water—how it comes from one source, spreads and goes to another." His design makes that clear. From the center, which represents Chicago's watershed divide, water flows in two directions. Six large steps to the west represent the Chicago River, Sanitary and Ship Canal, Des Plaines River, Illinois River, Mississippi River, and Gulf of Mexico. Six steps to the east represent lakes Michigan, Huron, Erie, and Ontario; the Saint Lawrence Seaway; and the Atlantic Ocean. (Look for the panel of explanatory text that misspells "Mississippi".)

Lohan said he wanted the water cannon to connect both sides of the river because while that stretch of the north side of the river was being developed as part of the City Front project, "the south side of the river was a wasteland. I wanted to trigger something there, to encourage the city to develop the property. And it worked like a charm."

Indeed, the fountain and water cannon helped convert the Chicago River from a "wet alley" into the classy water boulevard it's becoming, offering recreation and refreshment to walkers, cyclists, and boaters—on both sides of the river. Decades ago, most buildings turned their back to the river, but in the 1990s, developers began to invest millions of dollars in commercial and residential amenities along the water, and the trend continues.

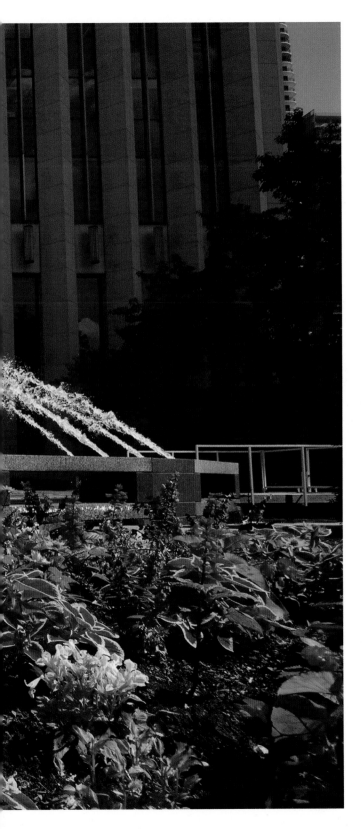

# 4. PLAZA FOUNTAINS

Downtown Chicago is sprinkled with many plaza fountains. The proliferation of plazas, especially in the 1960s, resulted from zoning rules that allow a building to be constructed higher if it includes setbacks and an open area at its base. But such open areas should not be afterthoughts, as often is the case. Instead, they should take into account the setting and surroundings.

The six **Aon Center Plaza Fountains** achieve this integration magnificently, although they're among the city's least-known water wonders. Two striking fountains are tucked away in the large sunken plaza on the south side of the building at 200 East Randolph Street. One circles a central platform that doubles as a performance stage; the other features a wide cascade of rushing water that tumbles down a stepped, rugged-looking, ten-foot-high wall. These impressive waterworks drown out city noise.

An attractive assemblage of trees, flowers, benches, gazebos, and large glass umbrellas (accompanied by adjacent eateries) decorate the stunning sunken plaza, inviting people to sit or study, read or relax. This urban oasis truly delights the eyes and ears, soothes the mind and body.

When the Aon Center opened in 1973 (as the Standard Oil Building), the plaza looked entirely different. The south wall featured a wide but simple fountain, with water falling straight down. The creative but poorly located **Sounding Sculpture** stood in the center of the plaza. This

The Aon Center, with no fewer than six inviting waterworks, is fountain heaven. The plaza's large central fountain beckons passersby and doubles as a stage for performances.

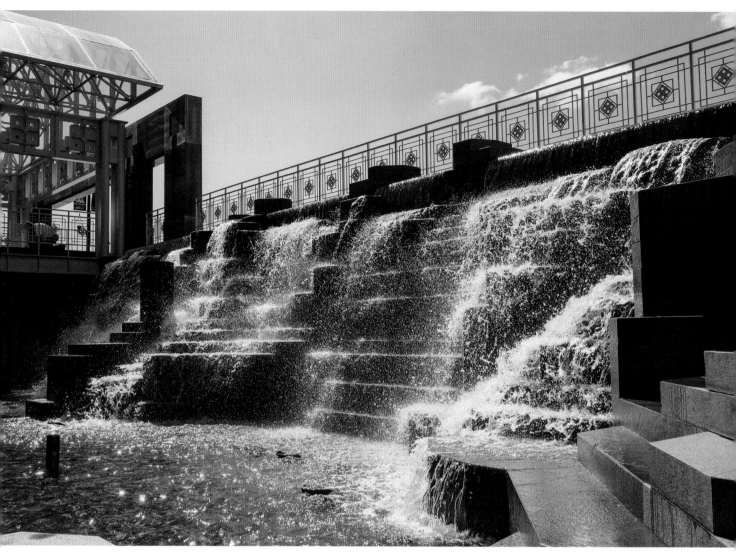

Loud, strong, and forceful, this fountain along the Randolph Street side of the Aon Center's sunken plaza is an unexpected, rugged treat in the heart of the city.

fountain consisted of eleven units, each made of numerous copper rods lined up and implanted in a rectangular, black granite base. The units were placed in a shallow four-thousand-square-foot pool with running water.

The idea behind this unusual work was that Chicago's famed wind would play the copper rods like a harp, producing ringing, musical sounds. The units were placed perpendicular to each other to catch more wind, and the rods varied in height from four-to-sixteen-feet to allow for different pitches and resonance.

Harry Bertoia said wind rustling through fields of wheat inspired him to create the sculpture. If the concept of the Sounding Sculpture sounds a bit far-fetched, consider that Bertoia was a widely renowned sound artist (and designer of chairs). He died in 1978, but in 2015 Important Records released a lavish eleven-CD boxed set of recordings from his many sounding sculptures.

A percussionist could have had a field day with the Sounding Sculpture, but it never made much music on its own because the sunken plaza shielded it from the wind.

Plaza Fountains

Once the centerpiece of the sunken plaza of what was then the Standard Oil Building, the Sounding Sculpture looked as though it had been plunked down in a big empty space.

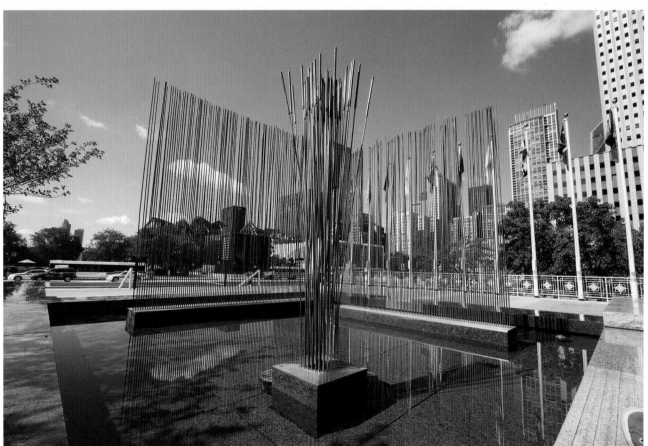

Designed to chime in the wind, the Sounding Sculpture has been split into parts and dispersed. Six units were installed in two reflecting pools on the southern corners of the Aon Center's upper plaza.

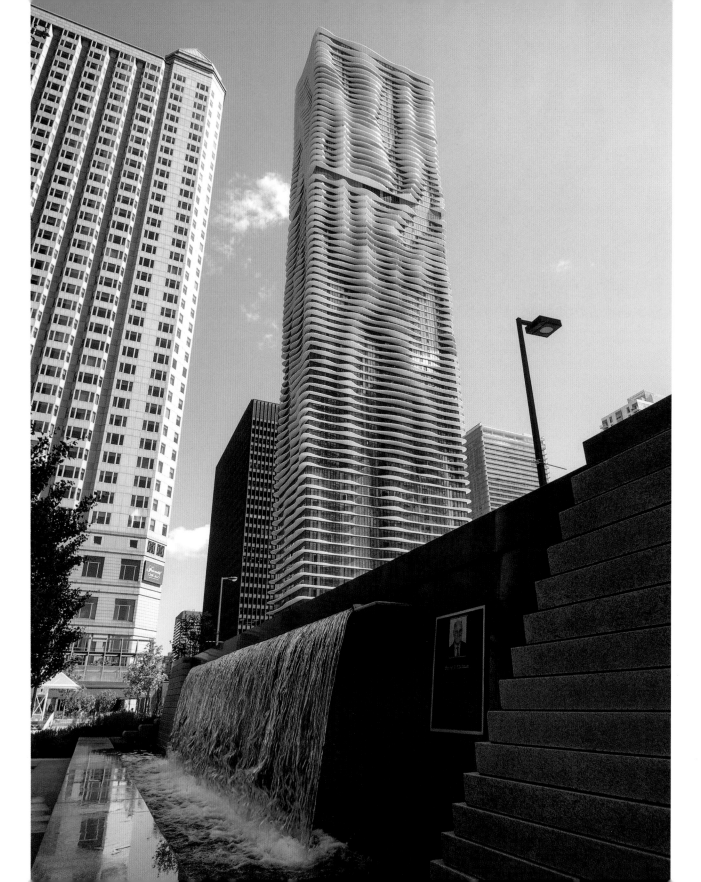

Under the headline, "Worth wading for?" the *Tribune* suggested in 1975 that people should "wade into the pool . . . and vibrate the rods with their hands."

A few years later the *Tribune* called for a remake of the plaza to incorporate "color, better seating, and a livelier character." The building did just that, but not until 1994 when Amoco (the building's new owner) installed the present configuration at a cost of $40 million ($65 million today). Critics approved, describing the changes as "the architectural equivalent of a shot of Tabasco sauce."

As part of the renovation, the Sounding Sculpture's eleven units were separated. Amoco took some of them when it moved to the suburbs in the 1990s, according to Mike Lyons, a former Aon Center operations manager. "I also heard Amoco was going to donate parts of the Sounding Sculpture to Millennium Park, but that didn't happen," he said. Six of the eleven units stayed with the property and have been placed in two small reflecting pools at the southeast and southwest corners of Aon's upper plaza, where they pick up more wind than before.

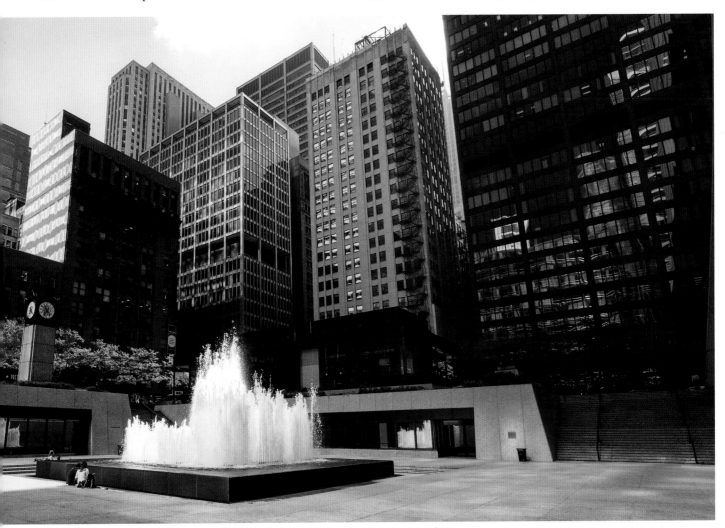

*Left*: Several fountains grace the Aon Center's upper plaza. Here, water seems to flow off the Aqua Building and through this fountain on the plaza's east side. *Above*: The fountain in the sunken Exelon Plaza puts on a lively, unpredictable water spectacle, right in the center of the Loop.

Meanwhile, two additional fountains, handsome and wide, enhance the building's upper plaza, which is full of alluring nooks and crannies. They offer more opportunities to sit beside or stroll by pleasant running water.

~~~~~~~~~~

In another alluring sunken plaza, the magnificent **Exelon Plaza Fountain**, at Monroe and Dearborn streets, throws water more than forty feet into the air, thereby summoning passersby to investigate. When they do, they find a fountain composed of nine six-foot-squares, each one consisting of several jets that shoot water up in unpredictable, cubelike patterns. The water then falls into a forty-five-foot-square basin and flows over its serrated edges. The fountain opened in 1973 and was designed to operate any time the temperature is above forty degrees.

The fountain can pump eighteen thousand gallons of water per minute, so it can be loud and forceful. The computer-controlled display of geometric blocks of water can also be soft and effervescent. The *Sun-Times* called it "a fountain that dances."

Smack in the middle of the Loop, the one-acre Exelon Plaza has restaurants on its multiple levels and doubles as an entertainment venue, offering occasional public performances. Still, some find the 125-foot-square open space stark. Dozens of trees line the plaza, and Chagall's *Four Seasons* mosaic livens up one edge, but the below-ground sections lack shade, wood, and greenery. Furthermore, the plaza is covered with white granite—the same stone that lines the sides of the adjacent, dramatically swooping sixty-story Chase Tower. This light-reflective surface creates a bright, hot environment, especially on sunny summer days.

Thank goodness for the frothy fountain, which converts what would otherwise be an unforgiving setting into a kinder, gentler place. It softens the surfaces, provides a dynamic element, and cools the space, especially for those who sit near the spray.

~~~~~~~~~~

A block west of Aon, two **Prudential Plaza Fountains** energetically shoot water skyward in a one-acre plaza along Lake Street at Beaubien Court. The terraced, landscaped plaza is attractive and offers plenty of seating to lunch or lounge, as well as a few restaurants. The water shoots high, making a pleasant sound in a welcoming open space just far enough east of the Magnificent Mile to offer a break from the crowds.

Farther north on Michigan Avenue between Chestnut Street and Delaware Place is the John Hancock Center's sunken plaza. Alas, it feels cramped and moatlike. Initially, it was rectangular and included an ice-skating rink. The plaza was not popular, however, so in 1989 Hancock reconfigured it into an elliptical and more open space, but it still feels confining.

Part of that reconfiguration involved building the attractive **John Hancock Center Fountain** along the western wall of the sunken plaza. Steps with flowing water descend steeply from both sides of the fountain and meet in front of a semicircular ring of waterspouts. The waterworks is vigorous and agreeably loud. At the same time, it's narrow and tucked away behind trees. Although the fountain does not have a commanding presence, it and its sunken plaza offer a refuge from the street noise and traffic.

~~~~~~~~~~

A block south of the loud Hancock fountain, the quiet **Jane Byrne Plaza Fountain** burbles gently in a plaza renamed for her in 2015. This ground-level fountain with a fifteen-foot-diameter basin features four small vertical jets surrounding one taller jet, thereby reflecting the shape of the nearby castellated Water Tower, with its four corner turrets and central spire. Victor Skrebneski designed the fountain and plaza in 2000.

Directly across the street from the Hancock, the serene **Children's Fountain** murmurs placidly inside the cloistered courtyard, or garth, of the Fourth Presbyterian Church. It fits neatly inside this peaceful space, helping to make it one of the most restful, contemplative places

John Hancock Center's sunken plaza has never lived up to its potential. The space is confining, and its fountain seems squeezed in along a wall.

in town. Water from the fountain's twelve-foot-high shaft dribbles into a twelve-foot-wide stone base trimmed with a crown and small animal motifs.

The top of this limestone waterworks, also called the **Garth Fountain**, features carvings of mothers and children.

The Fourth Presbyterian congregation dedicated its first church in 1871 on the day of the Great Chicago Fire, only to see the edifice burn to the ground. The congregation rebuilt nearby but quickly outgrew its new building. In 1914 it dedicated its current church on Michigan Avenue between Chestnut Street and Delaware Place. That makes this church and its fountain the second-oldest structures (after the Water Tower) on Michigan Avenue north of the Chicago River.

Church member Howard Van Doren Shaw designed and donated the fountain. Shaw also designed the parish buildings surrounding the quasi-monastic garth, creating the harmonious ivy-covered setting for the waterworks.

Fitting with the congregation's service orientation, the church and garth are open to all, whether locals or tourists, shoppers or churchgoers. Concerts, coffee hours, art exhibits, and "Music by the Fountain," a free series every Friday at noon during the summer, send a clear message: come on in! Attending a concert alongside the graceful fountain in this idyllic setting will carry you miles—and centuries—away from the hustle and bustle of the Magnificent Mile.

Plaza Fountains

When retail giant Sears was constructing its tower in 1968–72, designers considered a series of fountains for its outdoor plaza. That idea never became a reality, but the massive **Gem of the Lakes** fountain commands the lobby atrium of the building across the street at 311 South Wacker Drive. This piece is indoors, but the eighty-five-foot-tall glass-enclosed winter garden, complete with real forty-foot-tall palm trees, with plenty of sunshine and foliage, has a distinctive outdoor feel. Two waterfalls frame the large multitier fountain, which is capped with a large bronze figure of a windblown man, presumably sailing the Great Lakes. Designed in 1990 by Raymond Kaskey, Gem of the Lakes is Chicago's most impressive indoor fountain sculpture.

~~~~~~~~~~

Originally planned as a sunken plaza, the large Civic Center Plaza opened in 1965 at street level. The southwest corner of this renamed plaza is home to the **Richard J. Daley Center Plaza Fountain**, a fifty-five-foot-square waterworks at Washington and Clark streets. Jacques Brownson designed the plaza and the building.

The popular fountain features an unusual stepdown around its perimeter that seems to invite people to wade in. Early press reports called it a "walk-in fountain," and newspapers printed photos of adults and children in it, even drinking from the jets. As part of a 1996 plaza renovation to improve access for people with disabilities and to increase the amount of usable surface in the plaza, architects proposed raising the fountain to ground level. Fortunately, this idea was rejected because it would have eliminated the appealing stepdown configuration.

The renovation also increased the number of jets from about two dozen to almost two hundred. Ostensibly this change was to create more white noise, but another goal might have been to discourage wading. Nevertheless, a few

The low quiet Jane Byrne Plaza Fountain reflects the design of the castellated Water Tower, with its corner turrets and central spire.

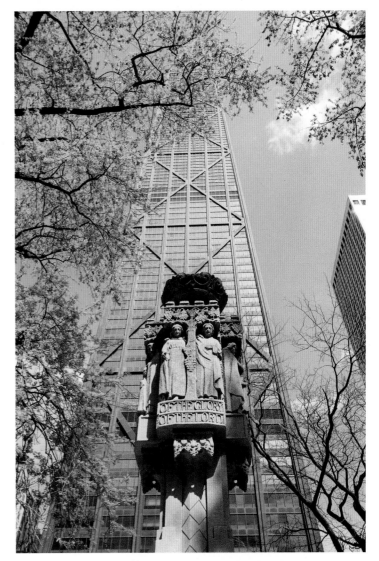

Dating to 1914, the Children's Fountain in the Fourth Presbyterian Church's garth gurgles away to the glory of God—in the middle of one of Chicago's preeminent shopping districts.

pedestrians still test the waters on hot days, and protestors occasionally romp in the water.

The sparkling fountain livens up this plain, underpopulated plaza and balances the Picasso sculpture on the eastern side of the vast space. The fountain delights passersby when it's dyed for the winter holidays, Halloween, and St. Patrick's Day. Because it's near several courthouses, attorneys have been seen tossing in a coin,

hoping to improve their day in court. (It's not known whether they retrieve their coins when they lose.)

~~~~~~~~

A fountain can enhance a small plaza, too. The commanding **Harris Bank Fountain** fits beautifully into the tight space at Monroe and LaSalle streets. It consists of seven branching petal-like pedestals over which water gushes spiritedly and flows smoothly. There are many other ways to interpret the fountain's design, including lily pods, toadstools, fish fins, and even the seven continents, awash in water. Six-and-one-half feet high, the bronze sculpture stands in an impressive concave dark-red-granite basin twenty-two feet in diameter.

Midwesterner Russell Secrest designed the fountain. At its 1975 unveiling, Harris Bank's lion mascot, named Hubert, dramatically removed a parachute shrouding the sculpture. Although not huge, the fountain is solid, weighing nineteen tons (including the basin). Still, its curvy, interconnected branches and rounded edges give it a soft gentle quality. Its distinctive blue-green patina adds to its appeal. The fountain was designed to be internally heated for winter operation, but it's not known how long this feature lasted.

The artistic **Kenzo Tange Fountain** at 515 North State Street embellishes another small downtown plaza and is equally well suited to its space. Water flows gently, almost silently, over the fountain's polished black stone mass. Tange was the elder statesman of Japanese architecture in 1990 when he designed the plaza and adjacent building for the American Medical Association (which vacated the building in 2013).

The low fountain is shaped as a right triangle with a hypotenuse of thirty feet. This reflects the dimensions of the plaza as well as the western portion of the angularly

The Children's Fountain and its peaceful cloistered courtyard have the power to sweep you miles—and centuries—away from the Magnificent Mile's hubbub. During the summer, the church holds free weekly concerts here.

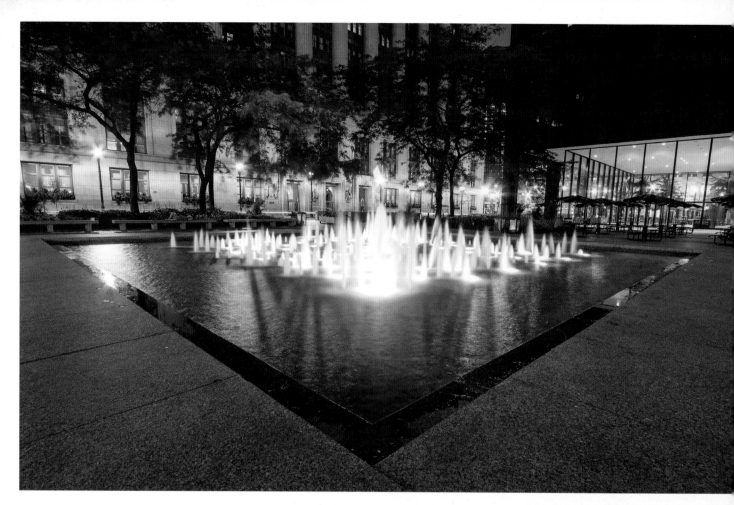

Above: The Richard J. Daley Center Plaza Fountain livens up the area's large flat space, as does the better-known Picasso sculpture on the other side of the plaza.
Right: One of the Daley Center Plaza Fountain's claims to fame is the way it's dyed for major holidays, including green for St. Patrick's Day and orange for Halloween.

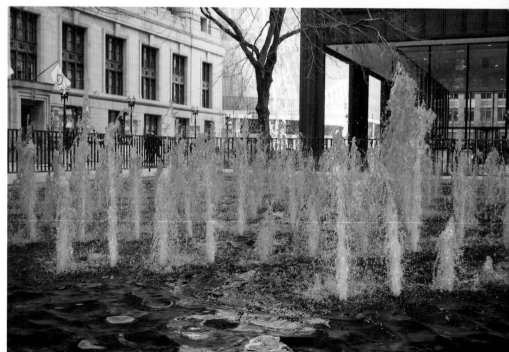

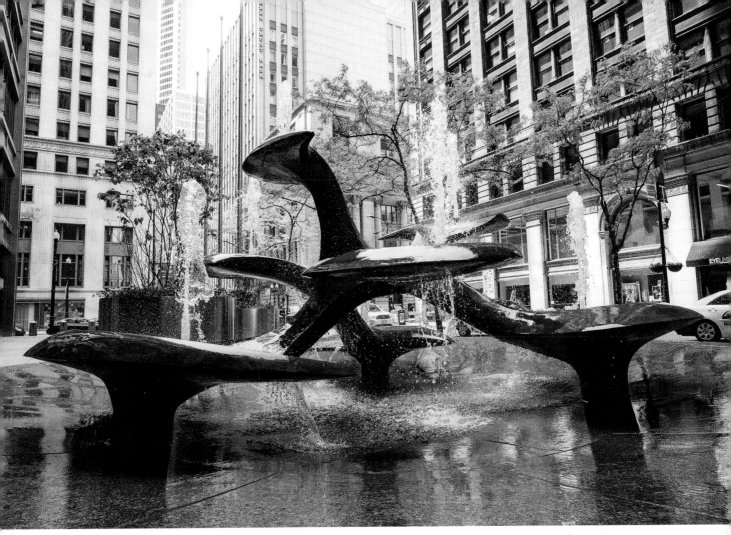

The curvaceous, relatively small but solid Harris Bank Fountain is perfectly designed for its tight, angular setting. It was internally heated for winter operation, but it's not known how long this feature lasted.

shaped building, with its distinctive four-story cutout at the top. A small but precious park to the southeast used to complement the fountain, but in 2009 a skyscraper replaced that rare downtown green space.

A concrete ledge surrounds the Tange fountain, making it a nice spot to sit and rest. That's what two ducks thought, anyway, in 2006. The couple took up residence in the fountain, off and on, for a few days, despite the din from the nearby busy intersection.

Outside Metra's LaSalle Street Station in One Financial Plaza at 440 South LaSalle Street, a brawny bronze horse trots atop a vigorous fountain called **San Marco II**. Water crashes down six steps at the base of the horse's large rectangular granite pedestal into a thirty-foot-diameter basin. The fountain dominates the building's plaza and is strikingly illuminated with colored lights.

Italian surrealist painter Ludovico De Luigi created this mythical stallion as a demigod that would breathe "life into a very cold material like bronze," he told the *Tribune* at the 1986 unveiling. He was inspired to create San Marco

II by the four triumphal horses that crown the front of St. Mark's Basilica in Venice. Historians date these horses to the fourth century in Constantinople (now Istanbul). After sacking Constantinople in 1204 during the Fourth Crusade, Venetians looted the horses and installed them on the terrace above the entrance to St. Mark's.

In 1797 it was Napoleon's turn to plunder. He took the horses to Paris, where they inspired the design of a chariot on top of the Arc de Triomphe du Carrousel. In 1815 the French returned the horses to Venice, where they stood over St. Mark's until the early 1980s, when it became clear that pollution and the elements were damaging the copper statues. Officials replaced them with replicas, moving the original horses inside.

Primarily a painter, De Luigi called San Marco II his "sculptor's diploma." He certainly mastered the art, as his sculptures now beautify sites around the world.

De Luigi made the ribs of San Marco II more numerous and pronounced to represent the lines in the sand that the tide leaves on beaches near Venice. He placed his equestrian statue in the middle of a pool, much as Venice is surrounded by water. And he made his horse majestic and virile to counter the decay of Venice's famous but failing horses of St. Mark's Basilica. The connection with Venice, where the stylized steed was cast, is so strong that the statue was ceremoniously floated down the canals of that island city before it was shipped to Chicago.

Today, the exquisite equine faces west to symbolize the westward settlement of the United States, which depended so much on horse power.

~~~~~~~

Just two blocks away, a plaza outside another market exchange is home to another striking fountain. The sleek, art deco **Chicago Board of Trade Fountain** matches the

San Marco II brings splendor and radiance to the plaza at One Financial Place, a polished granite skyscraper that houses the Chicago Stock Exchange. Artistically speaking, the fountain's horse journeyed from Constantinople to Chicago via Venice.

Plaza Fountains

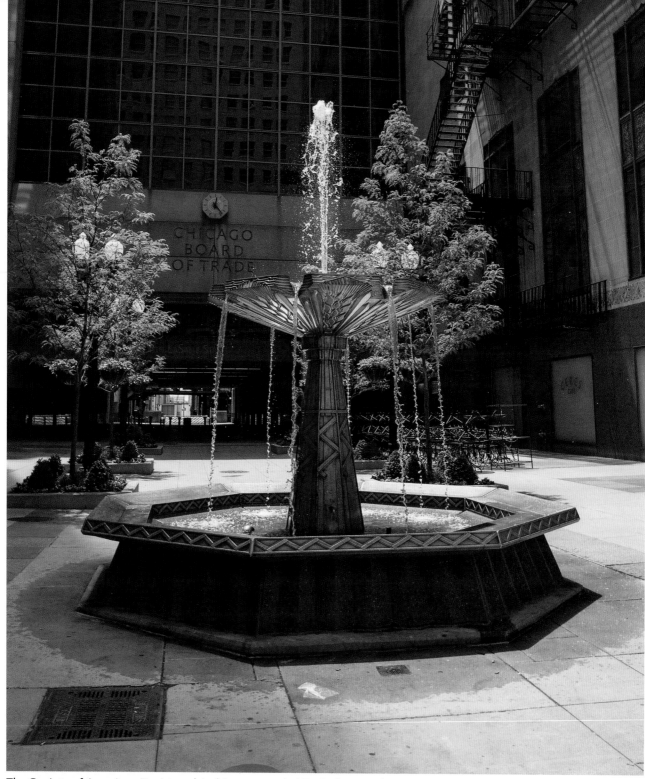

The Society of American Registered Architects awarded DeStefano and Partners a Design Award of Honor for its art deco Chicago Board of Trade Fountain.

style of the 1930 Chicago Board of Trade building at 131 West Jackson Boulevard, west of the plaza.

This two-tiered work of art is made of aluminum. Water drips from its upper bowl into a twenty-foot-wide basin near ground level. Both these elements are octagonal—a nod to the octagonal shape of the trading pits inside the Board of Trade, said Edward Windhorst, who designed the fountain. Its shaft and upper bowl carry a sculpted relief of a sheaf of wheat based on elevator-door designs inside the Board of Trade. The lower bowl, inside and out, is covered with polished terrazzo. This stylish fountain is elegantly lighted and decorated with red ribbons and green boughs during the winter holidays.

Windhorst originally planned three fountains for the large plaza, but that idea was deemed too expensive, he said. "Therefore, the relatively small, single fountain is underscaled for the space."

Established in 1848, the Board of Trade is one of the world's oldest options and futures exchanges. This fountain was unveiled in 1998 to mark the board's 150th anniversary.

Two remarkable granite statues flanking the fountain overshadow it. The twelve-foot statues of mythical Greek goddesses of agriculture and industry once stood on a ledge over the entrance to the Board of Trade's 1885 building. They disappeared in 1929 when the building was razed to make room for the current building. Thought to be lost forever, the five-ton statues turned up in 1978 near Glen Ellyn, Illinois, in surprisingly good shape. After being displayed in a parking lot at Danada Forest Preserve for several years, the Forest Preserve District of DuPage County returned both statues, which were installed near the Board of Trade Fountain in 2004.

Another notable downtown fountain was installed in 1982 at State and Washington streets on what was then the State Street Mall, limited to buses, taxis, pedestrians, and cyclists. Turning the street into a mall turned out to be a mistake, but **Being Born** was an attractive part of that grand experiment. Designed by Virginio Ferrari and installed in 1983, the sculpture consisted of two twenty-foot-tall, stainless steel circles on a granite base. The

structure released a continuous flow of water that filled a shallow reflecting pool. Since 1996, millions of people on their way to and from the Kennedy Expressway have driven by Being Born in its new location at Ohio and New Orleans streets. It no longer includes any running water.

~~~~~~~

The history of the **Chicago Vietnam Veterans Memorial Fountain** goes back to Veterans Day 1982, when Mayor Jane Byrne dedicated the original fountain at Heald Square, a plaza in the middle of Wacker Drive at Wabash Avenue. It was hailed as America's first memorial devoted solely to veterans of that war (beating the dedication of the more famous Vietnam Veterans Memorial in Washington, D.C., by two days).

The dedication of the Chicago fountain was moving. Cardinal Joseph Bernardin gave the invocation, and about two hundred veterans attended, many with tears streaming down their faces. "We've forgotten about this war," Byrne said. "To those who gave their lives, we can never say 'thank you' enough."

Byrne ranked this work one of her top two accomplishments as mayor (the other being her Children's Fountain). The eight-by-thirty-foot white granite fountain cost $360,000 ($891,000 today) and consisted of dozens of jets sending water into the air at an angle, creating a low tunnel of water in a long rectangular pool. It was by no means fancy. Nevertheless Barry Romo, a member of Vietnam Veterans Against the War, said the minute the water was turned on the site became "hallowed ground for Vietnam vets. [From then on] we always came to that fountain to hold our services."

As with the Children's Fountain, however, the Vietnam Veterans Fountain took a beating from Mayor Richard M. Daley. In 1996 the dedication plaque with Byrne's name was replaced with another that did not include her name. "No public official has the right to wipe away 14 years of history," Byrne said in response. Then the fountain was dismantled in 2000 or 2001 as part of the Wacker Drive reconstruction. Meanwhile, a time capsule Byrne had

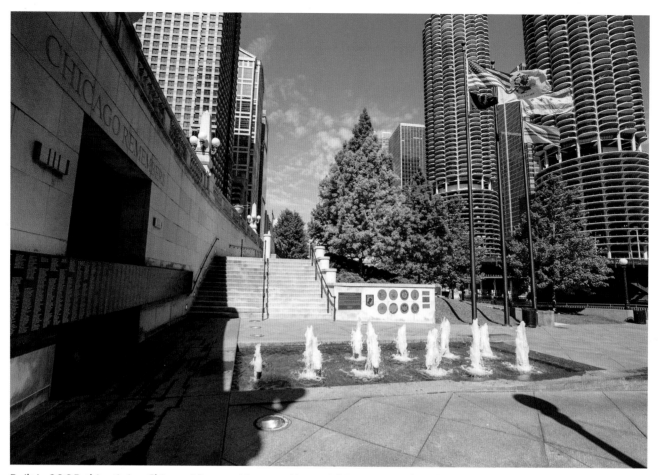

Built in 2005, this stirring Chicago Vietnam Veterans Memorial Fountain replaced another one that Mayor Jane Byrne had built nearby as America's first memorial devoted solely to the veterans of that war.

placed in the fountain was lost and never recovered. It contained the names of Chicago servicemen who had died in Vietnam and a letter to Byrne from President Ronald Reagan commending the city for honoring the veterans.

Wacker Drive was reopened in 2003, but without the veterans fountain. "The city is treating the old fountain like it was nothing—but it was blessed," Byrne said. "It contained the names of dead soldiers. This is no small thing."

Byrne maintained it took a lot of pressure from her and the press to get a new Vietnam Veterans Fountain built in 2005. In particular, Ben Joravsky at the *Reader* pursued the issue. The effort was worth it because the new fountain is a powerful tribute. The *Tribune* said it was "more visible . . . and more stirring" and that its location west of Wabash along the Riverwalk was a "showcase site."

The new fountain consists of a rectangular pool with a dozen water jets in front of a wall with running water. A wide strip of black granite on the water wall holds the names of almost three thousand Illinois soldiers who died or were missing in action in the war, and a timeline of significant events during the war lines the sidewalk.

Carol Ross Barney, principal designer at Ross Barney Architects, designed this serene setting. It includes terraced lawns, beautiful landscaping, and a dozen engraved emblems of the branches of the armed forces. Barney "employed the [fountain's] water to great advantage, not simply using it to tie the plaza to the river but to shape a space and form a mood."

The new setting incorporates elements of the original memorial. Meanwhile, the 1996 plaque without Byrne's

Plaza Fountains

name was placed along Wacker Drive facing the site of the original memorial. Appropriately, the plaque on the new 2005 fountain mentions Byrne. "Chicago Remembers" is chiseled into the limestone above the monument—words that could apply to the memory of Byrne's role as well as that of the veterans.

One unfortunate feature of the Wacker Drive reconstruction project is the new placement of the **Heald Square Fountain.** The low rectangular pool on Wacker Drive west of Wabash Avenue is tucked behind the massive statue of George Washington, Robert Morris, and Haym Salomon (sculpted by Lorado Taft and Leonard Crunelle). Like the original veterans fountain, the statue previously stood in Heald Square in the middle of Wacker Drive, along with an oval fountain. After Wacker Drive's reconstruction, the statue was moved to the sidewalk and a relatively small pool with jets was installed behind, where it's easy to miss.

~~~~~~~

Plazas dot buildings around the entire city, not just downtown. One of the most charming is a cozy plaza nestled in the Hyde Park Shopping Center at 55th Street and Lake Park Avenue. Its centerpiece is **Jacob and the Angel II**, a small fountain whose bubbly water seems to be trying to reach up to an abstract sculpture of a curled-up man wrestling with himself. Or is he wrestling with an angel? Or with God? The sculpture is based on the biblical

Jacob and the Angel II, in Hyde Park, is based on the biblical story of Jacob, who wrestles with unknown forces while seeking his identity.

Plaza Fountains

story of Jacob, who struggles courageously with unknown forces while seeking his identity. The bronze figure might be falling or rising, depending on one's interpretation of this enigmatic piece.

Paul Granlund, the artist and religious philosopher who sculpted the statue, had a fifty-year career creating more than 650 pieces of art, most of which can be found in his home state of Minnesota. His works include at least two other versions of Jacob and the Angel. This one was purchased from a gallery to replace a fountain by acclaimed South Sider Richard Hunt originally planned for this spot. Hunt's bronze and copper piece depicted a mythical phoenix rising from the flames of its funeral pyre.

Granlund's sculpture was funded by a group of local residents and installed in 1962. It is attractive, provocative, and well suited to the tranquil plaza. Yet, the statue's placement position on a metal post surrounded by a bulky black metal fence detracts from the work.

~~~~~~

The **Apple Store Fountain**, another waterworks that creates a relaxing spot in a commercial plaza, was built in 2010 between the North-Clybourn "L" Station and the Lincoln Park Apple Store. Local residents and commuters greatly appreciate this pleasant ground-level fountain because it helped turn a rough area—that included a bus turnaround—into an attractive, inviting place. Not only did Apple build the plaza, but it also spent $4 million renovating the nearby "L" station, one of Chicago's worst.

Designed by Delta Fountains and set in a tree-lined, chair-filled plaza, the understated Apple Fountain is about ten by thirty feet and features ten jets of water. *Tribune* columnist Mary Schmich suggested a way to show Apple the city's gratitude for transforming a pocket of blight into an urban showcase: sit next to this "instant supplier of peace" and read a book—on an iPad.

Another fascinating waterworks built on former CTA property is called **Freedom**. It's paired with a sculpture called *Fighter* in the tiny green space at Clark and Wisconsin streets that was used for a bus turnaround from 1967 to 1996. Chicago-based sculptor S. Thomas Scarff created both pieces. The catchy fountain is a large abstract metal sculpture that looks like a ship's rudder but is open to interpretation. Water trickles from it onto a concrete base and disappears into the surrounding red brick plaza without forming a pool. Nearby, trees and a brick wall create a nice sitting area. The Old Town Triangle Association made all this happen by buying the land, renovating it, purchasing Freedom, and opening the parklet in 2003.

Meanwhile, the Apple Store Fountain's success must have inspired the **New City Fountain**, built in 2015 half a block south on Halsted Street. Decorating the middle of the new retail and residential development's circular drive, this handsome fountain features about a dozen jets shooting strong but low streams of water up among several lavalike boulders.

In fact, several commercial developments and retail centers generate curb appeal with fountains. For example, the **Roosevelt Collection Fountain** on Roosevelt Road and Delano Court beckons shoppers, diners, and moviegoers into an attractive new retail district—a "New Deal" for the South Loop, as the *Tribune* put it. Resembling a babbling brook, the water flows over rocks and around flowers. Since it opened in 2012, the fountain has been a popular gathering place, as it is adjacent to a large sitting area, near a coffee shop, and colorfully lit at night. Across town, the traditional-looking **Clybourn and Diversey Avenues Fountain** began tossing water at the intersection of those two streets in 2015. This modest piece announces that the area, once gang infested, is now inviting.

~~~~~~

The **Piazza DiMaggio Fountain** does a great job of highlighting the statue of baseball legend Joe DiMaggio in the center of its plaza at 1430 West Taylor. Installed in 1998, the fountain is surrounded by trees and seating and includes six bubbling basins. Elaborately garnished railings, columns, dentils, and balustrades reflect the plaza's Tuscan architectural style.

Befitting its prime location in Little Italy, the Piazza DiMaggio Fountain incorporates several Tuscan architectural elements.

An Italian café would have been better than the Starbucks flanking Piazza DiMaggio on the west. Otherwise, the plaza is quaint and pleasant enough to make passersby linger—and perhaps to want to learn about Little Italy and DiMaggio.

Little Italy, once a port of entry for Italian Americans, still has an Italian flavor, particularly in its many restaurants. The neighborhood keeps getting smaller, however, because two campuses of the University of Illinois Chicago (UIC) continue to squeeze out remnants of the once thriving ethnic community. To an increasing number of people, the area is now "University Village."

As for Joe, many sports fans consider DiMaggio the greatest Italian American athlete. The legendary slugger belted 361 home runs. But he had a weak link to Chicago. Known as the "Yankee Clipper," DiMaggio was born and raised in San Francisco and played in New York City.

Would Mother Cabrini, an Italian who had a profound impact on Chicago, have been a better choice to honor in this prominent spot? George Randazzo, founder of the National Italian American Sports Hall of Fame across the street from the fountain, explained how the Yankee ended up here: "DiMaggio was America's first Italian American hero. No one in the United States had ever honored him with a memorial or park of this magnitude until we did."

The plaza and fountain are pleasant, but some locals opposed them. They worried about traffic flow and parking problems from turning Bishop Street into a cul-de-sac.

And they were upset about the city's hurry to build the plaza and a museum. "Why was there a rush?" editorialized the *Gazette*. "Unless, of course, it was to head off legitimate opposition and debate."

In any event, for anyone who wonders, "Where have you gone, Joe DiMaggio?" the answer is: to a plaza in Little Italy, where he's hitting one out of his own little park.

~~~~~~~

That's not a silo or water tower at Roosevelt Road and Halsted Street. It's a skyspace, a chamber for viewing the interplay of sky and light through an opening in the roof.

This one, simply called **Skyspace**, is one of Chicago's most aspiring pieces of public art. It aims to bring the sky into focus and change how we perceive the firmament. With curtains of water falling along its sides—and paired with a circular ground-level fountain—this ambitious work is one of the few skyspaces incorporating water.

Opened in 2006, Chicago's Skyspace is an elliptical glass and masonry structure, forty-three feet wide, with an opening suspended twenty-six feet in the air. Neon lights ring the outside of the structure, like a halo, and change color continuously after dark.

Skyspace acts as an aperture for looking up. It's like an observatory, albeit one without a telescope. Through it, one can better appreciate Chicago's sky without the horizon or buildings included, which heightens the sky's color and character. Meanwhile, the surrounding water curtains soften the sights and sounds of traffic, thereby intensifying the experience. The overall effect is most dramatic at dawn and dusk.

Perceptual artist James Turrell designed Skyspace, as well as the surrounding plaza and accompanying fountain that features a ring of lively water jets illuminated by submerged lights. He has installed skyspaces around the world but usually in churches, schools, and private residences. This one is the focal point of the UIC's Earl Neal Plaza, which was built as a gateway to the growing South Campus and named for an attorney who championed the university's development.

"We held an open competition and chose Turrell from thirty entries because his idea was to work with natural and artificial light to alter one's experience . . . personally and poetically . . . of being in a big city," said Judith Kirshner, dean of UIC's College of Architecture and the Arts and chair of the fountain's selection committee.

Such a challenge may be beyond most people rushing past this busy corner or waiting there for a bus. Also, it's tough to maintain Skyspace in this often litter-strewn open space. Still, to find a major work by a renowned artist in a public place outside the Loop is wonderful. "I love that it's open to the public," Kirshner said. "You don't have to go to a museum or pay to see it."

To help people better appreciate Skyspace, the university should install a display or panel explaining its meaning—how the edifice uses art and geometry, light and color, sound and space to frame a slice of heaven.

~~~~~~~

Better suited to its surroundings is **Nature's Friends**, one of Chicago's most charming fountains. It beautifies a placid plaza where busy Ogden Avenue once ran, back when it was a highway carrying heavy traffic through Lincoln Park, connecting Lake Shore Drive with Route 66 and other highways.

Between the 1960s and 1980s, the city removed a portion of Ogden Avenue as part of urban renewal. Demolition of the diagonal section between North and Armitage avenues in 1967 left behind cul-de-sacs and small open spaces, including one at Hudson Avenue and Menomonee Street—where Nature's Friends trickles away.

This sweet fountain portrays two smiling children spilling water from platters they hold. The overflow dribbles to their feet and through the pavement. Bronze birds are perched on the girl's shoulder, arms, and feet, while frogs adorn the boy. The birds represent "our ability to spread our wings and soar to new heights," while the frogs represent "many things in many cultures, from perseverance to prosperity," according to Gary Lee Price, who sculpted these life-size bronze figures.

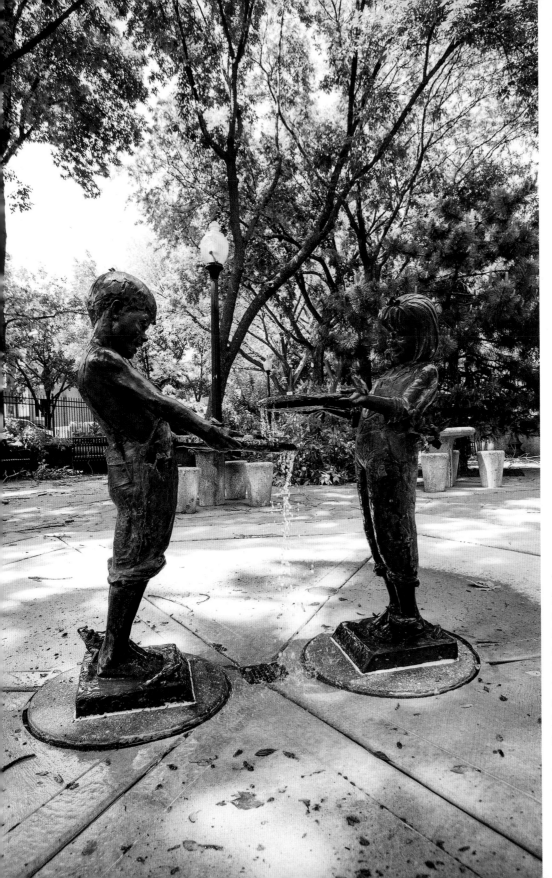

Thanks to the fund-raising and oversight of the nearby Lincoln Park Cooperative Nursery School, Nature's Friends trickles away in a quiet square. If children listen carefully to its soft, gonglike sounds, the melodies "will impart wisdom for a prosperous life," said designer Gary Lee Price.

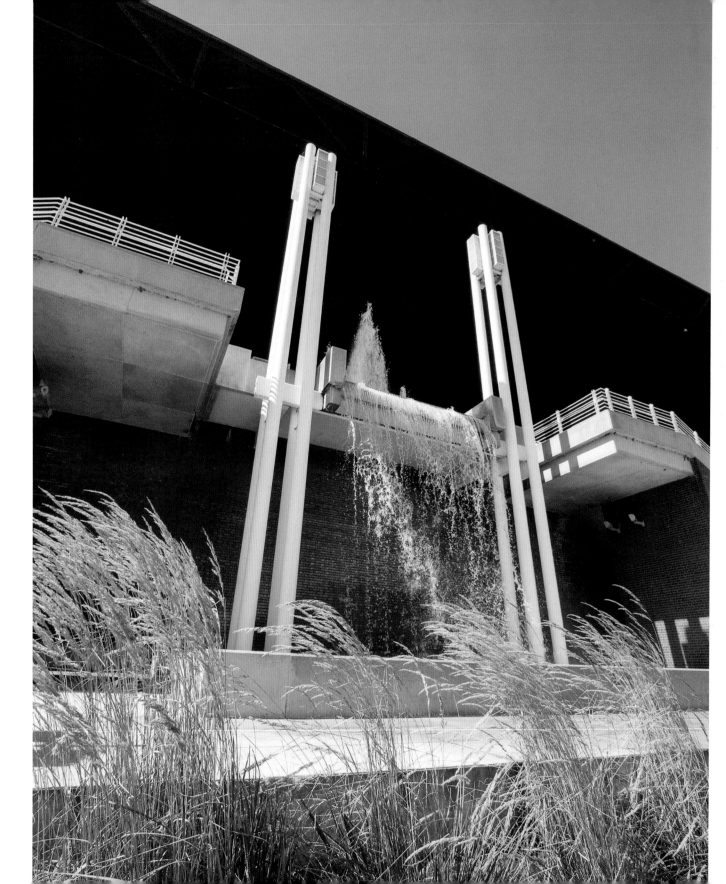

Nature's Friends makes soft, gonglike sounds, and if children listen carefully, the melodies "will impart wisdom for a long and prosperous life," Price said. Such sentiments are typical of Price, who advertises his work as "sculpture to inspire and . . . lift the human spirit." "I hope I can assist the world in visualizing a place . . . where bias and prejudice are long forgotten; where acts of kindness, mutual respect and love are everyday happenings."

The gentle nature of Nature's Friends belies the difficulty supporters had making this fountain happen. In 2000 a small granite waterworks that stood in the same spot sprang a leak and flooded the park. The following year the nearby Lincoln Park Cooperative Nursery School used the occasion of its fiftieth anniversary to raise $16,000 to purchase a new fountain.

The school planned to give this fountain to the city and pay for its installation as long as the city would repair the leak. Alas, this munificence was not well received. At the time, the city required such fountains to be original works of art, according to local alderman Vi Daley (no relation to Mayor Daley). But Nature's Friends was purchased through a catalog.

"When the city said 'no,' the school came to me for help," Daley said. "I intervened and had to plead the case all the way to Lois Weisberg," Chicago's longstanding commissioner of cultural affairs. "I said, 'Look, it's a *nursery* school. They raised the money *themselves*. And it's for *kids!*' Still, we had to battle for months before the city relented," Daley said, despite Chicago's legendary "aldermanic privilege," which usually grants aldermen what they want in their ward.

About sixty copies of Nature's Friends have been sold since it was introduced in 2000, making it Price Studio's best-selling fountain. Visit this park to see why.

On a completely different scale is the enormous **McCormick Square Fountain** at the west entrance of McCormick Place, 2301 South Martin Luther King Drive. This lively waterworks comprises one-quarter of a circle with a radius of almost 200 feet and includes steps with running water, high-powered jets, lights, and other dynamic features. The fountain typically operates only when the convention center hosts an event.

WET Design, known for showy Las Vegas–style fountains, designed this water wonder and installed it in the 1990s. The firm is also known for interactive fountains, but it got more than it bargained for here, according to scuttlebutt at McCormick Place. One day Maggie Daley, then the mayor's wife, got wet here while getting out of her car. Either the water pressure was too high or the wind too gusty. After that, the strongest jets were disabled for years, only to be restored for the 2012 NATO summit in Chicago. They are rarely operated anymore.

On the other side of the convention center, the attractive **McCormick Place Lakeside Center Terrace Fountain**, overlooking Lake Michigan, is more successful. Installed in the early 1990s at the edge of a large terrace two stories above the Lakefront Path, this tall, vigorous fountain reflects the values of the City of Broad Shoulders. Big and boisterous, it shoots water high into the air and lets it crash far below, on the ground. The falling water creates a refreshing mist, which cools hundreds of thousands of cyclists, joggers, and walkers who pass by on the Lakefront Path every season.

The tall, forceful Lakeside Center Terrace Fountain brings life to the black monolithic McCormick Place along the increasingly attractive southern portion of the Lakefront Path.

# 5. PARK AND PARKWAY FOUNTAINS

As its name suggests, **Gateway Plaza Fountain** is an impressive structure in an inspiring setting. It was inaugurated in 2000 on a commanding site near the corner of Peterson and Lincoln avenues in an extension of Legion Park. Previously, the dilapidated Riverside Motel, which had become a haven for prostitutes and drug dealers, occupied the spot. Local businesses and residents petitioned to have the forty-room motel torn down. Once it was gone, the park district converted the half-acre site into Gateway Plaza and built the fountain, which "ushered in a new era and symbolizes a brighter, more prosperous future for the community."

The fountain's large central bowl rests on a tall pedestal, and a jet shoots water high into the air. Three smaller bowls encircle the large one, and a shallow, forty-five-foot-diameter basin surrounds the ensemble, catching water from ten additional jets. The bowls and basin are made of concrete. Benches, planters, trees, and lighting fixtures enhance the stately setting.

Edward Windhorst is proud of the "vaguely Arts and Crafts" piece he designed, except for one aspect of it. The builders failed to line up the sections of the pedestal with the spouts of the large bowl. "When I pointed that out to them, they refused to fix it, saying the mayor was scheduled to cut the ribbon in a few days," Windhorst

The Gateway Plaza Fountain commands a prominent spot at Lincoln and Peterson avenues formerly occupied by the Riverside Motel, at one time a haven for prostitutes and drug dealers.

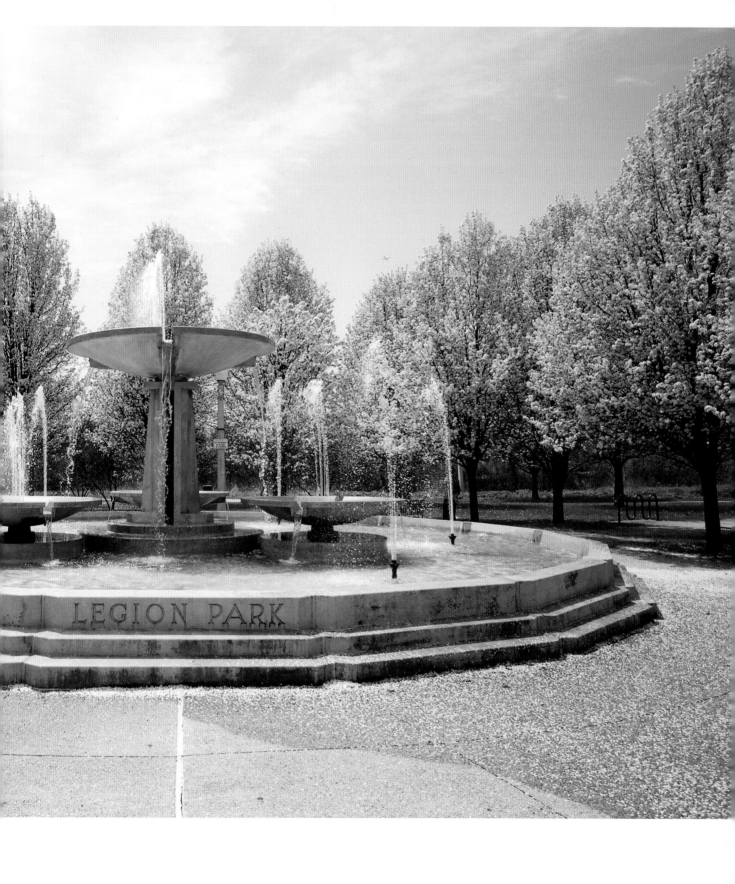

said. "The builder never got around to fixing it later, and I'm still annoyed about that."

The alignment is off by only six inches, not enough for most people to notice—nor to deter the large number of bridal parties who shoot wedding pictures there, especially when the nearby flowers and trees are in bloom.

Some consider the park and fountain, unveiled in 2000, a payback to long-standing alderman Patrick O'Connor for what the *Tribune* called his "virtual total obedience" to Mayor Daley. O'Connor served for twenty years as Daley's unofficial city council floor leader.

The **Seward Park Fountain**, at the corner of Division and Orleans streets, acts as another gateway. It serves as the eastern entrance to the neighborhood that once held the notorious Cabrini Green public housing projects. The projects are gone, replaced by townhouses, coffee

shops, and the landscaped park. Inaugurated in 2000, the fountain and a new clock tower heralded a fresh start for this area.

Originally, a fancy "wedding cake" design was proposed for this location. It was rejected in favor of a simpler plan consisting of the thirty-foot-diameter, seat-high concrete basin fed by eight water jets of varying heights. Although attractive, the fountain lacks details and appears to be oriented more toward vehicles than to pedestrians.

〜〜〜〜〜

The **Gold Star Families Memorial and Park Fountain**, one of Chicago's most unusual water features, honors Chicago police officers who died on the job. It features a concrete wall covered with sixteen large stainless steel

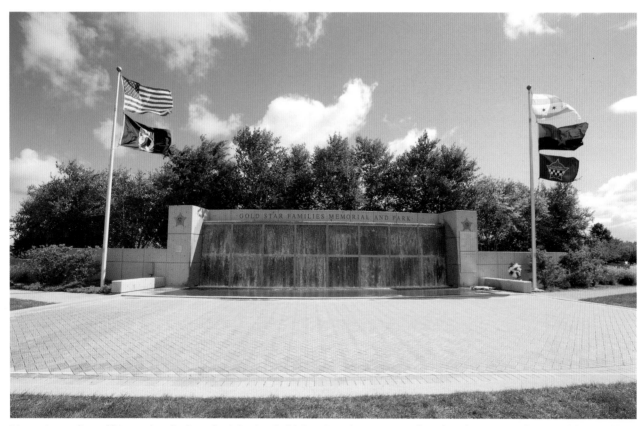

Honoring police officers who died on the job, the Gold Star Families Memorial and Park Fountain faces Soldier Field from its spacious site in Burnham Park.

screens arranged in an alternating pattern that resembles the checkerboard design on officers' hatbands. The water falls into a basin, from which lights shine on the screens, creating at night a dancing effect with the cascading water.

"Getting the screens just right was the biggest challenge," said Joe Petry, president of Delta Fountains, the builder. "The screens and stainless steel mesh had to be positioned just right so the water pouring down the wall behind the screens could be seen and heard with most dramatic effect."

East of Soldier Field on Museum Campus Drive, this striking fountain is visible and audible from afar. Its horizontal orientation and unique design make it refreshingly different from other fountains.

Inaugurated in 2006, the park and memorial include two towering pylons, a circular concrete wall inscribed with the names of the 570 (and counting) fallen police officers, and a bronze sculpture of an officer in a wheelchair. The fountain provides a gathering place for frequent vigils, parades, and services. "With many solemn events and features, we wanted to add a fountain so families and visitors could enjoy the space," said Philip Cline, executive director of the Chicago Police Memorial Foundation, which commissioned the park. "When we have an event, it's great to see kids playing in the water."

Water is appropriate for such a memorial "because it acts as a symbol of life and hope," said Petry, whose company was part of the team that created the enormous and moving fountain at the National September 11 Memorial in New York City.

Dozens of volunteers help keep the park and fountain in tip-top shape, and key to this effort is Jerry Migely. Years ago, Cline asked him to oversee maintenance. "He knew I love to garden, but ever since I took on this responsibility I've also become a plumber, electrician, computer programmer, and all-around handy guy," Migely said. He's spent a lot of time working on the control system in the eight-foot cube underground vault. Migely volunteers primarily because he was a Chicago police officer. "I knew some of the officers named on the memorial, and my dedication is to them," he said.

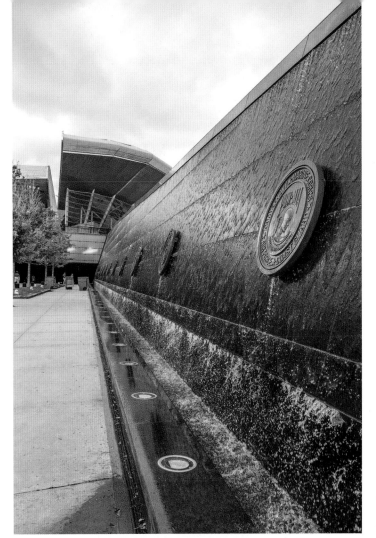

The Memorial Water Wall at the north entrance to Soldier Field features water flowing behind medallions of the armed forces.

A block northwest of the Gold Star Fountain, the **Memorial Water Wall** bedecks the north entrance to Soldier Field. Installed in 2003, this waterworks is composed of an elegant 280-foot-long wall of polished green granite posted with gilt bronze medallions of the Army, Navy, Marine Corps, Air Force, Coast Guard, National Guard, Reserves, Merchant Marines, and POW/MIA. A continuous veil of water flows gently down the wall, around and behind the three-foot-diameter medallions. Jeffrey Varilla and Anna Koh Varilla sculpted the medallions as well as the nearby Tribute to Freedom monument. "Originally,

the sculpture was designed to stand in the middle of the Water Wall, but the park district said it would be too heavy there, over the underground parking garage," Anna Koh said. "More people see it where it is now, so we're pleased with the final results."

~~~~~~~~~

Another block or so north is **Man with Fish,** one of Chicago's most playful fountains. In 2001 the John G. Shedd Aquarium surprised Chicago by unveiling this colorful figure of a sixteen-foot-tall man hugging an even bigger fish. Given the aquarium's Beaux-Arts design, one might have expected a traditional fountain with cavorting dolphins, but the aquarium knew Man with Fish would make a big splash.

The painted bronze sculpture stands south of the aquarium's main entrance. Water spouts out of the fish's mouth, pouring over the fish and the man into a thirty-five-foot-diameter, dome-shaped pool exquisitely inlaid with mosaics depicting aquatic creatures. Stephan Balkenhol, a German artist known for expressionless,

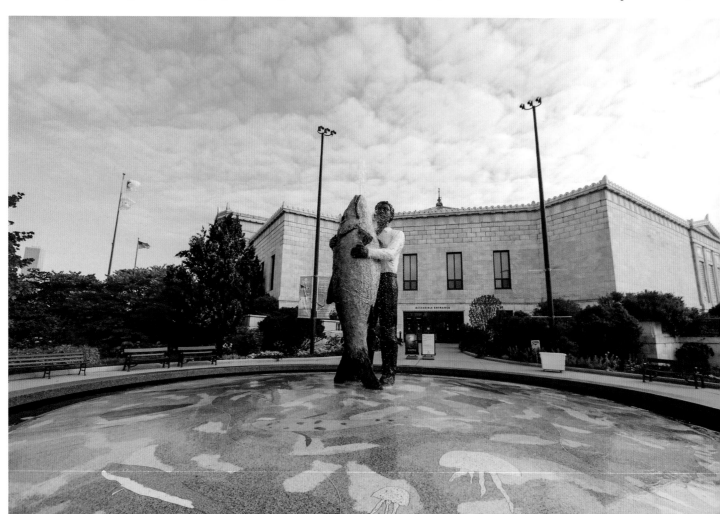

One of Chicago's most playful fountains, Man with Fish makes a big splash in front of the Shedd Aquarium. Water spewing from the fish's mouth sprays the man and the fish, both designed to be nondescript.

caricature-like sculptures with a humorous tone, created Man with Fish. He wanted to challenge the viewer to interpret his whimsical work. "By omitting gestures, specific clothing, and hairstyles, the figure becomes an 'everyday man' and can appeal to anyone," he said at the unveiling.

Shedd trustee William Sick donated the fountain in honor of his wife, Stephanie. Over time, it has become one of Chicago's favorite pieces of outdoor art and a popular stop on tours, where guides assure their guests that Man with Fish is "quite a catch."

True, people have compared the fountain to a tacky roadside attraction. CBS Channel 2 called it "bizarre." And one blogger mocked, "The sculpture raises such deep philosophical questions as: Is it possible for a man to hold a fish his size?" Still, the aquarium got what it was looking for with this fish out of water. These "figures are going to grab people's attention and maybe give them something to think about," said Ted Beattie, president of the Shedd. The fountain is not only fun, he added. It also speaks to humankind's stewardship of the aquatic world.

~~~~~~~~

Some park fountains, such as the **Fountains at the Park at Lakeshore East,** originated as part of a residential development. Installed in 2005, two series of five large interconnected pools enhance this beautifully landscaped, six-acre park in the center of several new high-rises.

Magellan Development Group, which developed the area, says the fountains are "the crescendo of the park." It spent $1.5 million building them and then donated them, along with the park, to the city. It's unlikely the city would have invested that much in such an amenity, but the investment paid off for the developer, said Ernest Wong, principal at site design group, ltd., which designed the park and fountains. "Many people moved to Lakeshore East, even from neighboring lakefront buildings. Apparently, access to this park and its fountains trumps lake views!"

The fountains' basins are wide and flat and seem to hug the big park, like two protective arms. Their multiple

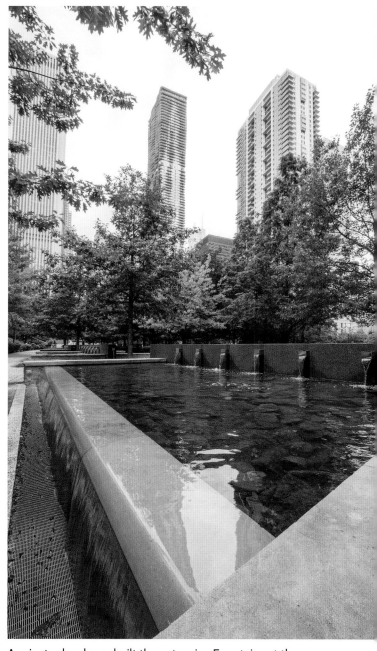

A private developer built the extensive Fountains at the Park at Lakeshore East and turned them over to the city in 2005. The architecture and design firm called site design group, ltd., designed the fountains, which are credited with a big part of the development's success.

waterspouts generate large volumes of gently cascading water. And the fountain incorporates many innovative features. For example, broken basalt stones fill the bottoms of the basins, "giving them texture and creating interest, even in the winter, when the basins have no water," Wong said. At the end of the basins, hidden inlets covered with decomposed granite make it appear as if the flowing water simply disappears into the ground. And the fountains have running water that kids can touch, "making it less likely they will jump into the basins," Wong explained.

~~~~~~~~~

Another new park by site design group, ltd., helped improve an entirely different setting: a rundown neighborhood on the South Side. Installed in 2001, the inspiring **Black History Fountain** is the centerpiece of Renaissance Park at 1300 West 79th Street. "Can you believe it? Something this beautiful on 79th Street?" asked Father Michael Pfleger, pastor of nearby St. Sabina Church, as he watched workers constructing it.

The fountain features a pile of eleven large black granite spheres, each inscribed with the name of an African American who contributed greatly to music, literature, sports, or social change. From this stack of polished balls, water flows to the ground, trickles through a series of narrow but long interwoven channels to a tall black granite plinth, where it mingles with falling water. The interplay of the water symbolizes how love and positive energy flow from these leaders into the community.

"The balls are like a natural spring, and the names on them represent all great African Americans, not just those named," said the designer Jerzy Kenar. "Kids can read

Black History Fountain in Renaissance Park at 79th and Throop streets helped turn around a troubled neighborhood. Designed by Jerzy Kenar, the tripartite fountain celebrates eleven accomplished African Americans (including Mahalia Jackson), naming each one on a large granite sphere.

Park and Parkway Fountains

these names, climb on the balls, walk over the flowing water, and become inspired. It's alive. You can touch and feel the water and the energy."

The name Renaissance Park refers to the rebirth of the neighborhood, once plagued with drug-related violence. Where vacant lots and crime used to rule, the park, an entertainment center, and stores now flourish. The park has become a community gathering place for festivals, block parties, and rallies. At one event, attendees could register to vote; at another, they could turn in a gun for $100 or a pair of gym shoes.

Renaissance Park and the Black History Fountain were developed primarily due to the efforts of St. Sabina Church and community-minded Father Pfleger. As the park was being developed, the church opened St. Sabina Elders Village, an eighty-bed senior building that opens onto the park. Its residents keep an eye on the park and its waterworks. "The fountain is a symbol of a beginning of a turnaround for this community," Pfleger said. "Has it worked? Absolutely. Crime has dropped by 85 percent, and the fountain is a visible sign of everything we're accomplishing here."

Kenar also designed the Shit Fountain, but his major works locally include the Millennium Doors at Holy Trinity Church; the holy water font at Loyola University's Madonna Della Strada Chapel; and the statues, seats, front door, and hand-carved wood altar at St. Benedict the African Church. In addition, Kenar created a number of pieces for O'Hare Airport and another on display at the Harold Washington Library Center.

For the record, the eleven African Americans whom the local community chose to name on the fountain's spheres are Mohammad Ali, Maya Angelou, Gwendolyn Brooks, Jean Baptiste Point DuSable, Ella Fitzgerald, Langston Hughes, Mahalia Jackson, Mae Jemison, Martin Luther King Jr., Harold Washington, and Muddy Waters.

～～～～～～

Also on the South Side, two fountains trickle away in Nichols Park. **Spinning Water Fountain** on 55th Street

Spinning Water Fountain in Nichols Park resulted from a 1964 contest open to Art Institute students to design a work of art for the Hyde Park–Kenwood community.

near Kimbark Avenue doesn't spin but is imaginative. The gangling sculpture stands in a shallow, crescent-shaped pool and consists of a tall copper tube topped with a gaggle of more than two dozen copper arms that spray water.

It's art, but it's not for everyone. One critic called it something left over from the "welding shop of disgruntled Streets and Sanitation workers." Ouch! But he might have been referring to the fountain when it was idle. It looks

much better, quite interesting, in fact, when the water is spraying. Unfortunately, the fountain has functioned only intermittently over the years.

In 1964 the Hyde Park–Kenwood Community Conference's park sculpture committee invited Art Institute students to submit artwork "the community served by a park can afford, will enjoy, and will be sufficiently proud of to protect and maintain." Three models were selected for the $200 ($1,500 today) prize from more than fifty submissions. Gary Wojcik's Spinning Water Fountain won, and his piece was built and installed in 1968. He's still an artist and specializes in custom metal work but has never designed another fountain.

Although the park sculpture committee had requested a piece that would be beautiful in winter and summer, the park district put the top of the fountain away for its first winter. According to a board member of the Hyde Park Historical Society, the fountain was not reinstalled for years. In 1990, it went missing again. Twelve years later, it was discovered in a park district storage area under the stands at Soldier Field. Stephanie Franklin, president of the Nichols Park Advisory Council, believes a three-foot-long vertical section that would raise the fountain higher is still missing. And ceramic tile plaques on the base memorializing five Hyde Parkers were in disrepair for years. The plaques were refurbished in 2014.

At the other end of the park, the **Nichols Park Fountain** is pleasant but not exceptional. Tucked away at 1330 East 53rd Street, the concrete fountain has a small jet that bubbles quietly in the middle of a low ten-foot-diameter basin. Formally arranged planting beds and rose gardens surround the fountain. The Hyde Park–Kenwood Community Conference and Nichols Park Advisory Council have been maintaining these gardens since they were installed, along with the fountain, in 1992.

About half a mile east of this fountain you can find **Ecstasy**, that is, an obelisk-like sculpture protruding from the 1928 Model Yacht Basin of the Harold Washington Playlot Park at 51st Street and Lake Shore Drive. Hyde Park resident Virginio Ferrari created the bronze

The Hyde Park–Kenwood Community Conference and Nichols Park Advisory Council maintain the gardens around the Nichols Park Fountain on 53rd Street.

Park and Parkway Fountains

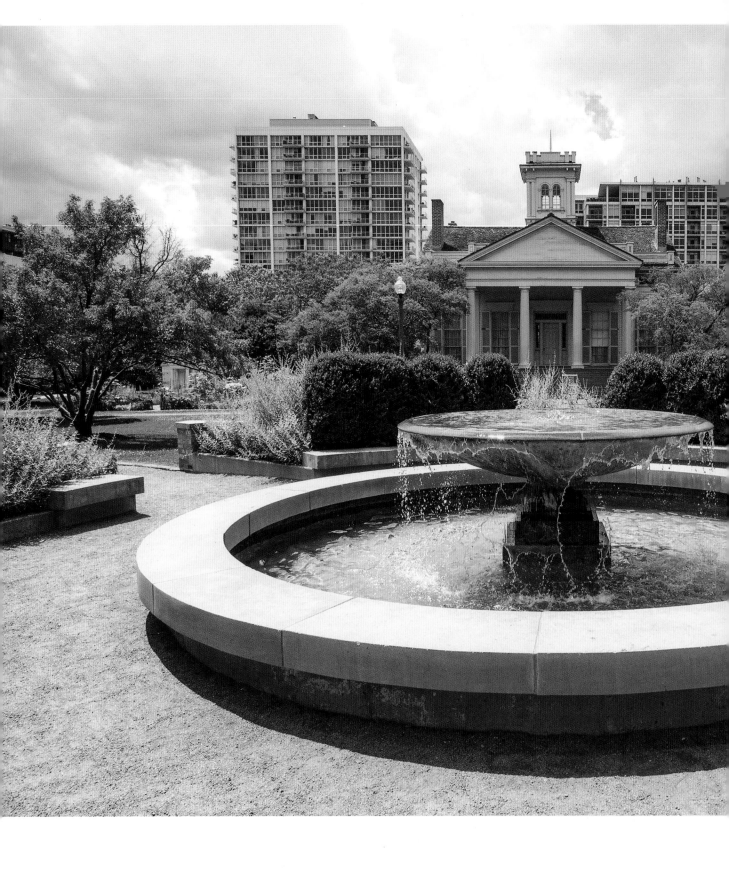

sculpture at Midway Studios in 1974 while teaching at the University of Chicago. Two years later, the sculpture was installed at the main entrance of Ravinia Park, the outdoor music festival in Highland Park, Illinois, where it stood until 1998.

In 2007 Ecstasy was installed in its current location along Lake Shore Drive as part of a revitalization of the park and basin, both of which were languishing. Surrounded by a dozen or so vigorous water jets, Ecstasy made a handsome fountain and was readily visible from Lake Shore Drive. Today the jets no longer seem to operate, the sculpture is hardly noticeable, and the basin is, once again, run down.

~~~~~~~

The lovely **Botanical Gardens Fountain** embellishes the center of the captivating Chicago Women's Park and Gardens at 1830 South Indiana Avenue in the Prairie Avenue Historic District. Fabricated by Robinson Iron and installed in 1999, the fountain features a wide shallow bowl that trickles water into an eighteen-foot-diameter basin near ground level.

The iron bowl lined with copper was originally designed to be all copper. That would have prevented the rust and deterioration that has developed. Still, the fountain's gentle splashing contributes fittingly to the serenity of this park, with its lush lawns linked by curving paths that lead to inviting nooks. Community and themed nineteenth-century gardens that provide vegetables, herbs, dyes, and medicines dot the park, which is surrounded by a few elegant old mansions, including the Glessner and Clarke houses.

The park and fountain's grace belies the fact that this idyllic setting was once mired in controversy. With much fanfare, the Department of Cultural Affairs in 1997 dedicated a new park on what was then a rundown four-acre

Since 1999 the Botanical Gardens Fountain has enhanced the lovely grounds at the Clarke House, which dates back to 1836.

patch of history littered with fragments of old buildings, which made the site look like a cemetery. The city dubbed the new park the Hillary Rodham Clinton Women's Park and Gardens. First Lady Clinton, with presidential aspirations and ties to Chicago, spoke at the festive dedication. To represent her continued presence in the park, she donated tulip bulbs of a variety that was named for her. At one time the park's fountain was to be inscribed with a quote from her.

But this happy scenario evaporated within three years as Clinton was stripped of the honor and the park was renamed Chicago Women's Park and Gardens. Perhaps this happened because of the Monica Lewinsky scandal, Hillary's diminishing presidential prospects, or her decision to move to New York City after leaving the White House. For its part, the park district attributed the name change, after the fact, to a policy that prohibits naming a park after a living person.

In any event, the debacle was an inauspicious way to launch a new park intended to celebrate the overlooked role of women in building and enriching Chicago. Plans called for the placement of four hundred brass plaques dedicated to influential women, and the park was supposed to help convert the surrounding area into a cultural and business haven for women. Barbara Lynne, president of the Near South Planning Board, predicted it would be "a catalyst for encouraging other women to come here and do creative things."

Although the plaques were never installed and only a few women-owned businesses set up shop nearby, the charming park shows a feminine touch, especially with the temperate fountain area by Tannys Langdon and the measured landscaping by Mimi McKay.

At one point, the park was home to a dainty **Fish Fountain** with a fish rising from its elevated bowl, and frogs and turtles ringing its lower basin. This fountain featured nineteenth-century designs based on molds and pattern books from that period. But in 2011 the park district removed it to make room for Helping Hands, a sculpture paying tribute to reformer Jane Addams. Helping Hands is true to the park's female orientation, but there was plenty of room in the park for both pieces of art. The fate of the Fish Fountain remains unknown; it's the one that got away!

~~~~~~~~

The **Douglas Park Water Court at Garden Hall** was in a beautiful prairie-style setting dating back to the early 1900s. Likewise, Garfield Park used to have formal gardens with a bandstand, pergolas, and two large rectangular **Garfield Park Fountain Pools**. People would gather around these gardens and water courts to watch the colors of the rainbow reflected in the misty spray. Only vestiges of these structures remain.

Today, the area has a couple of fountains. Built in 1998, the attractive **Garfield Park Conservatory Fountain** welcomes visitors to the 1908 conservatory at 300 North Central Park Avenue. This rustic rectangular concrete-and-stone structure seems to invite visitors to sit along its edge and listen to its gurgling water. The conservatory houses the **Moroccan American Friendship Fountain**, one of Chicago's most remarkable waterworks.

In May 2001 students from Chicago's Abraham Lincoln Elementary School went on an exchange trip to Groupe Scolaire Le Cedre, a private school in Casablanca, Morocco. A few months later, on September 11, terrorists attacked the United States. Although the schools' exchange program was put on hiatus, the teachers believed the need for better understanding between Americans and Muslims was greater than ever. To help bridge the gulf between the two cultures, Abdelkamel Lahlou, head of Groupe Scolaire Le Cedre, decided to give Chicago two decorative fountains made in Morocco's celebrated zellij tradition.

Zellij has been used to adorn palaces, mosques, and fountains throughout the Islamic world for more than a thousand years. Using this mosaic technique, craftsmen hand cut and arrange small, glazed terra cotta tiles into a kaleidoscope of colors and patterns. They meticulously place the tiles face down on a slab covered with petroleum jelly. This holds the tiles in place until concrete is

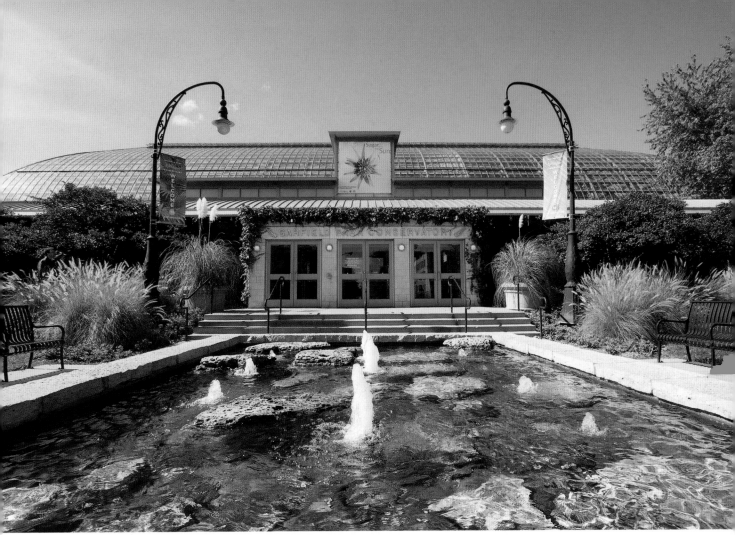

The rustic Garfield Park Conservatory Fountain welcomes visitors to the outstanding 1908 conservatory.

layered over them. After the concrete dries, the mosaics are flipped—and voila!

When zellij master Said Ben Adiba and artisans Hassan Jemghili and Jawad Rizki traveled to Chicago to build the friendship fountains, the United States was at war in the Middle East, so the artists' tools and tiles were confiscated at the airport. "It took intervention from Mayor Daley, Senator Durbin, and Chicago Sister Cities International to kick things loose," said Andrew Tinich, Lincoln Elementary's principal. "We really had to flex some muscle."

Once they got their tools back, the artists set to work building the fountain at the conservatory (as well as the second one at Lincoln Elementary). The conservatory

was selected because "this West Side gem was undergoing a major renovation," said Lisa Roberts, conservatory director. "In addition, the popular 'Chihuly in the Park' exhibit had just closed. That put the conservatory on the map but made people ask, 'What's next?'"

It took more than a month to build the eleven-foot-tall-by-eight-foot-wide fountain in the conservatory, during which time the artists welcomed park visitors to watch them work. "They became an exhibit unto themselves," Roberts said. "They spoke only French and Arabic, so communication was tricky."

"It was fascinating to watch the artists chipping away and laying the tiles backwards, in reverse," Tinich said,

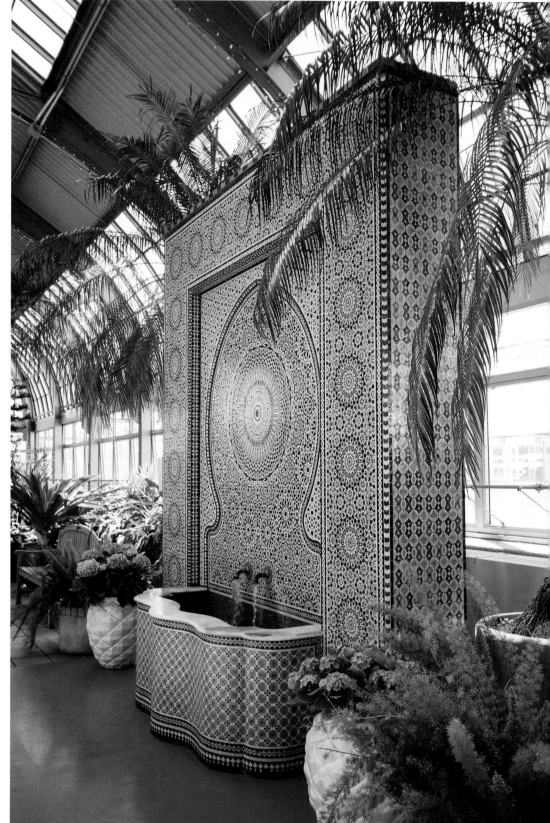

The Moroccan American Friendship Fountain at the Garfield Park Conservatory features the zellij mosaic technique. Craftsmen built the fountain on-site in 2003. *Sun-Times* columnist Irv Kupcinet called it "a dazzling and breathtaking addition to Chicago."

adding that there was no evidence of enmity during this project.

The artists completed their work in 2003, but the dedication of the conservatory fountain waited until 2004 so students from Casablanca could attend. Additional student exchanges have occurred since then, so the goodwill created by the fountains continues to flow, Lahlou said. He declined to reveal the cost of his gift, saying, "Art has no price. For me, the gift has more spiritual and intellectual value."

The Chicago-Casablanca Sister City Committee contributed greatly to the project, connecting people and covering costs.

The striking Moroccan American Friendship Fountain, with its floral motif and thousands of tiles of thirty different colors, has been a boon to the conservatory. It attracts visitors and has become a popular site for weddings and photos because, Roberts said, "the fountain makes for a natural 'altar' and faces a beautiful outdoor garden."

Adiba hoped his creation would symbolically connect Chicagoans with Arabs through the water running in their respective fountains.

Some fountains are out of the way, even hard to find. The two **North Center Senior Campus Fountains** are tucked away in the block northwest of Irving Park Road and Western Avenue, where Martha Washington Hospital once stood. When the hospital closed in 1991, the five-acre site was abandoned. Eventually, the property was developed with medical offices, a community center, and three senior residences. Completed in 2008, this senior campus won one of four nationwide "Livable Community Awards" from the American Association of Retired Persons (now AARP, Inc.), which cited the community programming, the green spaces, and, of course, the fountains.

The development's two rather generic fountains consist of three concrete bowls with water dripping from one to the next, ultimately flowing into a round shallow basin at ground level. Photographer Julia Thiel nicknamed these "Big Martha" and "Little Martha" in recognition of the former hospital. Little Martha is the centerpiece of a neat fenced-in corner park at the back of the property that includes architectural remnants of the hospital.

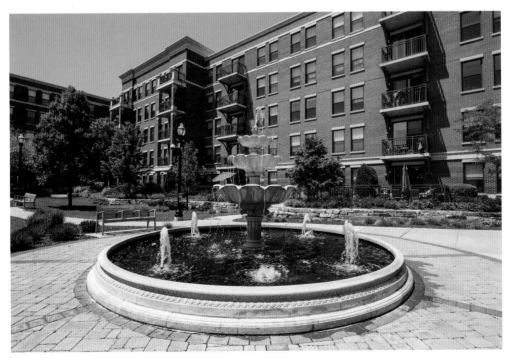

Two North Center Senior Campus Fountains beautify an award-winning senior housing complex where Martha Washington Hospital once stood. This, the larger fountain, sits outside the community center.

Big Martha has several water jets visible from the senior center's community room, offering lovely views. A visit to the campus on a hot day found a young man pushing an elderly relative in a wheelchair around the large water tosser to catch its refreshing spray. What a wonderful amenity!

Other relatively plain fountains are scattered around Chicago, many of them far from downtown. They include the **Damen Avenue Fountain**, at 819 South Damen Avenue, and the **East Side Pocket Park Fountain**, at 10051 South Ewing Avenue. Little is known about these waterworks, but the Chicago Department of Transportation maintains them because they're in or next to city streets. The stone, twenty-five-foot-diameter East Side Fountain has several jets and a patch of grass nearby. Incongruously, the massive Chicago Skyway looms overhead, while the fountain sits in the line of fire of an ominous U.S. Army tank the American Legion installed across Indianapolis Avenue in 1979 to honor veterans of the 10th Ward.

The **Auburn Park Lagoon Fountain**, at 406 West Winneconna Parkway, is even farther off the beaten path. It shoots water into the air from a languid lagoon, a remnant of marshes and wetlands that once dominated the area. A highlight of the Auburn Gresham community, this green spot, with its aerating spray, offers fishing and picnicking.

~~~~~~~~~~

The delicate, delightful **Dogwood Fountain** in the Blossom and Irving Levin Garden is also off the beaten path, but it's worth a visit. This small gem sits behind the Peggy Notebaert Nature Museum in Lincoln Park.

Omri Amrany designed the fountain in 2002 after winning a competition sponsored by the museum. Surprisingly, he's famous not for fountains but rather for statues of leading sports figures, including the one of Michael Jordan at the United Center.

Benefactor Blossom Levin wanted a fountain that incorporated blossoming dogwood flowers. Amrany used fractal art (a computer-based tool that creates similar but distinctive shapes, patterns, and colors) to design

Parts of the Dogwood Fountain behind the Peggy Notebaert Nature Museum were inspired by kids' art.

the flowers and branches, creating what he called "a galloping effect."

To create the fountain's small figures that squirt water, Amrany suggested incorporating kids' art. "We let the Levins' grandchildren draw creatures and invent animals, and that worked out well," he said. "The fanciful creations are the product of their imagination."

Unfortunately, the Notebaert does not mention its charming fountain on its website or include it on its

maps. Were it not for the attentive Roxanne Bertrand, who spotted this gem while working at the Lincoln Park Conservancy, the secluded Dogwood Fountain would not have been included in this book.

Another fountain on park district land near a museum is much easier to spot than this one—but its name is harder to remember. **In Celebration of the 200th Anniversary of the Founding of the Republic**, also known as the **Noguchi Fountain,** holds a prominent spot at 130 South Columbus Drive outside the Art Institute's east wing.

The short name refers to Isamu Noguchi, the Japanese American modernist who designed the fountain. Best known for monumental public sculpture, Noguchi built several waterworks, this one near the end of his career. He liked to incorporate natural elements and themes in his work and bring nature into cities.

The fountain's long, odd name refers to the occasion that the trustees of the Ferguson Monument Fund used to warrant funding it. The fund's rules require a monument "to commemorate worthy men or women of America, or important events in American History." It is telling, however, that rather than being unveiled July 4, 1976, in recognition of its name, the fountain was unveiled November 30, 1976, to coincide with the opening of the Art Institute's new wing. Perhaps a more accurate name for the $250,000 ($1.1 million today) fountain would have been "In Celebration of the Construction of the Art Institute's East Wing."

This is not to take away from the beautiful artwork, which is composed of two forty-foot-long pieces of rainbow granite Noguchi selected in Minnesota and positioned in a lighted reflecting pool, designed by Walter Netsch. The vertical slab represents a tree, with water rising up the column (similar to capillary action), then flowing down the front, rippling over grooves. The horizontal split cylinder stretches out close to the ground, with water flowing over each half. When the fountain was unveiled, it included thermo-controls for year-round operation, but this feature has fallen by the wayside.

Stainless steel elements hold the stone pieces in place, creating an interesting juxtaposition between the three-billion-year-old stone and the shiny new metal. The mirrorlike windows of the adjacent building enhance this effect. Much is made of the age of the granite, but the $H_2O$ flowing over it is even older, dating back to the origins of the universe.

Also intriguing is the way the flowing water colorizes and enriches the granite. Unfortunately, this effect can be hard to catch because the fountain is frequently not operational. In 2010 Jyoti Srivastava, who runs the excellent, photo-rich *Public Art in Chicago* blog, called this rarely functioning waterworks "an almost forgotten fountain." And in 2011 the blog *Architecture Chicago Plus* said it had "fallen into a state of neglect."

~~~~~~~

The **Olive Park Fountain**, one of Chicago's most ambitious set of waterworks, is not only neglected but appears abandoned. It's virtually unnoticeable at 600 East Ohio Street, on the southwest side of the manmade peninsula that houses the Jardine Water Filtration Plant. The plant was constructed in the 1960s and provides water to city residents.

In 1965 architect Dan Kiley designed Olive Park, including its fountain, which is composed of five large, circular, aerating basins from 75 feet to 145 feet in diameter. Diagonal walkways connect the stepped basins, each one of which was built at a slightly different elevation.

When the park opened, its $170,000 ($1.3 million today) fountain created quite a hubbub. Its jets were capable of shooting water one hundred feet high. It was illuminated for synchronized, multicolored water shows visible from Lake Shore Drive. And it was designed to run all year—operating in the winter with steam rather than water.

Kiley intended the five basins to represent the Great Lakes, but others have likened them to pools outside the palace of Versailles and stones in a Japanese garden. Today, the only image that comes to mind for these abandoned basins is lunar craters.

Virtually surrounded by water, the serene Olive Park offers great views of the city and lake. A wide canopied allée of honey locust trees lines the entrance. The picturesque park is named for Milton Lee Olive, the first African American to receive the Medal of Honor from the Vietnam War.

It's unlikely the Olive Park Fountain will ever operate again because the original plumbing would have to be replaced. Although the fountain needs an overhaul, it does not need what architects proposed for it in 2013. "Wheels of Chicago" would have built a large metal wheel above each basin the same diameter as its respective basin. Although inspired by the nearby Ferris Wheel on Navy Pier, the wheels would have been stationary, intricately patterned works of art.

~~~~~~

While some fountains are abandoned, others vanish. When the **Connors Park Fountain** was removed in 2012, some say the park itself disappeared. A small triangle of land at Wabash Avenue and Chestnut Street, Connors Park occupies one of the oldest green spaces in the city, dating to 1848. Renovations in 1999 added a sitting-level concrete fountain twenty feet in diameter with dozens of jets that created small arcs of water in the basin. A nearby pergola rounded out this serene setting.

Despite being in the Gold Coast and across the street from a five-star hotel, this park had problems with vagrants and vandals, as well as a poor maintenance record, according to local alderman Brendan Reilly. In 2011 he announced Argo Tea would be granted a fifteen-year concession in exchange for new landscaping and a promise to maintain the park and its perimeter.

The following year the city removed the fountain, and Argo built a relatively large store in the middle of the tiny

In Celebration of the 200th Anniversary of the Founding of the Republic, also known as the Noguchi Fountain, contrasts steel and stone, water and glass. The fountain comprises two forty-foot-long pieces of rainbow granite.

park, spreading tables and umbrellas around the exterior. This seating is available to the public, whether or not they buy anything at Argo, but some parkgoers who buy nothing don't feel welcome. Others object that the overbearing structure dominates the park and that the space has been turned over to private enterprise, as expressed in such headlines as "The Tea House That Ate Connors Park." One blogger said, "Connors has gone from being a welcome oasis of greenery in a densely built area to a chain teahouse with a pinched slice of park attached to it."

Ironically, inside the store on the spot where the outdoor fountain used to run, Argo installed a cylindrical stone fountain about four feet tall, covered with a sheen of flowing water and encircled by a bench. The discrete fountain does not come close to replacing the earlier one, even if that was the store's intent.

~~~~~~

The park district can also make a fountain reappear, as it did with the **Fuller Park Fountain**. This lovely, understated piece is a replica of one designed in 1912 by Edward Bennett as the centerpiece of a courtyard in Fuller Park, at 331 West 45th Street.

The courtyard, with its distinctive diagonal sidewalks, is the hub of a set of buildings that make up a field house. In the mid-1940s, the original terra cotta and concrete fountain was removed, and the courtyard was paved with asphalt. It remained a "foreboding paved space for more than forty years," according to the park district, which made amends in 1993 by renovating the courtyard and installing a new concrete fountain similar to the original one. This classically styled structure reflects the style of Bennett's adjacent field house. It consists of a bubbler on top of a small bowl from which water overflows into a larger bowl about twenty feet in diameter. A bust of Melville Fuller, U.S. chief justice from 1888 to 1910, overlooks the gurgling fountain and inviting courtyard from an elegant alcove in the field house.

~~~~~~

The Fuller Park Fountain creates a steady pleasant sound and contributes to the historic courtyard's handsome visual symmetry.

The conservation-oriented Stearns Quarry Fountain in Palmisano Park "handles water as a closed, continuous loop, just like in nature," said Hana Ishikawa, the principal at site design group, ltd., who designed it.

**Stearns Quarry Fountain** is as creative and curious as the historic site it garnishes. The unorthodox piece was designed to resemble the gangling cranes that once excavated limestone from this quarry at 27th and Halsted streets. And the fountain is in Palmisano Park, a site that for years was a troubled municipal dump and became mired in the Hired Truck Program scandal.

The Stearns Quarry, Chicago's first, opened in the 1830s and provided limestone for many of Chicago's earliest buildings. After its output declined, the site was closed in 1969 and converted to a landfill. Most of the quarry was filled in, and a mound rose thirty-five feet above ground level. Over the years, the landfill ran into trouble with environmentalists and regulators for containing toxic waste.

In 2004 the *Sun-Times* exposed a scandal at the city's $40-million-a-year Hired Truck Program that involved hiring private trucks to do city work at inflated prices. Many of the trucks sat idle while on the clock, and some of the trucking companies profited through political connections. Some of these trucks dumped loads in the Stearns Quarry landfill, which was later turned into Palmisano Park. The scandal was so linked to this site that in 2008 *Tribune* columnist John Kass dubbed the nascent Palmisano Park "Hired Truck Park." "Hundreds of millions of dollars . . . were made dumping expensive construction loads at little, if any, cost," he wrote. "Daley's Bridgeport buddies made fortunes there, and now it's being covered up" (literally).

By the time the park opened in 2009, its cost had climbed to $10 million, partly from the need for environmental remediation and partly for extras, including maintaining exposed fossil beds, providing a sledding hill and a fishing pond, highlighting city vistas—and installing a fountain.

Anchoring the park's northeast corner, the fountain features a large cylindrical mass of metal dangling ten feet above the ground. "The head's horizontal ribbing is reminiscent of the stratification of the limestone once quarried here," said Hana Ishikawa, the principal at site design group, ltd., who did the design work.

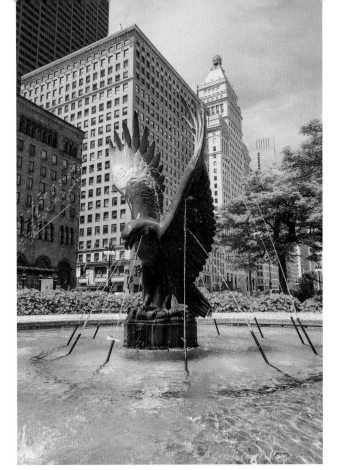

Two Eagle Fountains stand at Michigan Avenue and Congress Parkway, where they once seemed to guard an entrance to the Century of Progress. One is a golden eagle, the other a bald eagle.

Water drips from the head (like rain) into a narrow spiraling concrete channel that carries it to the park's wetlands and underground receptacles. From there, the water flows to the fishing pond and is eventually recirculated through the fountain. "Water is handled in a closed loop, just like in nature," Ishikawa explained.

~~~~~~~~~~

Grant Park has more fountains than any other Chicago park. In addition to those previously mentioned, several lesser-known waterworks dot the park.

Two **Eagle Fountains** guard the entrance to Grant Park at Congress Parkway. Each twenty-foot-diameter basin at

ground level holds a large bronze eagle, clutching a fish in its talons, poised for flight. Like the lions in front of the Art Institute, the two eagles are not identical. The northern one is a golden eagle, and the southern one is a bald eagle, and they display subtle differences.

Frederick Hibbard sculpted the eagles in 1931 in time for them to frame a stairway that was part of a grand entrance to the Century of Progress. (Congress Parkway now runs through the space the stairway once occupied.) Hibbard's stylized eagles reflect the fair's art deco style. Initially, several bronze fish circled the eagles and sprayed water toward them in arched streams. Regrettably, the fish were stolen in the 1960s and have been replaced with small inelegant pipes.

Until the creation of Millennium Park, three matching urnlike fountains lined the east side of Michigan Avenue at Washington, Madison, and 8th streets. Only the **8th Street Fountain** remains. Picking up where Daniel Burnham left off with Grant Park, Edward Bennett designed this fountain, which began flowing in 1927. The classically inspired piece consists of a high ten-foot-diameter bowl in the middle of a thirty-foot-wide basin. Water shoots up from a central jet and vigorously overflows the large bowl. The fountain is made of concrete tinged with pink granite aggregate, giving it a lovely russet color that's enhanced by the surrounding green trees and white concrete columns and balustrade.

Nearby, four fountains embellish the flower gardens surrounding Buckingham Fountain: **Turtle Boy**, **Crane**

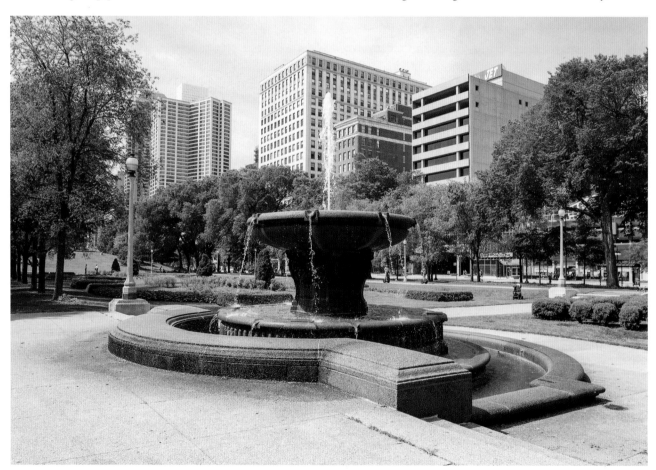

Only one of three fountains designed in 1927 by Edward Bennett for the east side of Michigan Avenue still remains: the 8th Street Fountain.

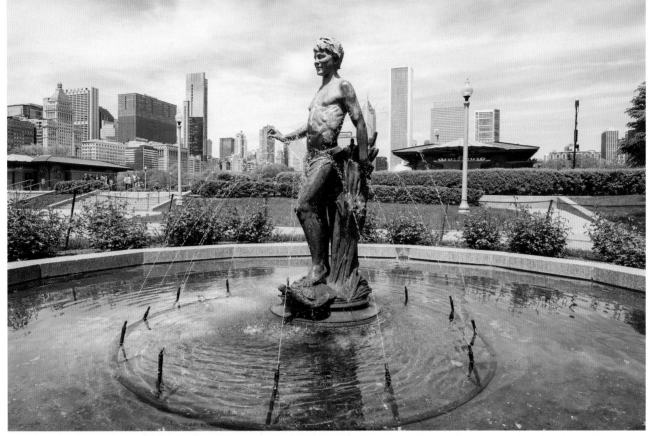

Four bronze fountain figures by Leonard Crunelle, including Turtle Boy, grace the gardens around Buckingham Fountain.

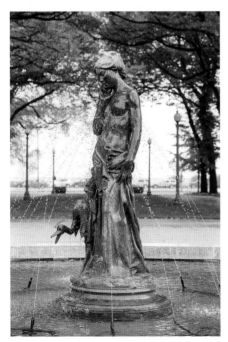

Crane Girl.

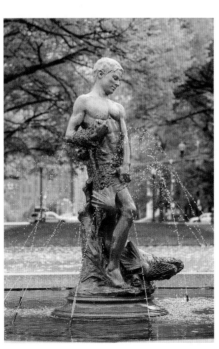

Fisher Boy.

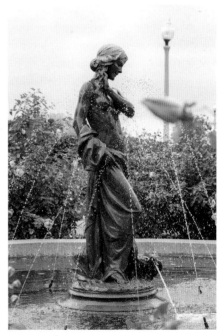

Dove Girl.

Girl, **Fisher Boy**, and **Dove Girl**. Each one features a six-foot-tall bronze figure of a child in a twenty-foot-diameter pool. Water gently sprays over the figures and their namesake animals, which rest at their feet.

In 1908 the figures (then in plaster) were included in an outdoor exhibition at Humboldt Park. The following year two of them were displayed in the Art Institute. By 1910 all four had been cast in bronze and installed in Humboldt Park's Rose Garden.

Vandalized in the early 1950s, the figures were stored away until 1964, when they were installed in their present place of glory as part of Grant Park's new flower gardens. There, the young subjects can once again smell the roses. Unfortunately, the weather and years of flowing water have discolored the statues.

Leonard Crunelle sculpted the pieces. Before specializing in sculpting children, he was a coal miner in Decatur, Illinois. His talent for molding clay figures caught the attention of Lorado Taft, and the master sculptor asked the young man to help him create art for the World's Columbian Exposition. Taft mentored Crunelle, who eventually joined him at Midway Studios.

The **Millennium Monument,** also called **Peristyle,** in Wrigley Square at the northwest corner of Millennium Park reflects the lakefront's classical and Beaux Arts traditions. Constructed in 2003, it harks back to Bennett's peristyle and fountain built on the same spot in 1917 but demolished in 1953 for lakefront landfill. At forty feet tall, the new peristyle is comparable in height to the original. It's made of sturdy limestone rather than concrete, so it should enjoy a longer life than the old peristyle did.

The William Wrigley Jr. Foundation donated $5 million for the monument, fountain, and square. Perhaps the organization was motivated by the fact that the age and architectural style of the old peristyle were similar to those of the Wrigley Building, just two blocks north. Designers improvised on that connection: The brass spout of the new fountain is a replica of the terra cotta finials on top of the Wrigley Building's exterior walls. In addition, the size and style of the new fountain—with its single spout that shoots water forty feet high in a forty-foot-wide ground-level basin—is similar to the **Wrigley Building Fountain,** which enhanced the plaza between the Wrigley Building and its annex until 2010.

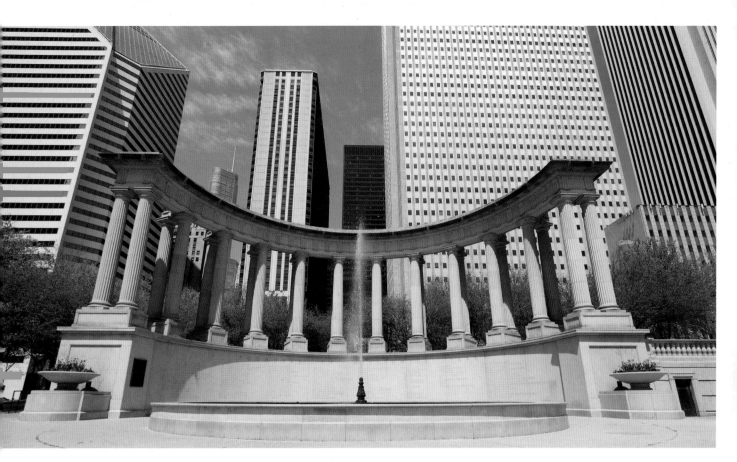

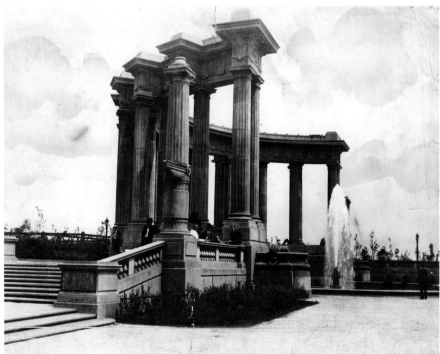

Above: The Millennium Monument, with its peristyle and fountain at the north end of Millennium Park, complements the Crown Fountain, that better-known water wonder at the south end.
Left: The Millennium Monument's 2003 peristyle and fountain reflect the original peristyle and fountain that stood on the same spot from 1917 until 1953, when the structure was demolished and used as landfill along the lakefront.

6. FOUNTAIN FRENZY

In the late 1990s official Chicago was flush with money, or at least it acted like it was. The city was planting thousands of trees, erecting miles of attractive park fences, installing planters in median strips, constructing handsome libraries, and—that's right—building or renovating fountains all over town.

In 1997 Mayor Richard M. Daley launched an ambitious neighborhood fountain program, saying, "Public fountains add beauty and fun to the community. . . . They help to humanize our urban environment and become popular neighborhood gathering places."

Many say Daley's trips to Paris motivated him to beautify transit stations, to launch bicycle sharing, and to build fountains. His fountain-building program was quite successful. Most of these waterworks still operate, enhance their communities, and bring joy to passersby.

Under the modestly priced program, the city budgeted $3 million ($4.5 million today) a year for fountains in pedestrian-friendly locations with the goal of revitalizing neighborhoods and building community pride. Some criticized the expense or scoffed at the notion that fountains could make a difference. Others rejoiced to see an amenity that would soften the city's hard surfaces and bring people together. Daley's idea "positively bubbles with good sense," wrote the *Tribune*'s Blair Kamin. "A

The Kempf Plaza Fountain is arguably the biggest success of Mayor Richard M. Daley's fountain program. It anchors an inviting plaza and long pedestrian-oriented stretch of Lincoln Avenue featuring the Book Cellar, Café Selmarie, and eclectic shops.

Daley's program initially planned to place fountains of this size and design all around town. Four were installed, including this one in front of the Cook County Criminal Courts, before the city decided to customize fountains to their surroundings.

fountain in the city can be a wonderful thing. It sparkles. It soothes."

Under different names at different times (including the Neighborhood Fountain Program and Neighborhoods Alive 21), the initiative lasted about five years. The Chicago Department of Transportation (CDOT) managed the program, while the Public Building Commission

of Chicago contracted with commercial entities for the construction work.

Early on, the city required that a neighborhood organization, community association, or local business group agree to help maintain a fountain in its area. After this requirement was deemed impractical and unenforceable, the city dropped it and assumed maintenance responsibilities. Nevertheless, many local entities still help with upkeep. The most successful fountains from this program have local watchdogs who plant flowers, pick up litter, and report the first sign of graffiti.

Ultimately, the program built or renovated more than twenty waterworks—from decorative to modern, from plain to ornate. There were so many new and renovated fountains flowing during this period that *Tribune* columnist Rick Kogan dubbed them "the fountains that bloom in the spring."

Initially the city took a cookie-cutter approach and envisioned the same fountain design all over town. Not known for design expertise, CDOT came up with a clunky, cast-concrete model with two stacked bowls. To save money, the city chose a tall design that allowed the operating mechanism to be installed under the fountain's base but above ground, rather than in a separate underground chamber. Due to this plan and the bare-bones design, the prototype came with a low price tag of about $100,000 ($150,000 today).

Some communities declined a new fountain because they did not like the design. Others did not want a fountain at all. Some of them feared water would attract the homeless.

Indeed, opposition stymied what would have been this program's first fountain. In August 1997 the city announced plans to plunk down its large prototype in tiny Mariano Park at 1031 North State Street. (The area is known today as the Viagra Triangle, where old rich men are said to pick up young attractive women.) CDOT's prototype would have been too big for this petite parcel. To make matters worse, the bulky piece was supposed to replace a small, low fountain already gurgling away.

In addition, the big fountain would have forced the removal of a delightful Prairie School pavilion designed

by Birch Burdette Long, a Frank Lloyd Wright protégé. Built in 1900, this ten-by-twelve-foot brick cabin sports a tile roof, striped columns, and terra cotta ornamentation.

Fortunately, Kamin objected to the size and proposed location of the new fountain. Furthermore, he wrote that the city's one-size-fits-all approach would "homogenize the city, erasing differences that give neighborhoods their special flavor. The generic approach straitjackets the art of architecture, shutting off fountains of creativity."

The city backed off. Instead, in 1998 it replaced the existing fountain in Mariano Park with the **Botanic Gardens Fountain,** a small model appropriate for this tight urban refuge, selected from Robinson Iron's catalog. Surrounded by a knee-high concrete ledge for sitting, this fountain suits the park's tree-lined, brick plaza.

Meanwhile, the city spared the precious pavilion, "a fine example of park architecture in an urban space that desperately needs it," according to preservation architect John Vinci. Today, the fountain and pavilion complement each other and give Mariano Park, built on land donated to the city in 1848, an Old World feeling.

~~~~~~~

Although rejected for Mariano Park, CDOT's prototype fountain was installed in four other locations: **Garfield Boulevard Fountain**, at 5500 South Western Boulevard

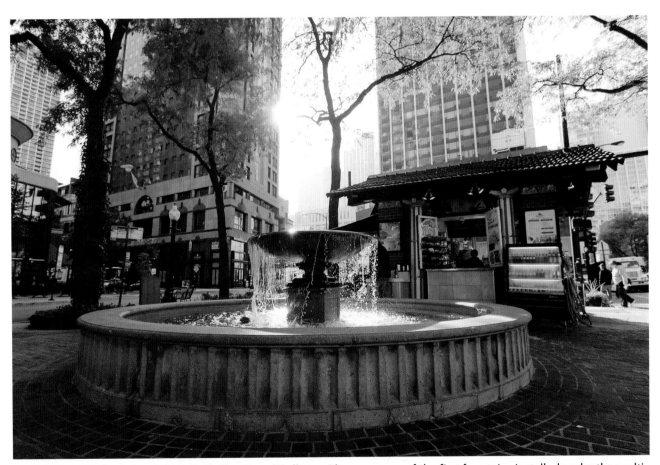

The Botanic Gardens Fountain at Rush Street and Bellevue Place was one of the first fountains installed under the multi-year fountain program that began in 1998.

in Gage Park; **Cortland Street Fountain**, on Cortland Street west of Clybourn Avenue; **Drexel Boulevard Fountain**, at Drexel and Oakwood boulevards; and **Cook County Criminal Courts Fountain**, at 2650 South California Avenue. Jan Strzalka, an attorney working at the courthouse, wondered how long the last fountain would endure, but it's holding up well, remains graffiti free, and imparts a bit of beauty to a rough area.

Soon into its fountain frenzy, the city wisely abandoned its in-house, cookie-cutter approach and hired DeStefano and Partners to design its fountains, "always with craft, human scale, and human delight primarily in mind," as the firm put it. Edward Windhorst, a staff architect and modernist designer, did most of the work. He had never designed a fountain but was known for streetscapes, including the one on Division Street featuring two stylish Puerto Rican flags in metal spanning the street.

Windhorst designed more than fifteen of the program's fountains, making him the city's most prolific fountain designer—Chicago's Fountain Meister. He says the program was a success, even though it was "clearly intended as a way for Mayor Daley to distribute political favors to loyal aldermen and supportive neighborhoods."

For example, in 1999 the city installed a waterworks in a cul-de-sac at 1080 West Vernon Park Place. Insiders claimed the location was chosen because one of Daley's sons lived nearby. Still, the **Vernon Park Place Fountain** is the centerpiece of an attractive, spacious plaza and attracts a lot of neighbors on summer evenings. Its large iron bowl fills with water that spills into a basin, creating a pleasant splashing that sparks conversation. The fountain itself is ordinary looking, but its brick-lined basin, as well as coordinated planters and pavers, mirror the brickwork of the surrounding homes and buildings, including the adjacent Tufano's Vernon Park Tap.

Another fountain thought to owe its location to political connections is the 2001 **Waller–Midway Plaza Fountain** at 5700 West Midway Park. Several influential politicians lived on this short boulevard, which connects to the west with Oak Park, Illinois, and to the east with a cul-de-sac at Waller Avenue on the edge of Chicago's Austin neighborhood. "The fountain was located here chiefly because city honchos lived on that lovely, isolated section of Midway Park," Windhorst said.

As if the Waller–Midway Plaza waterworks needed protection from Austin, a notorious area, it was placed between two churches: St. Martin's Episcopal and St. John Church of God in Christ. Windhorst lined up the fountain with St. Martin's front door and incorporated references to Prairie School features found in St. John. For example, the fountain was kept low to mimic the prairie. "This fountain offers a horizontal expression and layering effect in a compact way," Windhorst said. "Water cascades down shallow steps and flows around planters that are supposed to be full of prairie grasses." Unfortunately, the grasses are not kept up, and the beautiful waterworks is poorly maintained, often strewn with litter.

~~~~~~~~~~

Despite the role politics played in Daley's plans, most of the fountains in his program were well thought out and attractively designed. The **Kempf Plaza Fountain**, another example of Windhorst's skill, enlivens a plaza near Lincoln Avenue and Giddings Street. It stands out as a shining example of how a fountain can help transform a street and contribute to community development. "It's the poster child for a successful plaza and fountain," said John O'Neal, planner with the Chicago Metropolitan Agency for Planning.

To be sure, the fountain, also called **Lincoln Square Fountain** or **Giddings Plaza Fountain**, did not transform this section of Lincoln Square into the vibrant, pedestrian-oriented place that attracts people from all over town. This transformation started in the late 1970s, when the city closed Giddings Street at Lincoln Avenue and turned the cul-de-sac into Giddings Plaza. Benches, a performance area, decorative metal archways, stone obelisks, and new streetscaping contributed. But adding the fountain in 1999 was key. Today, it anchors this popular plaza and upscale community.

Edward Windhorst at DeStefano and Partners designed most of the waterworks in Daley's fountain program. For the design of the edging along the bowls of the Kempf Plaza Fountain, he borrowed a pattern from the stair stringers in the Monadnock Building.

This multitier fountain features a large square bronze bowl that gushes water into four smaller square bronze bowls, each of which spills into a large low basin. A fence around the basin keeps small children out, important because the plaza hosts many family-oriented activities.

Windhorst found design inspiration in Louis Sullivan's former Krause Music Store a few doors south on Lincoln Avenue. And for the design of the edging along the fountain's bowls he borrowed from the stair stringers in John Root's 1891 Monadnock Building. Kempf Plaza "is in a nineteenth-century neighborhood, so I wanted a nineteenth-century motif," he said. The edging was originally highly polished but has faded.

The Lumbard Lamp, an ornate streetlight given to the city by Hamburg, Germany, balances the fountain across the plaza and pays tribute to the area's rich German heritage. Further evidence of that heritage came in 1999, when the city renamed Giddings Plaza for brothers Harry and Guenter Kempf, proprietors of the Chicago Brauhaus, a longstanding restaurant on the plaza.

In 2012 Henry Weinhard's Brewery, of Portland, Oregon, selected Kempf Plaza's fountain to film a commercial. Legend has it that in 1887 Weinhard's was denied permission to pump beer through a public fountain in Portland. More than a century later, the Lincoln Square community granted this wish. During two all-night shoots, the cast and crew of more than seventy seemed to enjoy the fountain—and the bubbling beer. (Find the commercial on YouTube.)

~~~~~~~~~

Another successful custom-made fountain from this program is the **Lincoln Central Park Fountain**, at the northwest corner of Lincoln and Dickens avenues. Lincoln Central Association, a community organization, worked with alderman Vi Daley to erect the fountain in 2000. It replaced a nondescript concrete bubbler a little bigger than a birdbath.

The new fountain features a wide, shallow bronze bowl, remarkable for its hammered underside and trim modernist style. Its low concrete wall mirrors the low concrete retaining wall around the central portion of this small park. The fountain has an attractive irregular swirl that energetically pulses water out of its wide bowl into a large ground-level pool. Ironically, the appealing pulsating water is a "side effect" of a malfunctioning water-level regulator and the bowl having slipped out of balance. (Note to the Chicago Department of Transportation: Don't bother fixing this charming feature.)

Lincoln Central Park's previous layout was a Japanese-style garden completed around 1970 and "unloved"

by the community. "It had sunken areas that contributed to dereliction," said Windhorst, who redesigned the park. "We opened up the park and made it level to encourage walkers to cut through. This made it not only more inviting but safer, too."

It would be easy to *drive* by this pocket park without realizing it holds a fountain, but it would be impossible to *walk* by without noticing the splashing water. Locals appreciate the attractive landscaping and peaceful setting. They and their association show their love by planting flowers, picking up litter, and keeping an eye out for vandalism. And the association installed the park's stone path, logs, and decorative rocks.

Another community-oriented waterworks in a pocket park that relies on local support is the **Mid-North Triangle Park Fountain,** installed in 1998 at Belden Avenue and Clark Street. The land for this park was part of a 1840s grant from the Illinois and Michigan Canal Commission to help develop the area. The park became known as the Belden Triangle, but it was renamed Mid-North Triangle in 1991 because of the Mid-North Association's work to enhance the site.

The community organization still looks out for the park and fountain and sells brick pavers to support its work. (Look for the one with newscaster Bill Kurtis's name.) *Seated Woman with Children,* a marble statue attributed to Lorado Taft, once adorned this park. Originally the statue was part of the 1915 Lincoln Park band shell (near where the North Street Beach House now stands). Also known as *Lute Lady and Music,* the statue was moved to this park in 1970—where it sat until the fountain replaced it.

The fountain is small but exceptionally attractive, surrounded as it is by flowers, trees, and pavers set within a circle. The well-proportioned and nicely decorated fountain contributes to this oasis that offers respite along a

Although Chicago's best-known fountains are downtown, scores of attractive waterworks add a splash of life to Chicago's neighborhoods. In 2000 the Lincoln Central Park Fountain and its new surroundings replaced a small fountain in a Japanese-style garden that dated from the 1970s.

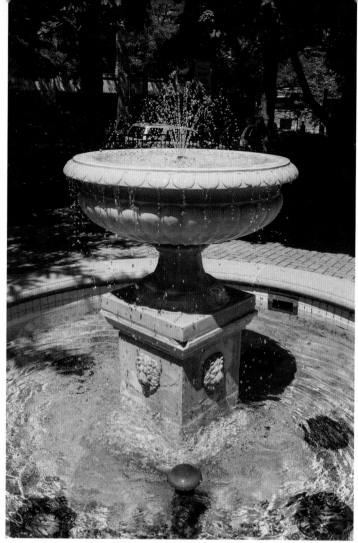

The Mid-North Triangle Park Fountain animates a tiny but attractive pocket park at Belden Avenue and Clark Street. *Seated Woman with Children*, a marble statue carved by Lorado Taft, once occupied the same spot.

busy street. As a bonus, the urn in the center of the low, round basin doubles as a Christmas tree holder during the holiday season.

~~~~~~

Richard M. Daley, who had a lot to say about the location and design of the fountains in his program, had a fountain built to honor his father in 2002. The **Richard J. Daley Library Fountain** fills the plaza outside the public library at 3400 South Halsted. Both library and fountain are basic, somewhat plain. Their location does, however, recognize not only Daley senior but also the political importance of Bridgeport and the legendary 11th Ward office, less than three blocks away, from which so many deals were struck.

"Out of admiration for his father, Richard M. wanted to dress up this fountain, but that didn't last long," Windhorst said. An elegant bronze frame around the piece (based on motifs by Louis Sullivan) was stolen less than a month after the fountain opened. It has never been recovered or replaced.

With or without the bronze frame, this fountain won't win any awards, according to Windhorst. "A fountain does not work well unless it's a focus. This one sits next to a featureless building and does not stand out, so it's unlikely to attract much attention or generate commercial or residential synergies."

~~~~~~

Daley also played a direct role with the **Printers Row Park Fountain**. In 1998 the city approached local residents at a community meeting about installing a fountain in a vacant lot at 700 South Dearborn Street. The quarter-acre area had been designated for a new park to enhance the historic district, once famous for printing, binding, and publishing and, more recently, as home to the *Chicago Tribune* Printers Row Lit Fest. "Naturally, we said yes, since a fountain sounded like a good thing, certainly better than nothing," said Mary Ivory, a member of the Historic Printers Row Neighbors.

Within forty-eight hours, the city installed a fountain in the vacant lot, Ivory recounted. "That made us feel like we had been 'consulted' only to sanction a fountain that had already been selected for this location."

And not well selected, at that. The fountain was a standard, black Victorian bowl—the small and dainty "Roman Minimus on Octagonal Basin" from Robinson Iron's catalog. "It looked like something that belonged in someone's backyard rather than in a park in an important historic neighborhood," Ivory said.

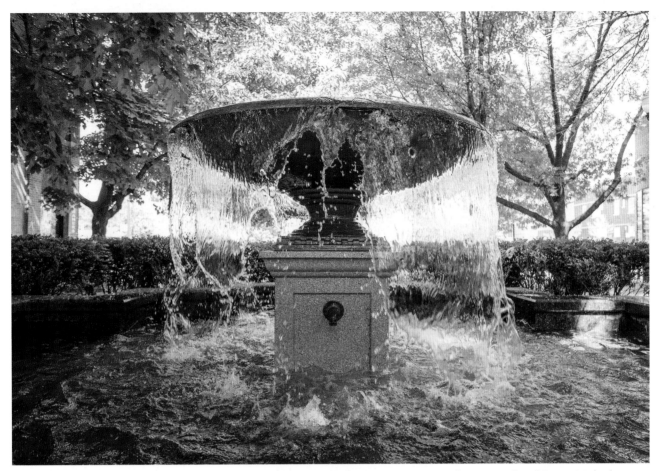

Richard M. Daley honored his father with the Richard J. Daley Library Fountain in a plaza on Halsted Street in the heart of Bridgeport.

Daley thought so, too. He happened to work out in a gym across the street. When he noticed the fountain, he proclaimed it uninspiring and ordered it replaced by one more appropriate for a neighborhood full of late nineteenth-century buildings and, increasingly, inspired loft conversions and trendy condominiums.

The small black iron fountain was quickly removed, and by the following year a large colorful bronze one was installed. Windhorst designed the new fountain and found inspiration in the terra cotta details on the Second Franklin Building, just south of the planned park. He created reliefs on the three-tiered fountain and filled them with colored enamel paint, as if they were tiles. "We picked the three most prominent colors and created a mosaic effect over the fountain's bronze elements," Windhorst said.

The new fountain was mounted in the same spot as the previous one. In part to save money, Windhorst reused the existing, ground-level basin, even though it was smaller than he would have wanted. This explains one of its unusual features. Rather than flowing over the outer edge of the large bottom bowl, water drains from inside the center of that bowl, near the shaft. Windhorst did, however, add a sixteen-foot-wide planter around the original basin to make the base appropriate to the height and size of the new fountain. Locals say the planter discourages people from washing clothes or themselves in the fountain.

The fountain helped further plans for the park. Historic Printers Row Neighbors, which morphed into the South Loop Neighbors, fought off developers, absentee landlords, plans for a parking lot, and city officials indifferent

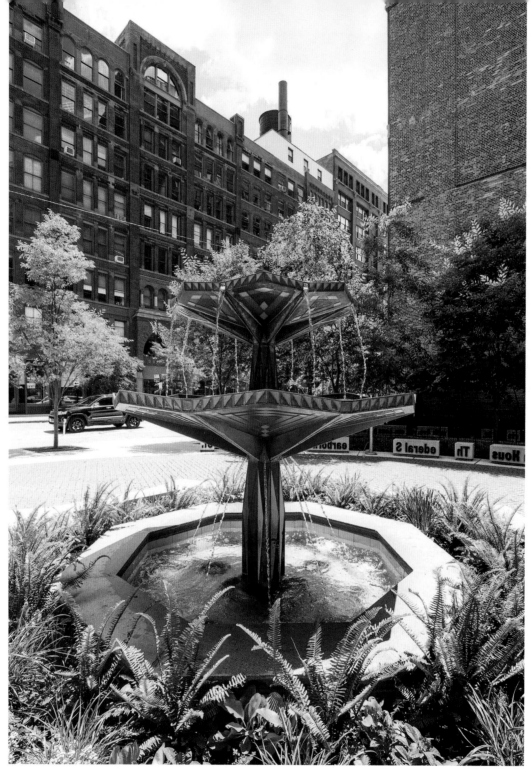

The design and colors of the striking Printers Row Fountain and its park reflect the character of this former printing district. It took two tries to get this park's fountain right, but the result was well worth the wait.

to the neighborhood's character. In 2009, ten years after the new fountain was installed, the community was finally able to dedicate its new Printers Row Park. Designed by Ernest Wong of site design group, ltd., the park features a grassy mound and inventive concrete blocks for sitting that are adorned with large inverse letters representing the moveable type that was once used nearby to print books and catalogs.

In a curious development, the small Victorian-style fountain that briefly preceded the current fountain was pulled from storage and installed on the west side of the Chicago Cultural Center at Randolph Street. Chances are Daley would not have approved of this fountain's placement here, either. The **Garland Court Fountain** is squeezed onto the sidewalk of what is effectively little better than an alley.

~~~~~~

The **Phil Richman Fountain**, another new waterworks from the program, bubbles away in Bixler Park at 57th Street east of Kenwood Avenue. Twenty feet in diameter, this fountain features a three-and-a-half-foot-high granite cone with water spouting from the top and falling into a basin. A concrete sitting wall rings the basin.

As this modest structure was being installed, local residents complained they had not been consulted about a fountain. "Why are we giving up our only grassy area where kids play Frisbee and football?" asked a representative of the Friends of Bixler Park, a group that had formed two weeks earlier over this issue.

One person who advocated for the fountain was Phil Richman, a quintessential Hyde Parker. The University of Chicago graduate was active in the community and served for many years as the publicist for the popular 57th Street Art Fair. He got his wish when the fountain was inaugurated in 1998, just two weeks before he died. Two years later it was named for him. That's not what some locals call it, however. Because of its mound-like shape, they refer to it as "the boob."

The first fountain in Printers Row Park lasted only a few months at that location. Daley found it inappropriate for the site and ordered it removed. After a couple of years, it reappeared as the Garland Court Fountain west of the Chicago Cultural Center.

The outside of the concrete basin contains twenty framed spaces intended for plaques honoring local leaders. Only one of them holds a marker, however, and it's for Richman.

Old Town's **Burton Place Fountain**, probably the program's most peculiar work, sits in a cul-de-sac at Burton Place and Wells Street. This piece is composed of nothing more than a plain shallow concrete square, pushed up against the wall of a building, with a small waterspout

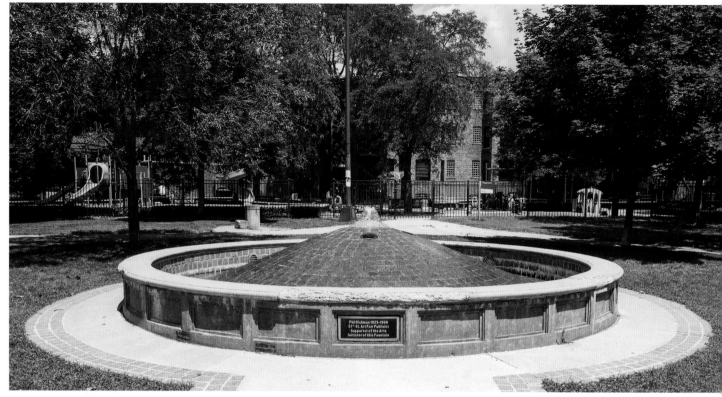

The Phil Richman Fountain honors a quintessential Hyde Parker who graduated from the University of Chicago and served for years as the publicist for the 57th Street Art Fair.

that resembles a showerhead in the middle. Windhorst designed it but disavows the result. He cut his work short due to what he described as hassles during the planning and design phases, including from those who wanted a fountain that would have corresponded with the nearby artistic Edgar Miller House. "That fountain is little more than a place holder for what could have been," he said.

Realizing the fountain leaves much to be desired, the Old Town Merchants and Residents Association commissioned architectural firm Lohan Anderson to design a new one to serve as a focal point and create a space for people to gather. Dirk Lohan designed a beautiful space with a band shell, raised planting beds, and an elegant fountain that would have extended onto the sidewalk along Wells Street, but this gem was never built.

Two unsuccessful fountain renovations of Daley's program include the **Portage Park** and **Sun Yat-sen Park** fountains. The former is near that park's entrance at Irving Park Road and Central Avenue. Built in the mid-1930s as a Works Progress Administration project, it had a distinctive flagstone design that was used throughout the park. The renovations did not hold, as the fountain is a ruin.

The latter is on 24th Place at Princeton Avenue. Named for Sun (the Republic of China's founding father and first president), this fountain was built in 1976 on a small strip of land along the Stevenson Expressway in Chinatown. A bronze bust of Sun rests atop a marble pedestal mounted in a shallow rectangular basin containing a pool with several water jets. The pedestal is inscribed with quotations of Confucius. Over the years the fountain fell into disrepair, and in 2001–2 the city restored it. There's little

Fountain Frenzy

to show for the work, however, because the fountain has not operated for years, and the pool simply collects litter and leaves.

~~~~~~

The most controversial fountain of Daley's program is the **Nelson Algren Fountain**, where troubled waters have been flowing since its inception, demonstrating that a neighborhood fountain best succeeds when it fits in with its surroundings, has an appealing design, and enjoys community support.

The trouble started well before 1998, when the city decided to build a fountain named for Algren on a triangular plaza at the intersection of Division Street and Milwaukee and Ashland avenues. This was once the center of Algren's fictional universe—but also the heart of Chicago's proud Polish American community. The hard-boiled Algren made a career writing novels about Chicago's gamblers, hookers, and hustlers. He lived near the plaza, and many of his hapless characters were Polish. *The Man with the Golden Arm* tells the story of lowlifes in this Polish neighborhood (and was made into a movie starring Frank Sinatra). *Never Come Morning*, which tells the story of a thuggish Polish boxer, was so virulent that the Polish Roman Catholic Union called it a "Polish-baiting, church-hating book," and the Chicago Public Library refused to stock it.

The Polish community and many residents near the Polonia Triangle at Division Street and Ashland and Milwaukee avenues opposed the Nelson Algren Fountain because the author wrote about life in the area with brutal honesty.

After the prickly, often tormented Algren died in 1981, local luminaries, including Mike Royko, Studs Terkel, Herman Kogan, and Art Shay, formed the Nelson Algren Committee, which in the 1990s suggested the fountain.

By 1998 the area around the plaza was more Hispanic than Polish. Nevertheless, the idea of honoring Algren opened old wounds with the Polish residents and institutions still in the area. Ultimately, a compromise allowed the new fountain to be named for Algren as long as the plaza's traditional name of "Polonia Triangle" was made official.

The plain fountain features a ready-made, nine-foot-diameter iron bowl. Water drips into an eighteen-foot-diameter pool but no longer evenly, as the bowl is poorly supported. Cars, trucks, and buses on three of the city's busiest streets roar by, drowning out the sound of the splashing water.

Despite the plaza's shabbiness and the fountain's unimaginative design, an Algren quote ringing the base inspires: "For the masses who do the city's labor also keep the city's heart." Algren also once said, "Chicago is an October sort of city even in the spring." That's why fountains are needed—even a lopsided one purchased from a catalog, like this one.

Many people want to see the setting improved, but efforts have so far failed. In 2008 the Wicker Park Bucktown Special Service Area launched a competition for "an artistic, colorful, functional, and reusable" way to cover the fountain in winter. One entry suggested circling it with panels of photographs of local residents, allowing anyone to submit entries. Nothing came of the competition, but the idea seems to have presaged Crown Fountain, albeit in a modest, low-tech fashion.

~~~~~~~~

The **Peaches Memorial Fountain** represents the other end of the spectrum. This memorial is well suited to its location, has been embraced by the community, and is vigilantly maintained.

Located on a parklike traffic island at 5730 North Clark Street, the four-tiered fountain is noteworthy in many ways. It shares the space with the tall Eagle Monument dedicated to World War I veterans. It's beautifully landscaped. And it's one of Chicago's few fountains named for an "ordinary" person who was not a soldier, politician, or business leader.

When Mary Ann Smith became alderman of the 48th Ward in 1989, drugs, abandonment, and arson plagued the area. "It was important to help the community change its expectations of itself," Smith said. "While working on basic issues like crime and education, I wanted to do wonderful, surprising things, like plant trees and build parks, things you wouldn't expect to see in a rundown neighborhood."

In 1998 Smith secured a fountain for her ward from Daley's program. Given the limited budget, she did not hire an artist or form a committee to select the best design for the space. Rather, she settled on whatever fountain the city had to give, as long as it was not too large and didn't allow people to play in it.

Smith wanted the fountain to be noticed, so she chose a prominent spot where Ashland Avenue connects with Clark Street. Just to the north, another traffic island is full of flowers and landscaping provided by Gethsemane Garden Center, an established store and a community gathering place. In business for more than forty years, this garden center not only does a thriving business. It also hosts community events, such as children's festivals and the Annual 48th Ward Halloween Festival.

But the fountain's name, "Peaches," is not a reference to any peach trees or peach-colored flowers for sale at Gethsemane. Rather, it was the nickname of Rosalie Siegel, who lived nearby and worked at the garden center for more than a dozen years. Peaches died in 1997 from complications related to diabetes, which had claimed one of her legs and confined her to a wheelchair. Despite her illness, she kept spreading joy at the store and advising customers, including Smith, about flowers and gardening.

"Peaches would cheer us on, so I decided to name the fountain for her because she 'got it'—the importance of beautifying the neighborhood," Smith said.

The Peaches Memorial Fountain was named for Rosalie "Peaches" Siegel, an employee of the Gethsemane Garden Center, which operates across the street, helps maintain the area, and is a boon to the community. Peaches's heart "gave her away," says the plaque.

"Peaches was a wonderful person, inside and outside the store," said Robert Levy, a longtime friend of hers and a manager at Gethsemane. "If she knew a fountain was named for her, she would have tears in her eyes and just melt down to the ground."

Near the fountain is a stone marker with a photo of her and the words, "Peaches. Her smile made you laugh. Her growl made you run. But her heart gave her away." Unfortunately, the marker looks like a tombstone and has prompted speculation that someone is buried here.

As the fountain was being planned, local residents questioned the expense of trying to beautify rough-around-the edges Edgewater and whether such an attempt would work. But the piece has succeeded beautifully and become a local landmark. Inspired by this success, a neighboring community group is working to place a fountain about a mile southeast at the intersection of Broadway and Bryn Mawr Avenue. Will it be named for someone special?

7. FORGOTTEN FOUNTAINS

Chicago has probably lost more outdoor public fountains than the 125 or so that currently toss water around town. Many were poorly designed. Others were ravaged by the elements or inadequately maintained. Still others were removed because of renovations or changing tastes. Maintaining a fountain certainly costs more than maintaining a statue or plaque. But Chicago would be richer—culturally, artistically, architecturally, and historically—if these lost fountains had been preserved.

Many fountains kick the bucket without a trace. For others, a photo or postcard is about all that remains —a stark, two-dimensional testament to what was lost. Such images spark one's curiosity, but it's often impossible to discover the backstory. Who designed and paid for the fountain? Was it supposed to inspire or memorialize something?

The extensive photo archives of the Chicago History Museum hold a photo of the **Cupid Fountain**, a small decorative affair topped with an impish looking figure who appears to be holding a dagger in one hand and a trident in the other. The record places the fountain circa 1880–1910 and mentions landscape architects Swain Nelson and Olaf Benson, but "enquiring minds want to know more." Another photo at the museum depicts a fountain in Washington Park, twenty-five feet high by sixty feet wide, with two levels of spray pouring off the center shaft, which is topped with more than eight large attractive light globes. The record mentions 1871, Calvert Vaux, and Frederick Law Olmsted. Reportedly, Washington Park, which stabled more than one hundred horses, had several similarly large fountains. Little

is known about another waterworks that used to shoot three crowns of water from a large pool in the North Garden at the Art Institute and was accompanied by a "panoply of flags."

A couple of old photos depict the massive **Buffalo Fountain** in Ravenswood that fortunately happens to be mentioned in a few written records. In 1914 Ravenswood residents voted to create a park district. Strapped for money, the district had to limit itself to small parks and started with a 0.07-acre piece of land bound by Sunnyside,

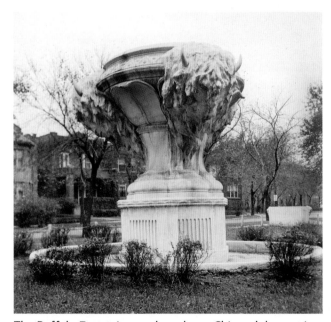

The Buffalo Fountain may have been Chicago's largest in proportion to the space it occupied. The sixteen-foot-tall behemoth with three bison dominated the 0.07-acre Buffalo Park at Sunnyside, California, and Manor avenues.

The Crunelle Fountain's nude boy in Sherman Park made the Roman Catholic Felician Sisters living across the street uncomfortable, so the Chicago Park District removed the sculpture.

California, and Manor avenues. Hired in 1918, Carl Nilsson, a Swedish artist and local resident, designed a circular, illuminated fountain with three enormous buffalo heads facing outward. Presumably, water poured from their mouths into a large basin that surrounded the urn-shaped piece. The purpose of the buffalo motif, which also embellished the park's benches, is unclear. In any event, early residents began referring to the place as Buffalo Park, and the name stuck.

The massive, sixteen-foot-tall structure cost $700 ($11,000 today) and dominated the tiny triangular park. The concrete did not hold up well, and by 1941 the fountain had fallen into such disrepair that the Chicago Park District razed it, despite objections from local residents,

some of whom claimed the newly formed citywide park district was insensitive to the wishes of local residents. The fountain was never replaced, and most locals don't know that the name of their cherished little park comes from the enormous but forgotten Buffalo Fountain.

~~~~~~~~~

Other stray but precious museum photos depict the small, unusual **Crunelle Fountain**, and a few articles flesh out its story. It dates to a 1908 art exhibit in Humboldt Park organized by the influential Municipal Art League "to forward the beautification of the city." The organization wanted to demonstrate "the wonderful possibilities of a

skillful combination of landscape gardening and sculpture . . . and to encourage sculptors to remain in the city and give it their best work."

One of the participants, Leonard Crunelle, sculpted a fountain featuring a boy, probably in bronze, standing above and behind a semicircular stone basin. The handsome sculpture was "set like a jewel" in Humboldt Park, said the *Tribune*. "It's evident at a glance that the scene is improved by the statue, and that the statue is set off by the scenery without the slightest incongruity."

After the exhibit Crunelle's piece was installed in an alcove on the north wall of the Sherman Park field house near 52nd and Throop streets. There it troubled the Felician Sisters who worked across the street at St.

John of God Church. They objected to the subject's frontal nudity. On an unknown date, the park district removed the sculpture, which has since disappeared. The alcove and basin are still there, however, with the latter used as a planter. (In 2012 the large Renaissance Revival church was dismantled, piece by piece, and reassembled as part of St. Raphael the Archangel Church in Old Mill Creek, Illinois.)

～～～～～

The **Nymph Fountain** also offended some people, but it lasted only a few months. In the late 1890s Lorado Taft envisioned a large stylish fountain with nymphs and

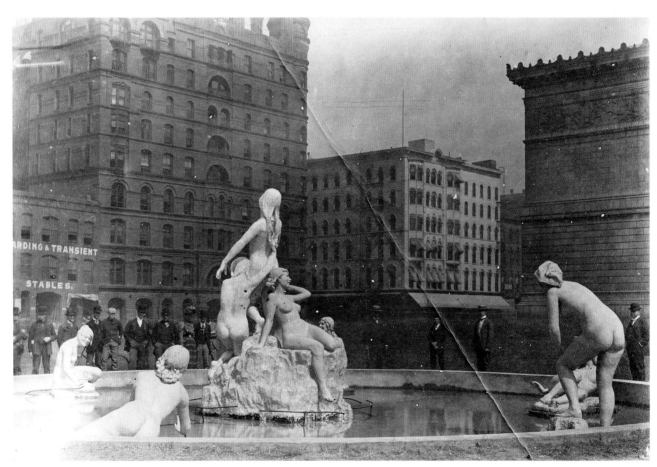

The Nymph Fountain, a class project of Art Institute students in 1899, surprised many people when it appeared overnight along Michigan Avenue. It was the talk of the town but was vandalized and removed after a few months.

Forgotten Fountains

assigned the work to a female sculpturing class. In early June 1899, under "the friendly darkness of night," Taft's students assembled their fountain on the lawn south of the Art Institute. The figures were made of plaster or staff, temporary materials, because Taft and his students regarded the work as a class project.

Early the next morning the public awoke to find a new forty-foot-diameter fountain featuring eight larger-than-life nude female figures in sensuous poses. This created a stir and attracted crowds that at times required police to manage.

The Nymph Fountain became the "talk of the town," and politicians, editorialists, and religious figures weighed in. "The nymph is not an intellectual goddess . . . [and] stands for nothing related to high or noble intellectual accomplishments," said the Women's Christian Temperance Union. But after he "trundled down to the lakefront on his bicycle . . . to take a look at the fountain," Mayor Carter Harrison Jr. proclaimed the work "not in any sense objectionable." The *New York Times* reported, "Preachers, or some of them, think the nymphs should have been provided with mackintoshes [raincoats], while even the most ultra of Chicago's art cliques would not resent a shirtwaist as a sop to the prudish majority of the city's population."

By mid-July vandals had "practically ruined" the Nymph Fountain, the *Boston Evening Transcript* reported. "Nearly every figure in the fountain had been mutilated, and many nymphs had their hands and arms broken off." The article did not specify whether *upright* or *uptight* citizens did the damage. In any event, what was left of the fountain was removed mid-August. Taft said at the time he hoped the fountain could be rebuilt in "imperishable bronze," but that never happened.

~~~~~~~~~~

A bit more is known about the memorable **Pioneer Court Fountain** that once livened up the high-profile plaza south of the Tribune Tower. The marble fountain's fifty-foot-diameter basin echoed the openness of the

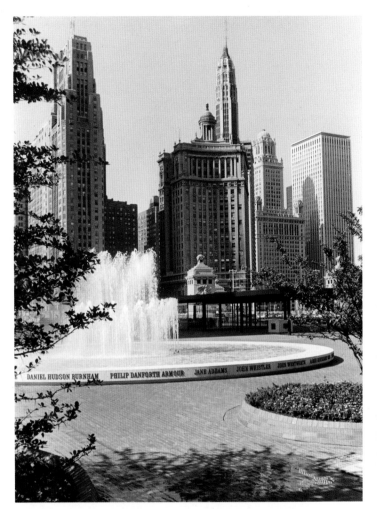

The handsome original Pioneer Court Fountain, installed in 1965, named twenty-five important figures in Chicago's early history. After the same number of years, it was dismantled.

eighty-thousand-square-foot plaza. At the same time, its several jets, which shot water high into the air, mirrored the tall buildings surrounding the plaza.

The plaza dates back to the early 1960s, when Equitable Life Assurance replaced a parking lot here with Pioneer Court and its building. The fountain debuted in 1965, and the rim of its basin became a popular spot to sit, lunch, and people watch.

That sidewall held the names, set in bronze, of twenty-five pioneers selected by the Chicago Historical Society

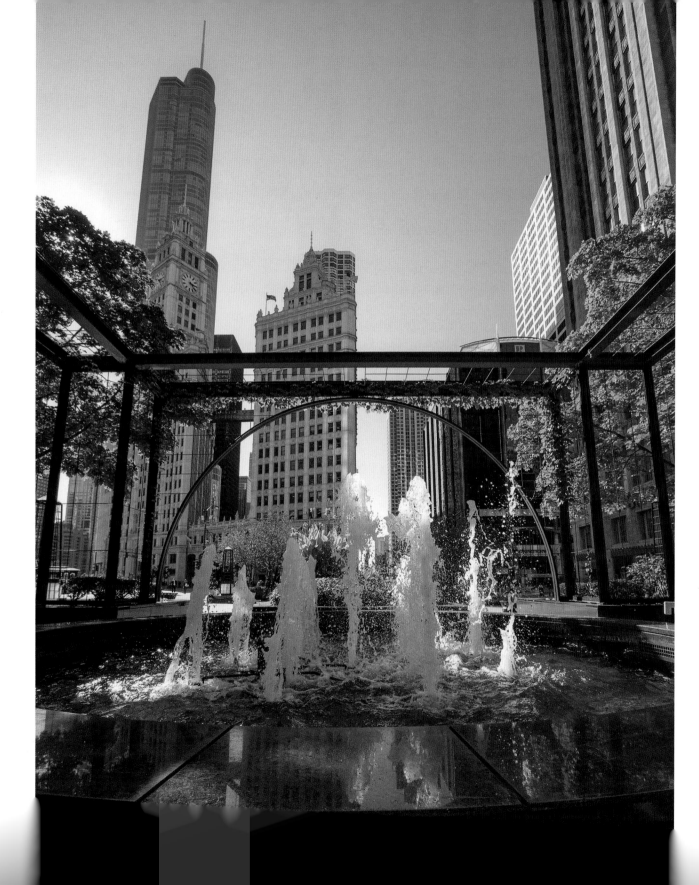

(now Chicago History Museum) "for their contribution to Chicago's birth, growth, and greatness": Jane Addams, Philip Danforth Armour, Daniel Hudson Burnham, Richard Teller Crane, John Crerar, Steven A. Douglas, Marshall Field, William Rainey Harper, Carter Henry Harrison, Gurdon Saltonstall Hubbard, William Le Baron Jenney, John Kinzie, Cyrus Hall McCormick, Joseph Medill, Walter Loomis Newberry, William Butler Ogden, Potter Palmer, George Mortimer Pullman, Julius Rosenwald, Martin Antoine Ryerson, Jean Baptiste Point Sable (*sic*), Charles Henry Wacker, Aaron Montgomery Ward, John Wentworth, and John Whistler.

The list included a few surprises: Why only one woman? Did Medill, a failed mayor but *Tribune* editor, make the list because of the *Tribune's* involvement in the project? Which Carter Henry Harrison, senior or junior? Meanwhile, DuSable, the "Father of Chicago," suffered the dishonor of having his name misspelled.

This fountain lasted only twenty-five years before it was removed in 1990 as part of a plaza renovation. It's not known what became of the letters that spelled out the pioneers' names, a few of which were missing when the water still flowed. The **New Pioneer Court Fountain**, stretching three hundred feet, is attractive but less distinctive and impressive than its predecessor. Still, it contributes to the wide-open plaza, which continues to be an important public space. With the help of the fountain, the plaza has attracted an incredible variety of events and exhibits, from the kitschy sculpture of Marilyn Monroe in 2011–12 to a classy Diner en Blanc in 2013. (Diner en Blanc is an impromptu, outdoor, sit-down dinner where attendees dress in white. Fountains in Daley Center Plaza and the Art Institute's South Garden have also helped to attract similar white nights.)

The construction of the ballyhooed transparent Apple Store in 2016 will draw more people to Pioneer Court and the fountains in its vicinity.

Although less distinctive than the original one, the New Pioneer Court Fountain is an attractive feature of this large, popular public space.

Across the street from Pioneer Court, the modest **Plaza of the Americas Fountain** has been operating off and on for years. When the plaza opened circa 1963 with its bronze statue of Mexican president Benito Juarez, it included modest but appealing fountains that were illuminated by multicolored lights. This grandly named plaza, displaying the flags of the nations belonging to the Organization of American States, now sports an uninspiring pool consisting of three small jets splashing into a small rectangular basin in front of the statue.

~~~~~~

We know more about the lost but once spectacular **Yerkes Electric Fountain** that attracted tens of thousands to Lincoln Park. Built in 1890 southeast of the South Pond (near the lakefront at about 1800 north), this dazzling seven-foot-tall fountain was 120 feet in diameter. It had two rings of jets shooting water inward and one central jet shooting water as high as 110 feet, creating a pyramid effect. Most alluring were its lights and colors, provided by fifteen electric lamps of eight thousand candle power, each coupled with five different-colored glass lenses. A team of operators underneath the fountain ran the show, described by a reporter as "ever-changing shades of prismatic color in graceful curves, dropping like iridescent gems into the basin below."

With its innovative use of electricity, the fountain foreshadowed the World's Columbian Exposition of 1893. And with its captivating colored light show, it foreshadowed Buckingham Fountain.

Charles Tyson Yerkes was an archetypical nineteenth-century robber baron known as a "Transit Titan" but also "Goliath of Graft." In the process of buying up Chicago's horse-drawn street railways and building much of its cable car and "L" systems, Yerkes acquired a reputation as a ruthless businessman adept at bilking investors. In an attempt to burnish his reputation, he gave $23,000 ($612,000 today) for the Electric Fountain.

Everyone gushed over the popular attraction. An 1895 history of Chicago said, "The projection of strong electric

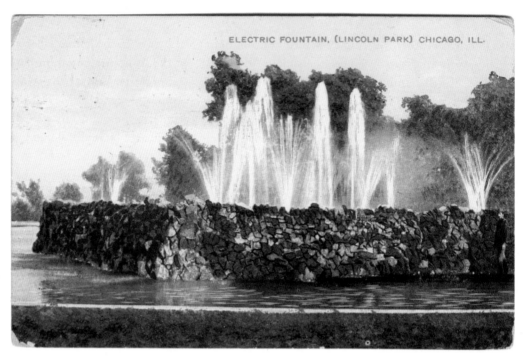

ELECTRIC FOUNTAIN, (LINCOLN PARK) CHICAGO, ILL.

Charles Tyson Yerkes, known as a Transit Titan but also the Goliath of Graft, funded the Yerkes Electric Fountain in 1890 to improve his poor standing with the public. The stratagem didn't work, but the spectacular fountain generated a lot of traffic on his transit lines.

light through colored glass on falling water . . . renders Lincoln Park one of the most favored pleasure grounds in the country." A reporter compared Yerkes to Caesar, who created "public spectacles of such magnificence that he became at once the people's idol."

It's doubtful the Electric Fountain made Yerkes an idol or even did much to improve the public's negative view of him. As people realized the best way to get to the fountain was to ride Yerkes's cable car line to Lincoln Park, they suspected Yerkes's motives. "Thousands dropped nickels into the importunate hands of Yerkes's conductors for the sake of looking at Yerkes's 'gift,'" noted the *Tribune*.

Yerkes was more or less run out of town in 1899 by disgruntled colleagues, dissatisfied transit riders, and a hostile press. His absence left no one to advocate for his Electric Fountain or pay for its expensive upkeep. Neglected and vandalized, it was removed in 1908.

~~~~~~

While the Electric Fountain lasted only seventeen years and suffered an ignoble end, the **Olson Rug Waterfall**—another popular multicolored illuminated water marvel —lasted more than twice as long and brought tears to people's eyes when it was demolished. This unlikely yet widely successful waterfall wowed young and old, attracted tourists, and buoyed Chicagoans' spirits during the Great Depression and beyond. Although it was not a fountain, strictly speaking, many people describe it as one—and a favorite one, at that.

In 1935 Walter Olson built a park on the southwest corner of Diversey and Crawford (now Pulaski Road) avenues next to his huge rug mill. About two hundred workers took six months to build the park using eight hundred tons of stone, thirty-five hundred perennials, and countless trees. Materials were trucked in from Wisconsin, so the park was "playfully dubbed the 'Bohemian Dells'" in recognition of the ethnic background of many who lived nearby.

Olson intended the park for his employees, but the public flocked there. It included a rock garden, bird sanctuary, and duck pond. But the centerpiece was a roaring thirty-five-foot-tall, multitier waterfall that emptied into a lily pool at the rate of fifteen thousand gallons per minute (more than the flow through Buckingham Fountain during its peak displays). The park, free of advertising,

One of Chicago's "Seven Lost Wonders," the enormous Olson Rug Waterfall was extremely popular throughout the Midwest but was demolished in the 1970s.

was open every day to midnight, and up to five hundred thousand people visited annually. They kept coming back because the foliage changed with the seasons and the décor changed with the holidays. Performances by Native Americans were popular, especially because Olson had symbolically deeded the land back to them.

Marshall Field's bought the complex in 1965 and closed the park in the 1970s to make room for a parking lot. For someone who never experienced or heard about the Olson Rug Waterfall, it's hard to imagine how treasured it was, but it topped the *Tribune* list of "Chicago's Seven Lost Wonders" compiled in 2005.

Fountains graced Chicago's two world fairs. The **Columbian Fountain** was a focal point of the 1893 World's Columbian Exposition. Dominating the central Court of Honor, this magnificent piece featured Columbia atop the Barge of State, heralded by Fame, oared by the Arts and Industries, and guided by Time at the helm—all of which was surrounded by numerous water jets. The 1933–34 Century of Progress featured many waterworks, but the **Exposition Fountain** in the North Lagoon stole the show. With a flow of sixty-eight thousand gallons a minute, it was billed as the largest fountain ever built. It included a 570-foot-long series of ostrich plume jets culminating in a dome of water more than seventy-five feet wide and forty feet high.

Meanwhile, Riverview Park boasted **Creation**, a dazzling display of water with a highly decorated wall symbolizing creation as a backdrop.

But this book does not cover fair fountains or Riverview Park because such spectacles are well described elsewhere. One exception is the Century of Progress's **Cascade of Months** because it was built as a permanent installation and survived for several decades after the fair closed.

One of Chicago's most distinctive lost fountains, the Cascade of Months was built in front of the Adler Planetarium and featured twelve colorful ground-level terrazzo panels. A thin sheet of water flowed over them and accentuated the shimmering effect of the bright, underlying terrazzo, which is composed of ground marble, glass, stone, or metal mixed with a binder, such as cement or epoxy. The mixture is then poured into patterns outlined by metal strips, allowed to harden, and polished. For the Cascade of the Months, craftsmen used more than fifty colors of paint and marble chips in a binder of white portland cement. The work sparkled, at least initially.

The panels depicted the months in stylish symbols designed by muralist John Norton, a modernist who saw himself as an interpreter of nature. He depicted January with a snow crystal; February, a tree covered with snow; March, the sun at the vernal equinox; April, rain and lightning; May, spring flowers; June, summer blooms; July, heavy foliage; August, wheat fields; September, harvest

The Cascade of Months, with one panel per month, was built in front of the Adler Planetarium as part of the Century of Progress. It continued to flow until about 1970.

104—The Adler Planetarium, Grant Park, Chicago

corn; October, ripened grapes; November, falling leaves; and December, an evergreen tree.

The Cascade of Months was the focus of a five-hundred-foot-long, ninety-three-foot-wide esplanade that the National Terrazzo and Mosaic Association built as its exhibit for the fair, saying, "no other installation in the history of the Industry . . . will do as much toward broadening the general knowledge and appreciation of Terrazzo."

That may have been true during the fair, but afterward the esplanade and its fountain fell into disrepair. By 1968 the work was in a "deplorable" condition. The planetarium removed it circa 1970 during a building expansion project. Although Chicago's freeze-thaw cycle can be merciless, Richard Bruns, executive director of the association, said, "The planetarium's installation could have been maintained because we have exterior installations from the early 1900s that are still in good shape."

Those who remember the bright terrazzo panels covered with flowing water must miss this "glistening magic carpet of color harmony."

～～～～～

Some forgotten fountains are still in place but not known or recognized as fountains and are unlikely to ever operate again. For example, the defunct **Victor Lawson Memorial Fountain** on the east side of the Chicago Daily News Building along the Chicago River at 400 West Madison is an empty shell. (Lawson was the longtime owner and editor of the newspaper.) This once mighty fountain had an unusual design: three large portals about twenty-five feet high gushed water into a semicircular basin near ground level. It has not run for decades and frequently suffers the ignominy of being covered with advertisements, such as an image of a log cabin promoting Washington Mutual Bank in 2003.

When they were built in 1929, the Daily News Building and its plaza and fountain made big news. "Their beauty will be massive, symmetrical, thoroughly American, and modern," raved the *New York Times*. Especially

important was the way the edifice embraced the river, decades before such a practice was required. In fact, the building was Chicago's first significant modern commercial skyscraper to face the river. To see how striking this was, just look across the river at the Civic Opera Building, which opened the same year. That building turned its stark unadorned back while the Daily News Building opened its arms to the river with its four-hundred-foot-wide plaza, highlighted by its commanding fountain.

～～～～～

Some fountains disappear not due to neglect but because they fall victim, like collateral damage, to renovation or rebuilding. The **Gateway Park Fountain**, a beloved water spectacle in front of Navy Pier created by WET Design, lasted only twenty years because a new park was built there.

When the fountain opened in 1995, Chicago celebrated its fun interactive design. "Watch out[,] Buckingham Fountain," shouted a *Tribune* article that went on to quote a tourist saying, "I've never seen anything like it."

The computer-programmed water wonder featured a large black granite block with more than twenty "skyrockets" that shot water as high as one hundred feet. Surrounding the block, two hundred "nanoshooters" buried at ground level delivered unpredictable bursts of water one inch to six feet high in fast-acting sequences. Kids chased around the dancing spurts of water and clung to the five-foot-high granite block to catch water cascading over its sides, as they would years later at the Crown Fountain.

The Gateway Park Fountain "explodes, with a dozen plumes of water high into the sky," wrote *Tribune* columnist Rick Kogan. "Water shoots from holes in the pavement. Children giggle and get wet. Mothers and fathers sit there, watching in wonder the power and beauty of the liquid fireworks."

Yet in 2016 the Gateway Park Fountain was replaced as part of a renovation for Navy Pier's centennial headed by landscape architect James Corner, the lead designer of Manhattan's acclaimed High Line. The Polk Bros.

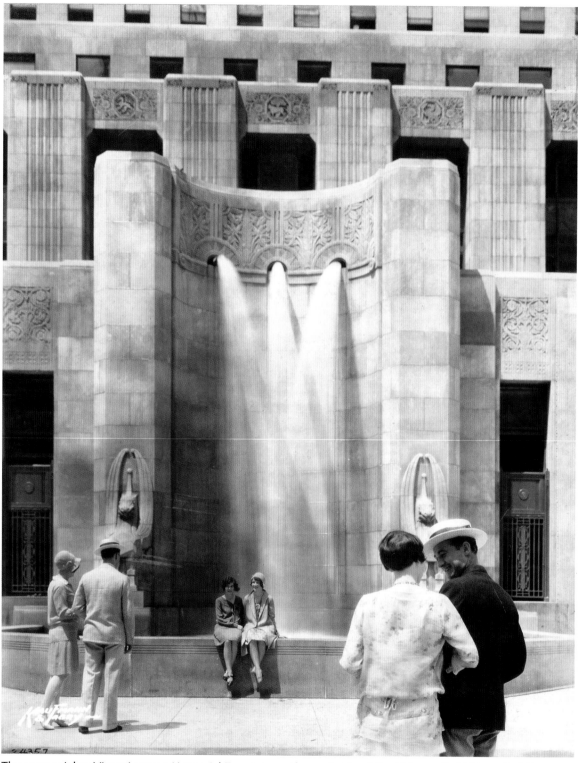

The once mighty Victor Lawson Memorial Fountain on the east side of the Chicago Daily News Building along the west side of the Chicago River still stands but is just an empty shell.

Once heralded as a rival to Buckingham Fountain, the fun interactive Gateway Park Fountain lasted only twenty years. It was removed in 2016 to make room for the new Polk Bros. Park Fountain.

Foundation donated $20 million to remake the thirteen-acre Gateway Park—and rename it Polk Bros. Park.

The new seventy-five-foot-diameter **Polk Bros. Park Fountain** is more interactive and inviting than the previous fountain. Visitors can walk through shallow pools and under arcs of water that shoot as high as nine feet. They can also climb on the large horseshoe-shaped concrete berm that rises as high as two feet. Some 150 programmable nozzles spray water in playful, choreographed patterns. In a unique feature for Chicago waterworks, occasional waves of fog veil the revelers.

Meanwhile, the fate of Navy Pier's Crystal Gardens is unclear. This glorious six-story glass atrium is famous for its **Leapfrog Fountains**—thirty jets that shoot glasslike cylinders of water over walkways into planters and pools. They work by using compressed air to create tubular streams. Mark Fuller of WET Design developed this technology as an undergraduate and took the idea with him to Disney, where he built a leapfrog fountain at Epcot in 1982. The technology has since been implemented around the world.

Often when a fountain disappears it's lost forever. **Charitas**, however, disappeared for years and was resuscitated, although only as a statue. The eight-foot-tall bronze statue of Charitas debuted in 1922 as part of a fountain featuring a wide basin and water jets. It stood atop a large square pedestal at one end of the basin.

Ida McClelland Stout won a *Daily News* competition to sculpt the statue, which depicts a woman holding two children and symbolizes charity to underprivileged youth. Its original placement in Lincoln Park west of the Daily News Fresh Air Sanitarium—a health center that accommodated more than thirty thousand children each summer during its peak—recognized the humanitarian work done there. ("Charitas" comes from the Greek word for charity.)

When work on the northbound lanes of Lake Shore Drive in the late 1930s required removal of the fountain and a portion of the sanitarium (now the Theater on the Lake), the park district moved the statue to the Garfield Park Conservatory. Regrettably, the conservatory painted the bronze statue white to match Pastoral and Idyl, two white marble figures sculpted by Lorado Taft that were displayed there. Expert conservationist Andrzej Dajnowski was hired in the 1990s to remove the paint from and restore Charitas, but in 2001 the conservatory moved the statue into storage to make room for its blockbuster Dale Chihuly exhibit, *A Garden of Glass.* The statue remained in storage, even after Chihuly's exhibit closed the following year. "No charity for Charitas," said the *Sun-Times* in 2003.

In 2016 the park district reinstated this lovely statue just south of the Theater on the Lake, near where it originally stood as part of a fountain. Although no water bubbles around Charitas, Stout's statue has been returned to

Captivating visitors to Navy Pier, Chicago's most popular tourist destination, the illuminated, multicolored Polk Bros. Park Fountain is quickly becoming one of Chicago's favorite water wonders.

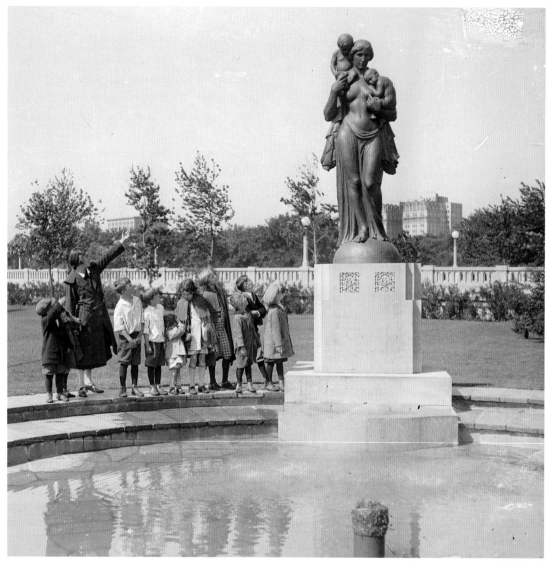

This statue of Charitas stood in a fountain along the lakefront until the 1930s, when it was moved to the Garfield Park Conservatory. In 2016 Charitas was returned to this location and reunited with its original pedestal, seen here. (During the intervening years, the pedestal held a bust of Chicago Symphony Orchestra conductor Georg Solti in Lincoln Park.)

its original pedestal, which during the intervening years held the bust of Chicago Symphony Orchestra conductor Georg Solti in front of the Lincoln Park Conservatory.

The nearby **Archbishop's Residence Fountain**, a small fountain in front of one of Chicago's grandest mansions at 1555 North State Street, comes and goes annually. The Catholic Church dismantles it every year to make room for a manger scene during the Christmas season. The modest three-tier concrete fountain topped with an acorn looks similar to many others around town and has no religious or liturgical significance. Cardinal Francis George had it installed in the late 1990s but later regretted not having installed a more elegant iron fountain. In 2003 the fountain was toppled over and cracked by late-night revelers, but it was quickly repaired.

8. CITY OF FOUNTAINS

Kansas City, Missouri, celebrates its own style of jazz, blues, and barbeque and calls itself many things, including "Paris on the Plains" and "Heart of America." Its biggest claim to fame, however, is being America's City of Fountains. Its logo, a stylized fountain, decorates things all over town, from the city's flag to its sewer covers. Quite simply, Kansas City has fountain fever.

Chicago—which might have to settle for the title "Second City of Fountains"—could learn a thing or two from Kansas City about outdoor public waterworks.

Kansas City's claim to fountain supremacy is valid given that the medium-sized city has more than fifty outdoor public fountains and two hundred in its metro area. Plus, its hotels, shopping centers, restaurants, buildings, and museums have more than their share of interior waterworks. Finally, fountains grace the front yards of many homes.

More important than the numbers, Kansas City has many original, artistic fountains. Its water tossers "cover the waterfront," from one depicting Adam and Eve to another honoring the citizen soldier; from the petite Brookwood Fountain with a sculpture dating back to the seventeenth century to the massive, modernistic Barney Allis Plaza Fountain, with water cascading down more than a dozen block-long steps; from the brawny fountain at the phallic Liberty Memorial to the feminine Muse of Missouri, which depicts a goddess bestowing guidance on travelers along the Missouri River.

Kansas City prides itself on a fountain that flows up; playful fountains, such as one in the form of a big hand holding a cup; and three fountains that run all winter. The Northland Fountain shoots water high into the air and

lets it freeze on the way down, thereby creating spectacular ice sculptures. (Heat from lights keeps some of the water flowing and the pipes from freezing.) And the Rozzelle Court Fountain, at a restaurant in the Nelson-Atkins Museum of Art, greatly enhances one of Kansas City's finest dining experiences.

~~~~~~

Kansas City built one of its first fountains at 15th Street and the Paseo (a parkway) in 1899 when it was but a cow town. Ironically, this waterworks was modeled on Versailles's Latona Fountain—as was Chicago's Buckingham Fountain years later.

Many early fountains were designed to water horses. A few of these practical fountains sported decorative flourishes and provided drinking water for people, too. The local humane society erected more than one hundred drinking fountains for man and beast, including one in 1904 with a streetlight on top that now resides at the Wyandotte County Museum.

Purely decorative fountains also sprang up around town, many of them in parks. One of the most memorable was in Electric Park, an amusement park opened in 1907. This fountain featured a platform that could be raised and lowered. Typically, it carried young female models bathed in colored lights and dressed as historical or biblical characters. A fire ravaged the park in 1925, and this fountain was never rebuilt.

Country Club Plaza launched Kansas City in the direction of becoming the City of Fountains. Opened in 1923,

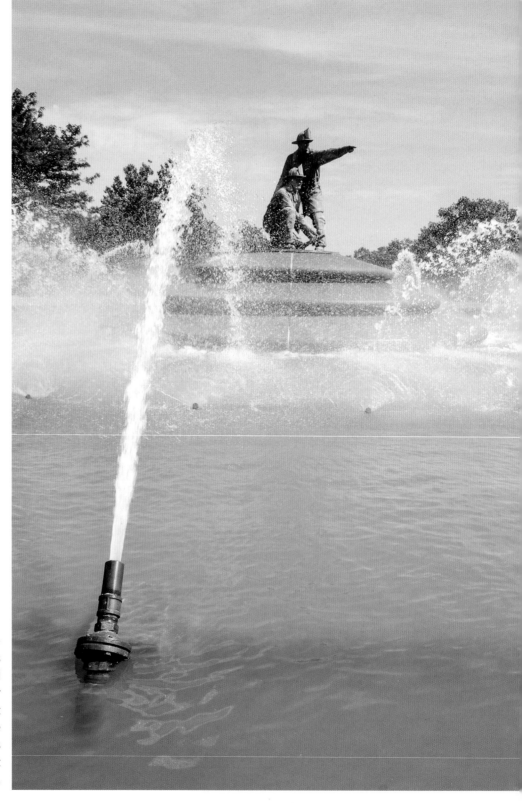

The Firefighters' Fountain memorializes Kansas City firefighters who died in the line of duty. Water shoots from forty-eight nozzles that resemble those found on fire hoses and surround two stalwart firefighters in bronze.

*Left*: Kansas City has a serious case of fountain fever. A stylized fountain serves as its official symbol and decorates many things all over town, from its flag . . . to its sewer covers [*right*]. Courtesy of the City of Kansas City, Missouri.

this upscale shopping district southwest of downtown was modeled on Seville, Spain, with abundant courtyards, artwork—and fountains. Developer J. C. Nichols used these amenities to enhance the district's retail offerings. Today the fifteen-square-block area with myriad fountains remains Kansas City's preeminent shopping district.

Two prominent waterworks in the Plaza—the William Volker Memorial Fountain (1958) and the J. C. Nichols Memorial Fountain (1960)—spurred interest in this art form and pumped up the idea of identifying the town as a fountain city.

In 1973 the City of Fountains Foundation was established to raise funds for new fountains, build a trust fund for maintenance, and promote the importance of water tossers to Kansas City. It planned to build one fountain every year but couldn't maintain such a pace. Today it focuses on maintenance and renovation. "Times change . . . and today we find many Kansas City fountains on life support," the foundation explained.

〜〜〜〜〜〜

In 2013 the foundation launched its Wish Upon a Fountain campaign aimed at raising $2.5 million to shore up nine fountains that needed major repairs. These fountains include many of Kansas City's most iconic waterworks, starting with the Nichols Fountain.

The water in this dramatic fountain blasts away from several vigorous jets and falls from two concentric bowls into an eighty-five-foot-wide ground-level basin. Four bronze dolphins romp in the shallow pool, each carrying two children. As part of the renovation, workers returned to its rightful place one of the fountain's original dolphins, which had somehow turned up in Florida after being on the lam for more than fifty years.

Other fountains renovated through this campaign include the following:

- The ornate Seville Light Fountain is a replica of Seville's Plaza de Los Reyes Fountain. Its thirty-foot-tall central shaft is carved in marble, and water flows from four masked faces around its base. It needed $500,000 worth of work.
- The William Volker Memorial Fountain depicts St. Martin of Tours surrounded by a centaur, two angels, and a beggar with whom he shares his coat. For fun, one of the angels plays a flute from the wrong end while the other wears a wristwatch.
- The sixty-by-one-hundred-foot Children's Fountain is one of the city's largest. It portrays six

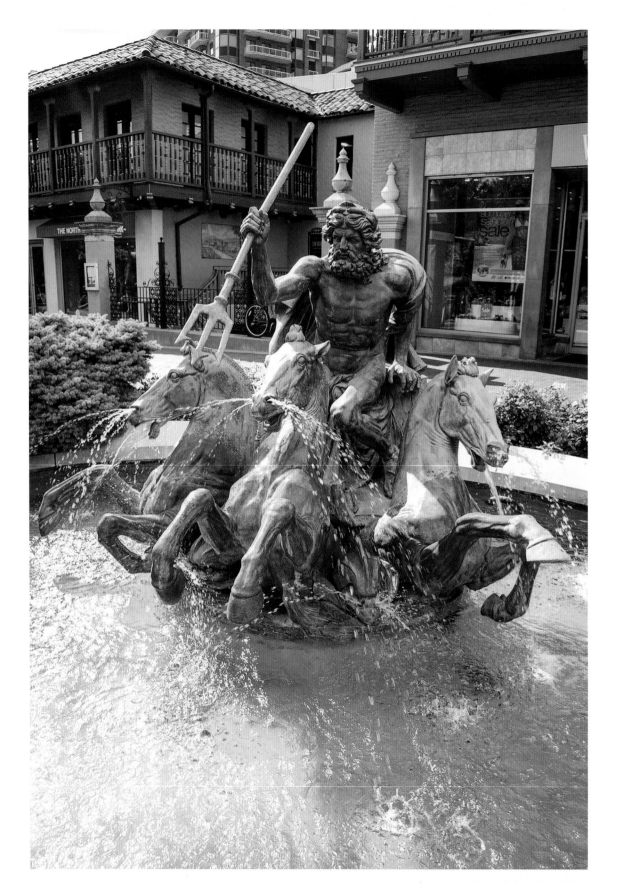

The eminently walkable Plaza district features dozens of decorative fountains—from ducks to penguins and Greek goddesses to local heroes.

nine-foot-tall bronze figures of children on pedestals playing soccer, performing a handstand, et cetera, activities "that shape young lives, making childhood a joy."

- The Spirit of Freedom Fountain honors African Americans and was designed by prolific Chicago sculptor Richard Hunt. Its imaginative five-thousand-pound metallic centerpiece represents freedom as well as the improvisational style of Kansas City jazz.

~~~~~~~

Nothing in Kansas City says "fountain" as clearly as Country Club Plaza, where more than twenty fountains bear witness to the city's love affair with aquatic showpieces. The area is the country's first shopping center designed to accommodate customers arriving by automobile. Today shoppers find the quaint area eminently

The eight-thousand-pound lead Neptune Fountain was purchased in 1952 for its weight from a scrap dealer and installed on a sidewalk in Country Club Plaza.

walkable, partly because its fountains are so approachable and captivating.

The Court of the Penguins depicts five-foot-tall birds gamboling around an ornate, bubbling basin. The naughty bronze-and-marble Boy and Frog Fountain depicts a frog squirting a boy—or is it the other way around? The festive Fountain of Bacchus depicts the Greek god of wine surrounded by nymphs and satyrs. And the eight-thousand-pound lead Neptune Fountain—with the fierce Roman god of the sea waving a trident and riding three horses that spew water from their nostrils—nicely clutters the sidewalk where it inspires smiles and selfies. All told, the Plaza proves the power of fountains to attract crowds and anchor a commercial district.

~~~~~~~

Kansas City's most remarkable waterworks, the Eagle Scout Memorial Fountain, features a twenty-two-by-forty-foot marble sculpture that once crowned the Seventh Avenue entrance to New York City's famed Pennsylvania Railroad Station (demolished in 1963). Originally a clock adorned the seven-foot-wide laurel wreath at the center of

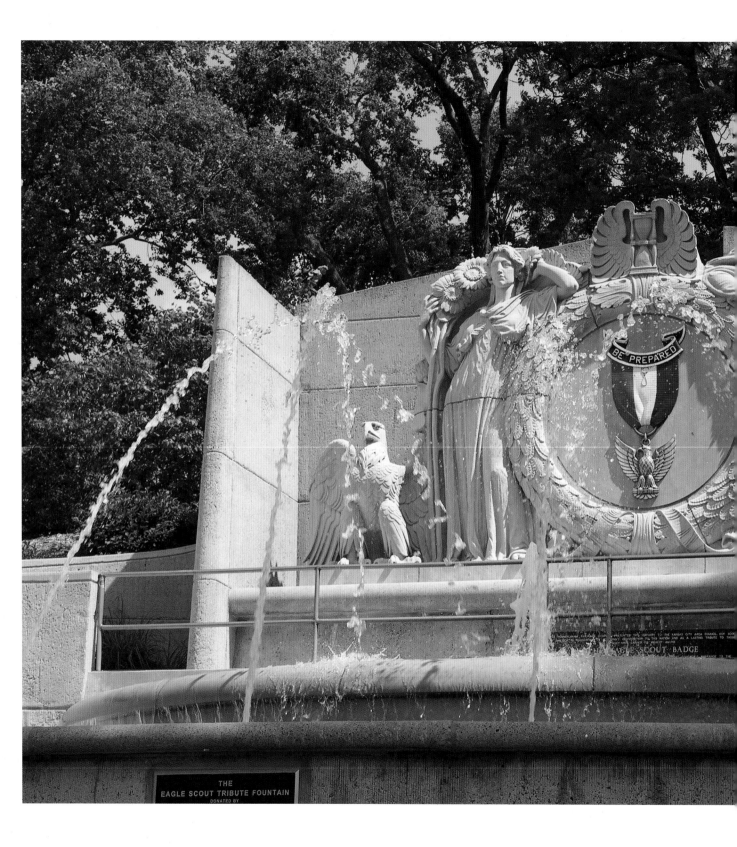

BE PREPARED

THE
EAGLE SCOUT TRIBUTE FOUNTAIN
DONATED BY

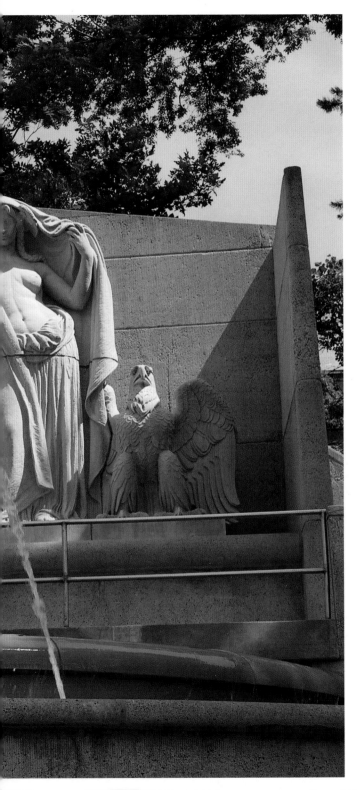

the sculpture; today an enlarged replica of an Eagle Scout badge hangs there instead. Repurposing the carving as a fountain was admirable, but the result is a bit odd.

Two semicircular pools with several jets of water in front of the sculpture create a pleasant splashing sound. Amazingly, the designer added the fountain elements to "intentionally detract from the female figures" flanking the wreath. The problem? One of the women is bare breasted, leading critics to question whether the sculpture violates any Boy Scouts precepts.

~~~~~~~~~

The baseball Royals' legendary Kauffman Stadium is famous for the Fountains (formerly known as the Water Spectacular), a majestic ensemble of pools, jets, and scalloped cascades behind the outfield fences. A 322-foot-wide section allows the team to claim it runs the largest privately funded fountain in the country. The illuminated multicolored waterworks often shoots off in tandem with fireworks, and a special display is reserved for Royals' home runs and victories. The fountain got a great workout in 2015, when the Royals won the World Series.

Every year Kansas Citians celebrate their fountains and the values these waterworks represent. On Fountain Day, the second Tuesday in April, the city's public fountains spring back to life, quenching the thirst of parched muses and mermaids and announcing the return of springlike weather.

Many of the city's fountains are frequently dyed in honor of a team, a cause, or an event. In a creative twist, the city and foundation often sell the dyed water to fans or supporters, thereby raising money for fountain maintenance. The popular Nichols Fountain, for one, holds seventy thousand gallons of water, so dyeing it creates quite a revenue stream.

The Eagle Scout Fountain's huge marble sculpture once crowned the Seventh Avenue entrance to New York City's famed Pennsylvania Railroad Station. An enlarged Eagle Scout badge hangs where a clock once kept time.

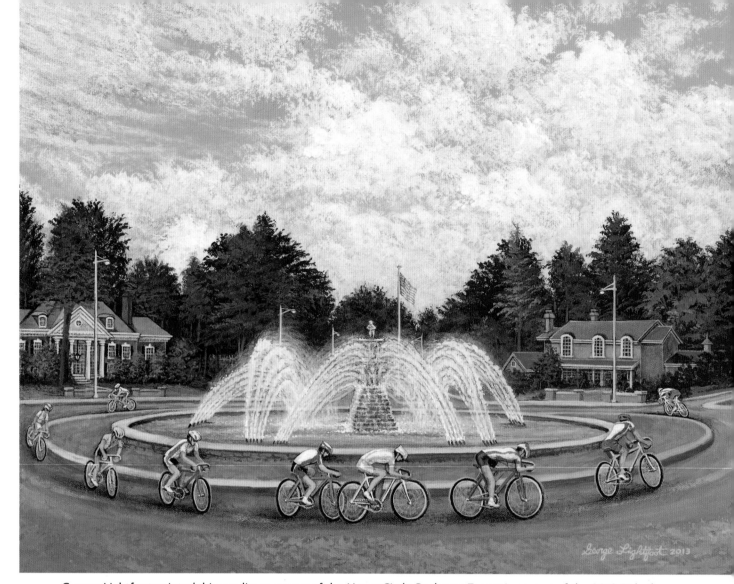

George Lightfoot painted this acrylic on canvas of the Meyer Circle Seahorse Fountain as part of the 2013 Ride the Fountains Bicycle Tour. The painting sold before it was completed. The centerpiece of this fountain is a seventeenth-century stone sculpture from Venice, Italy.

Another inspired idea is the "splash mob," a festival held at a fountain to raise money and familiarize people with it. These events include a press conference, music, and entertainment.

Every June the Kansas City Metro Bicycle Club and others sponsor the Ride the Fountains Bicycle Tour. Waves of cyclists tour fountains all over town, with the tours terminating at a festival. Up to seven hundred cyclists have participated in one year, and 40 percent of their registration fees goes to the foundation. In 2014 more than five hundred cyclists rode, ending up in front of Union Station, where the Henry Bloch Fountain's 232 jets arranged in concentric rings create choreographed displays of water atop a large, sleek black-granite surface.

A highlight of the bicycle tour has been the Plein Air Art Festival, in which artists draw or paint fountains along the routes. This allows cyclists and others to watch and interact with the artists at work. The artists auction

City of Fountains

their pieces and donate half the proceeds to the foundation. In 2014 artists produced eighty paintings, and the auction raised $7,000. The city has also sponsored fountain photo contests.

"When people argue that the fountains aren't worth the money, we say they're part of the very fabric of Kansas City," said Mark McHenry, director of the Parks and Recreation Department. "We'd lose a lot of money and part of our spirit if we didn't continue to support and treasure our fountains."

To help protect its fountain heritage, Kansas City has passed laws aimed at discouraging recycling centers and salvage companies from buying scrap metal that looks like it might have been stolen. In addition, the city sets aside 1 percent of the budget of each municipal building's construction project for the creation of original art, and much of this money goes to fountains. Plus, the city requires that new fountains have an endowment equal to at least 25 percent of the cost of the project. Meanwhile, the foundation manages endowments for more than thirty waterworks and sculptures.

"Kansas City's unique and varied water sculptures do more than just give our neighborhoods and public spaces vitality and a special sense of place," said Heidi Downer, marketing manager at the Parks and Recreation Department. "They commemorate and celebrate the visions, deeds, and generosity of generations of Kansas Citians who helped make so many of our collective wishes come true."

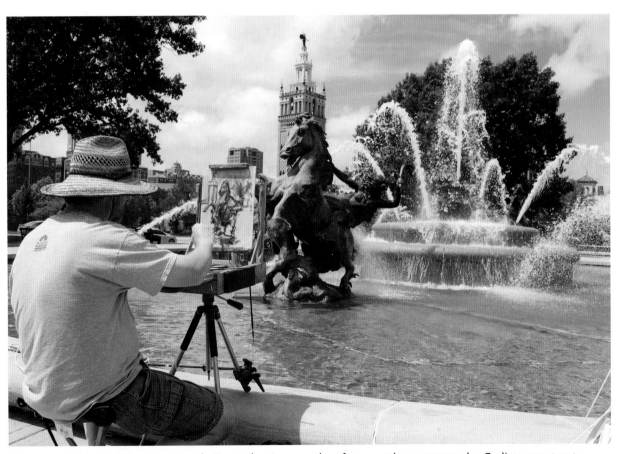

The annual Ride the Fountains Bicycle Tour takes in more than forty outdoor waterworks. Cyclists can stop to watch artists paint or draw fountains, and the artworks are sold to raise money for fountain repairs. Here, in 2014, Nyle Gordon paints the Nichols Fountain.

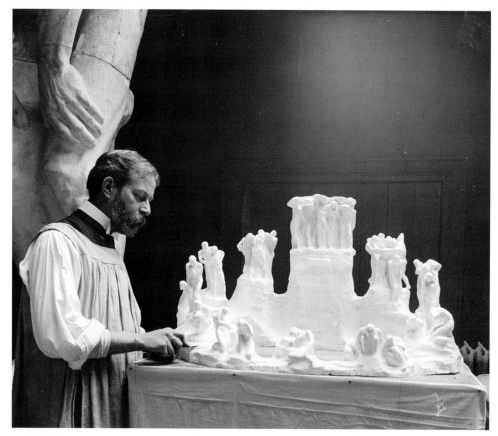

One of Chicago's most striking planned but never built waterworks was the Fountain of Creation. Lorado Taft envisioned it for the east end of the Midway Plaisance to complement his Fountain of Time on the west end.

9. CREATIVE FOUNTAINS, PAST AND FUTURE

Over the years, Chicago could have been home, sweet home to many more fountains. Some would have been colossal, others modest, still others odd.

In 1967 pop artist Claes Oldenburg, who grew up in Chicago, demonstrated that the Windy City is indeed a place to "make no little plans." He proposed replacing the "obsolete" Buckingham Fountain with an enormous fountain consisting of an arm resembling a windshield wiper. The **Giant Wiper** was to swing back and forth between two rectangular swimming pools along the lakefront from Jackson Drive to Balbo Avenue. As it flapped at various speeds, the wiper would have filled with water each time it dipped into one of the pools. The water would have then dripped out as the wiper lifted, delighting kids in the pools. Plans included a fast pace at night, when the pools were empty.

Fountains are alive. They attract, inspire, and rejuvenate people. Artists, designers, and architects have configured them in a seemingly infinite variety of ways.

Oldenburg resurrected a scaled-down version of this wild idea a decade later when he was hired to create a sculpture for the Social Security Administration Building at 600 West Madison Street. Ultimately, he went with his now famous *Batcolumn*.

Another grandiose fountain that never saw the light of day was proposed for Grant Park in 1908 by the architectural firm Hill and Woltersdorf as a way to use twenty-four granite columns being discarded after the demolition of Chicago's old City Hall. The massive monument—let's call it the **Old City Hall Fountain**—would have featured water shooting forty feet up in a ninety-two-foot-diameter rotunda, "with the heavens as a dome." (Today two of these columns can be found in the Cancer Survivor's Garden at 445 East Randolph Street.)

The two-hundred-foot-tall **Chicago Memorial to Heroes of War** would have been more farfetched, even though the proposal won a first-place $20,000 ($280,000 today) architectural prize in 1929. The open monolith was to be built on an island opposite Buckingham Fountain with a large fountain in the center.

When Henry Graves died in 1907, the Chicago pioneer settler left money to build a fountain in memory of Ike Cook, his trotting horse. His will stipulated that a life-size bronze statue of Ike be erected atop a fountain that would flow into a large drinking basin for horses. It suggested locating the structure at the intersection of 55th Street and South Park Way (now Martin Luther King Drive) near what was then the Garden City Racetrack, where Ike had raced. The *Tribune* reported the park board accepted Graves's money in 1909 for the **Ike Cook Fountain**, which was designed by Charles Mulligan but never built.

Graves is better known for commissioning Lorado Taft to design a statue called *Eternal Silence* in Graceland Cemetery to honor his father, Dexter.

Speaking of Taft, he proposed the **Fountain of Creation**, Chicago's best-known-but-never-built waterworks. Taft based his design on the story of Deucalion, the Noah of Greek legend, and his wife, Pyrrha, both of whom survived a deluge and repopulated the earth. The colossal sculpture would have featured thirty-six figures on an ascending plane, with water cascading around them. He planned it for the eastern end of the Midway Plaisance to balance his Fountain of Time at the western end. Donors and the public, however, were not enthusiastic about this piece, and Taft died before realizing it.

Taft's two massive fountains were only part of his vision for the Midway. He planned to build a canal along the one-mile stretch, which explains why the Midway green is sunken today. He wanted to cross the canal with three ornate bridges and line it with statues of the world's greatest idealists, mostly from antiquity. At first, the public praised this plan. One reporter said Taft would create "an outdoor collection of art on such a magnificent scale that this city will leap gaps of a thousand years." Later Taft and his classical ideas fell out of favor. His plan for the Midway was a pretentious sermon in stone, and all that's left of it is the sunken green and a desolate Fountain of Time.

Many other fascinating fountains were planned but never built. The architects who designed the Prudential Building in 1955 considered incorporating the company's Rock of Gibraltar logo into a plaza-level fountain. Instead, the logo ended up as a bas-relief up on the west side of the building. And years later, sculptor Jerry Peart proposed, perhaps in jest, a fountain to commemorate the 1992 Loop Flood that would have consisted of an enormous pipe—the diameter of the tunnels that flooded—with water, fish, and debris pouring out.

Among the most impressive proposals were several fountains visionary architect John David Mooney designed for **Navy Pier** in the 1980s. He envisioned a renovation of Navy Pier that was "entirely a celebration of water." It featured a huge fountain in the lake south of the pier, an ice skating rink at the west end, and a huge illuminated trellislike fountain at the east end. The last

would have created a transparent curtain of water in the summer and an ice sculpture in the winter.

Mooney also proposed a fountain maze for kids, barges as stages, and amphitheater seating along the edge of the pier, ideas that have been implemented elsewhere around Chicago. "Fountains promote rest and relaxation," he said, "and we need a lot more of them, especially in places they wouldn't be expected."

~~~~~~~~~

One unexpected place for a fountain would be as part of a building's gutters. Such passive rainwater fountains reduce runoff and do not require electricity or pumps to operate. They are starting to appear around Chicago as part of a revolution in building design and water management, both of which increasingly strive to treat runoff as a resource rather than as a waste product. One example is the **Judge Fisher Senior Apartments Fountain** (5821 North Broadway), where a canopy over the building's entrance captures rainwater and directs it through scuppers to a garden that forms the focal point of the entryway. Site design group, ltd., created this one.

The innovative firm also built the **Langston Hughes Elementary School Fountain** (240 West 104th Street), a system that captures rainwater in a cistern and directs it via fountains through three planters, one after the other. When a passive rainwater fountain is built at a school, educational benefits kick in, too. "This system teaches kids about water issues," said Hana Ishikawa, principal at the firm. "They see the fountains putting rainwater to good use and capturing enough water that these plants almost never need watering." The physics and biology behind such water features in schools encourage students to study underappreciated STEM subjects (science, technology, engineering, and math). Meanwhile, the fountains and planters get "extra credit" for beautifying the school.

Other green aspects of new fountain design involve water conservation and permeable pavement. The **Mist Fountain** at Mary Bartelme Park, built in 2010 at Monroe and Sangamon streets, uses both and was built on a former industrial "brownfield" site, a tract of land that had been developed, polluted, and then abandoned. Five rectangular arches spray an unpredictable mist on passersby who activate the mist by pushing a button. The mister uses only about four gallons of water per minute and shuts off automatically after a few minutes. The mist itself is as light as a cloud, so anyone can walk through it without getting wet. The polished metallic arches, set at different angles, are attractive at night and when the water is shut off for the winter.

"I'm glad community members selected this gateway design and have since adopted it as an identifying element for their community, for example, putting it on brochures," said Ishikawa, who designed the fountain. In fact, the Mist Fountain has achieved a bit of fame. It's been used in Watch Dogs video games and in Chicago's Olympic bid.

Site design group, ltd., has built other conservation-oriented fountains activated by buttons, levers, or hand pumps, including one in a nature play garden at the Garfield Park Conservatory. And the group's interest in passive fountains extends to drawing water from roads and fields, as well as from roofs.

"The traditional concept of a fountain as something you look at—and usually from a distance—is giving way to more dynamic and engaging designs," Ishikawa said. "It would be great to see more exciting, vibrant, and creative fountains all over town."

For example, water running off a playing field at **James Wadsworth Elementary School** (6650 South Ellis Avenue) will be captured and channeled into a gravity-powered fountain, if the project gets funded. Water would drain slowly so the fountain would continue to run for quite a while after it rains. Afterward the water is stored underground and allowed to percolate into the ground. Supported by the Metropolitan Water Reclamation District, this project is part of Openland's Space to Grow program aimed at transforming schoolyards into inviting green spaces that encourage health and outdoor learning.

Fountains are becoming not only greener but also more interactive and animated, with digital controls and

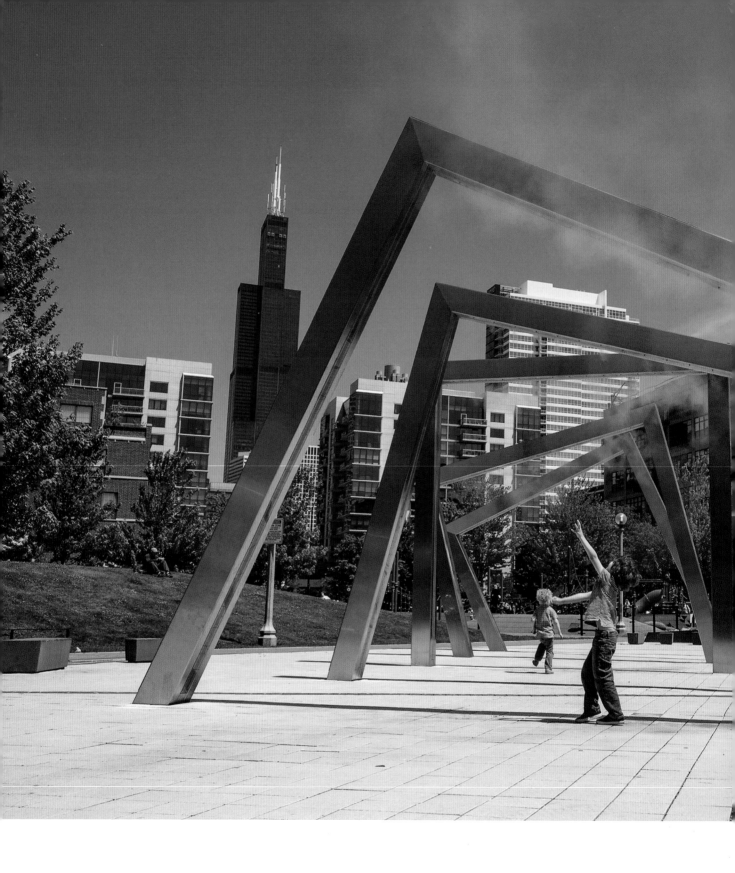

integrated music, color, and choreography. The interactive **63rd Street Beach House Fountain** (built in 1999 as part of the renovation of a 1919 Classical Revival–style bathing pavilion) allows children to use push buttons to manipulate more than one hundred undulating water jets. When it's in operation (not often enough) the fountain features three concentric circles of ground-level jets that shoot water to the rhythm of music and pulsating lights.

"Traditional, classical designs are out, and dynamic, even crazy designs are in, like fountains spewing fire from gas-fueled nozzles," said Joe Petry of Delta Fountains. Another trend is that water in a fountain is more likely to be the actual subject of a fountain rather than an accessory to a statue or structure. In other words, water itself is the sculptural medium that takes shape and defines the piece.

~~~~~~~~

Water—that baffling substance that fuels fountains—is associated with health, youth, cleanliness, and purity. It's part of umpteen religious ceremonies. In countless creation stories, land and life emerge from water. Humans begin their lives in water, which is second only to oxygen in sustaining life. Perhaps that's why humans are hardwired to crave water and enjoy its soothing sounds and compelling movement as it spurts and sprays, flows and falls.

But water can also hurtle from the sky, smash buildings, and drown people. Our awareness of water's destructive power makes it even more appealing to sit near a fountain where the water, like a lion at the zoo, is controlled.

Water is the most studied substance on earth. Dissecting its *H*s and *O*s, we find that water is nothing short of amazing:

The earth's water was formed in outer space billions of years ago.

The wonderfully creative and interactive Mist Fountain at Mary Bartelme Park demonstrates new ideas in fountain design: it uses very little water (just a mist), stands on permeable pavement, relies on users to activate it, and is designed to look attractive at all times.

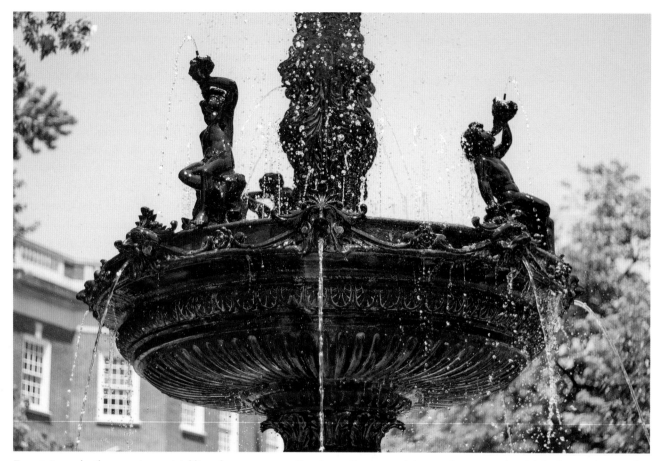

Fountains, whether roaring or trickling, fun or provocative, have the potential to make passersby think about water and better appreciate this precious resource. Mayor Jane Byrne's Children's Fountain certainly celebrates water.

Water is the earth's only substance that appears naturally in all three common states of matter: solid, liquid, and gas.

Water on earth isn't destroyed. It just moves around: evaporation, condensation, precipitation, and runoff. So, Fountain Girl's water could have bathed Cleopatra, and Buckingham Fountain's water could have flowed through Louis XIV's Latona Fountain at Versailles.

Being ubiquitous, water is often taken for granted. Fountains, however, help focus attention on water, not only its beauty but also its usefulness. By keeping water front and center, fountains can encourage interest in, curiosity about, and love of water. They can also remind people of the need for fresh water and strengthen the growing interest in preserving this vital resource.

The conservation-minded might object that fountains waste water, but virtually all fountains today are recirculating, so the only water "lost" is from leakage, evaporation, and wind, which is minimal.

Fountains send a message. In ancient Rome, with its abundantly flowing waterworks, the message was this: The Roman Empire is strong, thanks in part to its engineering and building capabilities for delivering water from distant places. In Las Vegas, with its flamboyant fountains, the message is different: Money and muscle can create a delusional world in the desert.

More well-designed sustainable fountains in Chicago could send a message, too: That the city has vast affordable and sustainable water resources close at hand. Fountains

could become a testament to Chicago's water wealth, telling the world it has water, water everywhere—lake water, river water, rainwater, runoff, storm water, sewer water, treated water, fresh water, and fountain water.

Such a message—that Chicago has water to spare, even share—could help attract residents who don't want to live in a parched environment, as well as companies, industries, recreational ventures, and research centers that depend on water, in any of its myriad forms. Water is a critical ingredient in many things from beer to computer chips and from power generation to ecosystem management. Using fountains to advertise the area's water resources would help reposition Chicago from a formerly declining city in the Rust Belt to a newly thriving one in the Wet Belt.

When it comes to fountains, Chicago is not always the city that works. Many of its water tossers are in disrepair. On any given summer day, a few will be inoperable. Many will trickle when they should surge. Others will need restoration, a coat of paint, or a wax job.

Many fountains seem orphaned. The poster child for neglect is the **Cortland Street Fountain**, one of the prototype fountains installed in 1998 at the beginning of Mayor Daley's fountain program. This hulk clutters the sidewalk in a forlorn industrial zone next to railroad tracks, a bus stop, and a former Finkl Steel building along Cortland Street, just west of Clybourn Avenue. It would be easy to think the three-tier behemoth was dropped off by

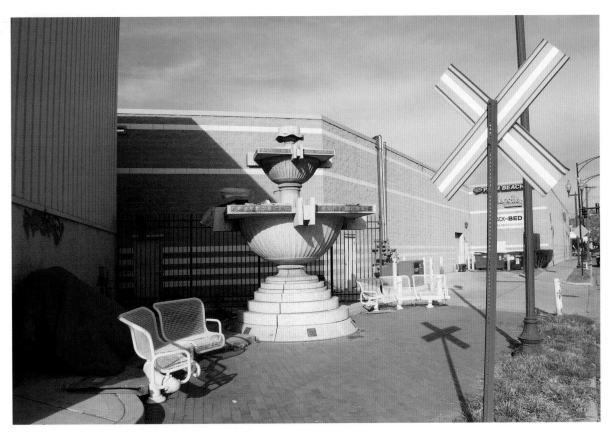

When it comes to fountains, Chicago isn't always the City That Works. The Cortland Street Fountain, the poster child for troubled waters, was poorly located in an industrial zone near Clybourn Avenue, is not maintained, and does not operate. It just collects litter.

accident. Yet the benches and streetscaping make it clear the fountain was purposely placed here. Full of litter, this white elephant has not operated in years.

Another orphan, the **Manuel Perez Plaza Fountain**, hangs on at 4345 West 26th Street. It was installed in 1980 in memory of Manuel Perez Jr., who died in World War II and posthumously was awarded the Congressional Medal of Honor. The *Tribune* once reported that "local Mexican-American vets have campaigned hard to keep his memory alive." Today, however, the ten-foot-tall fountain seems to have been dishonorably discharged.

On the plus side, in 1978 Chicago enacted the Percent-for-Art Ordinance, which stipulates that 1.33 percent of the cost of constructing or renovating municipal buildings and public spaces be set aside for public art. This law will continue to make money available for building and renovating fountains.

~~~~~~

Chicago could certainly make more of its fountains. For one, it could run a few fountains in the winter, a practice that has been tried with limited success but should not be discounted. In the second decade of the twentieth century, the **Electric Ice Fountain** graced the north end of Grand Boulevard (now Martin Luther King Drive). It resembled a Christmas tree in that it had a thirty-foot-tall center post and metal branches, and was lit up by thirty lamps. Heat from the lamps kept water flowing from overhead long enough to coat the branches before it froze, gradually creating an "electric iceberg." There's no record of how long this fountain operated, but in 1913 *Popular Mechanics* published a photo of it loaded with ice and said, "The remarkable beauty . . . is so simple it can be duplicated easily and inexpensively wherever the weather remains at the freezing point for any considerable time."

One of the many charms of Millennium Park's Crown Fountain is that it's attractive day and night, summer and winter. The *Tribune*'s Blair Kamin said it "brings the art of the urban fountain into the twenty-first century."

Creative Fountains, Past and Future

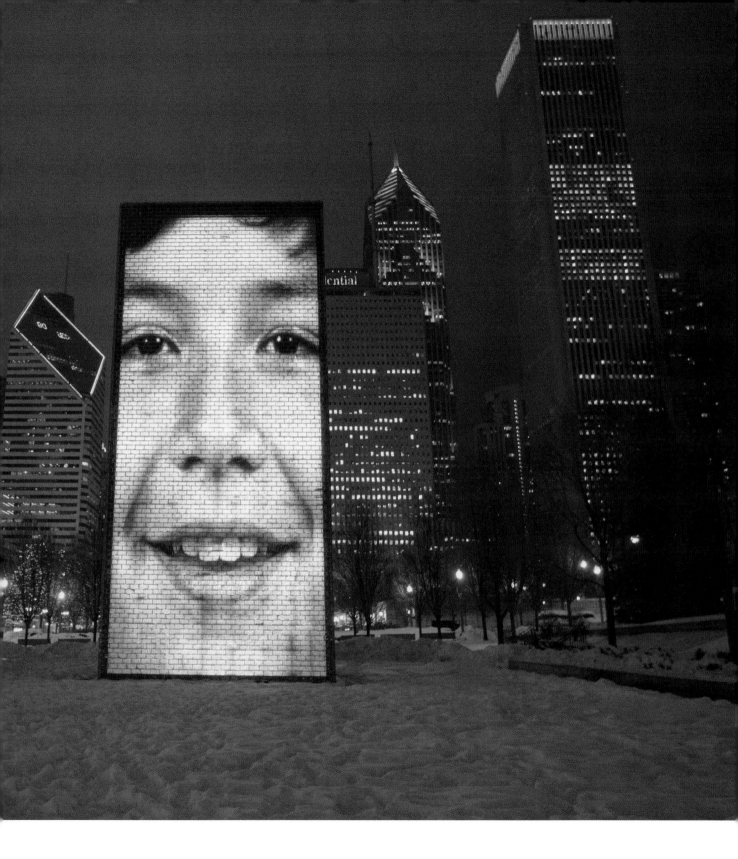

Other fountains have been built with winter operation in mind. When it opened, the Harris Bank Fountain downtown had heaters in its large bronze petals to keep the water flowing in the winter. The Exelon Plaza Fountain was designed to run whenever the temperature was above forty degrees. And the Richman Fountain in Bixler Park was supposed to operate through the winter using antifreeze, but it's not known whether it ever operated in this fashion.

Chicago's most ballyhooed winter water wonder appears to have been a bust. When Olive Park opened in 1965, its five basins were designed to operate with water in the summer and steam in the winter. "These fountains probably will be the first wintertime operation of their kind in the world," said Milton Pikarsky, Chicago public works commissioner. The steam was to shoot one hundred feet in the air and be illuminated with multicolored lights, "providing a spectacular view along Lake Shore Drive." There are no reports, however, of the steam ever operating.

More often than not, when a fountain freezes in Chicago, it's by accident due to an unexpected cold spell. Freezing water can severely damage pipes.

Another way Chicago could improve its record would be to design fountains that are attractive all year, with or without water. "For a fountain to be successful in the winter," John David Mooney said, "it needs more elements than just water. It needs attributes that will give it life even when the water won't be running." His *Falling Leaf* in Urbana, Illinois, is a fountain for all seasons. Its twelve-foot-tall polished stainless steel leaves hang over a basin that's accessible and appealing even when empty. The metallic leaves are dazzling when wet in the summer, surrounded by colorful leaves in the autumn, or part of a snowscape in the winter. In Chicago, however, only a few fountains hibernate handsomely.

Another idea for Chicago would be to allow man's best friend to romp in its fountains at the end of the season.

This would give new meaning to "dog days of summer." Since 1999 "Doggie Dip" at the Falls Aquatic Center in Cedar Falls, Iowa, has been raising money by letting dogs play in water features the day after these attractions close to humans. Depending on the weather, this event usually attracts a large crowd—up to 450 dogs and 800 people. "There's no downside, except for a few landmines left behind in the grass," said Bruce Verink, the center's recreation division manager.

There are many other ways to revel in fountains. Why not use them for events and exhibits, or as the subject of photo contests? Walking, bus, and bike tours of fountains would generate interest, too. In 2015 several fountains were included in Statue Stories Chicago, a program that allowed people walking past certain monuments to receive a callback on their mobile phone about the art and history of that work.

Why not hold fountain birthday parties? Organize parades around them? Decorate them? Why not let kids splash in them on special occasions? Festivals in Little Italy have been known to flow wine through fountains. The Printers Row Park Fountain serves as the centerpiece of the *Chicago Tribune* Printers Row Lit Fest, a book bash that attracts up to ninety thousand attendees every June. Meanwhile, Lollapalooza, which attracts almost three hundred thousand music lovers to Grant Park every summer, wouldn't be the same without Buckingham Fountain.

Fountains could be used for art or history classes, included in scavenger hunts, or featured in trivia contests. And they would make great settings for concerts, plays, readings, fashion shows, community picnics, ice cream socials, organized exercise sessions, tai chi, arts-and-crafts fairs, beauty contests, markets, and talent shows.

Chicago's fountains are truly something to celebrate. Let the good times flow!

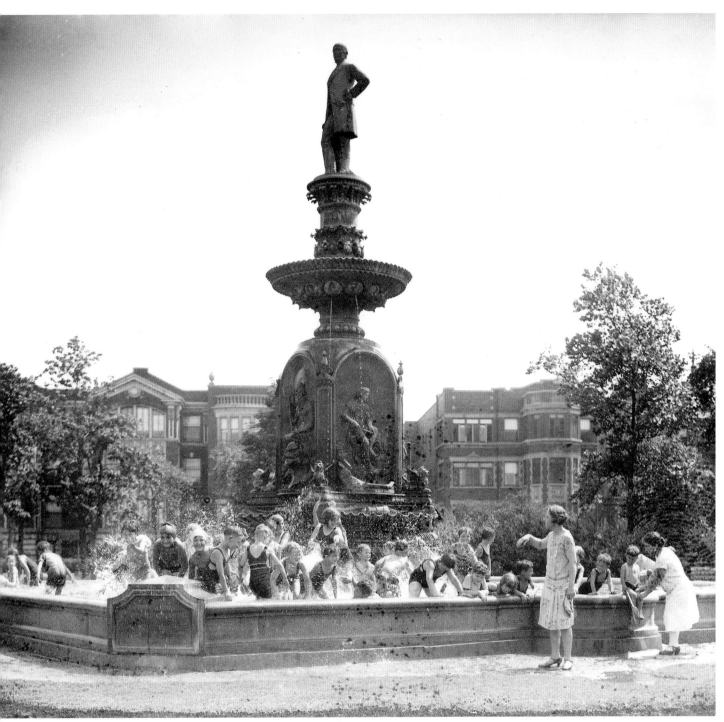

Chicago was born of water, and the 1883 Drexel Fountain, Chicago's oldest waterworks, serves as a reminder of the city's origins. Most of Chicago's fountains could bring a smile to your face, a thought to your mind, a wish to your heart. Next time you see one, stop, look, and listen; relax, think, and dream!

Appendix

Notes

Reader's Guide

Photo Credits

Index

# APPENDIX
## Chicago's Major Fountains

This list includes most of Chicago's outdoor public fountains, with information that will help readers locate more than 120 of them—primarily decorative ones but also a few unusual drinking fountains. Every fountain on the list is discussed or pictured in this book. Not all of Chicago's outdoor public fountains, however, are listed here, but those that do appear are the most prominent or interesting ones. Furthermore, all of these fountains are still standing, in one shape or another, even though some of them are no longer functional. Unfortunately, just as many or more outdoor public fountains have been removed throughout Chicago over the years.

| Name | Location | Built | Moved, Rebuilt, or Replaced | Notes | Page No. |
|---|---|---|---|---|---|
| Algren, Nelson | Milwaukee & Ashland aves | 1998 | | Polonia Triangle | 125 |
| Americas, Plaza of the | 420 N Michigan Ave | ca 1963 | 2010 | | 133 |
| Aon Center–Sounding Sculpture | 200 E Randolph St | 1973 | 1994 | | 63 |
| Aon Center–Sunken plaza (two different) | 200 E Randolph St | 1973 | 1994 | | 61–63 |
| Aon Center–Upper plaza (two similar) | 200 E Randolph St | 1994 | | | 64–66 |
| Apple Store | North Ave & Halsted St | 2010 | | | 80 |
| Archbishop's Residence | 1555 N State St | ca 1998 | | Removed every winter for nativity scene | 142 |
| Auburn Park Lagoon (two identical) | 406 W Winneconna Pkwy | unknown | | | 102 |
| Bathtub | 1840 W Hubbard St, in courtyard | 2006 | | Access via alley | 8 |
| Black History | 1300 W 79th St | 2001 | | Renaissance Park | 92 |
| Board of Trade, Chicago | 131 W Jackson Blvd | 1998 | | | 74, 76 |
| Botanic Gardens | 1031 N State St | 1998 | | Mariano Park | 115 |
| Botanical Gardens | 1830 S Indiana Ave | 1999 | | Women's Park & Gardens | 97 |

| Name | Location | Built | Moved, Rebuilt, or Replaced | Notes | Page No. |
|---|---|---|---|---|---|
| Buckingham, Clarence, Memorial | Columbus Ave & Congress Pkwy | 1927 | | | 41–45 |
| Burnham, Daniel (aka Lost) | 111 N State St, inside Macy's | 1992 | | In atrium over what was Holden Ct | 28 |
| Burton Place | Wells St & Burton Pl | c 2000 | | | 123–24 |
| Byrne, Jane, Plaza (aka Water Tower) | Michigan & Chicago aves | 2000 | | West of the Water Tower | 66 |
| Charitas | Lakefront Path & Fullerton Ave | 1922 | 2016 | Former fountain, now a statue | 141 |
| Centennial, Nicholas J. Melas, Fountain and Water Cannon | McClurg Ct & River Dr | 1989 | | River Esplanade Park | 56–59 |
| Children's (aka Garth) | 866 N Michigan Ave | 1914 | | Fourth Presbyterian Church garth | 66–67, 69–71 |
| Children's (Jane Byrne's work) | Clark St & North Ave | 1982 | 2005 | Originally at Heald Sq in Wacker Dr | xxii, 1–2, 158 |
| Clybourn and Diversey Avenues | 2000 W Diversey Ave | 2015 | | On sidewalk near shopping mall | 80 |
| Columbus, Christopher | 801 S Loomis St | 1892 | 1966 | Arrigo Park, formerly a statue | 22–24 |
| Connors Park | Wabash Ave & Chestnut St | 1999 | 2012 | Inside Argo Tea, Connors Park | 105 |
| Cook Country Criminal Courts | 2651 S California Ave | 1998 | | | 114, 116 |
| Cortland Street | 1230 W Cortland St | 1998 | | | 159 |
| Crown | Michigan Ave & Monroe St | 2004 | | Millennium Park | 45–47 |
| Daley, Richard J., Center Plaza | Washington & Clark sts | 1965 | | | 69, 72 |
| Daley, Richard J., Library | 3400 S Halsted St | 2002 | | Next to Richard J. Daley Library | 120, 121 |
| Damen Avenue | 819 S Damen Ave | unknown | | | 102 |
| DiMaggio, Joe, Piazza | 1430 W Taylor St | 1998 | | | 80–82 |
| Dogwood | 2430 N Cannon Dr | 2002 | | Behind Peggy Notebaert Museum | 102–3 |

| Name | Location | Built | Moved, Rebuilt, or Replaced | Notes | Page No. |
|---|---|---|---|---|---|
| Drake, John (aka Ice Water) | 2921 E 92nd St | 1892 | 1909 | Not functional | 15–17, 29 |
| Dream Lady (aka Eugene Field Memorial) | Lincoln Park Zoo, near primate house | 1922 | | | 35–38 |
| Drexel Boulevard (aka Thomas Dorsey) | Drexel & Oakwood blvds | 1998 | | | 13, 116 |
| Drexel, Francis M. | Drexel & Hyde Park blvds | 1883 | | Drexel Square | 10–13, 163 |
| Eagle (two nearly identical) | Michigan Ave & Congress Pkwy | 1931 | | | 107–8 |
| East Side Pocket Park | 10051 S Ewing Ave | unknown | | | 102 |
| Ecstasy (in Model Yacht Basin) | 51st St, west of Lake Shore Dr | 2007 | | Harold Washington Playlot Park | 95, 97 |
| 8th Street | 801 S Michigan Ave | 1927 | | Grant Park | 108 |
| Elephant Drinking | Lincoln Park Zoo, south of café | 1992 | | Lincoln Park | 35 |
| Exelon Plaza | Monroe & Dearborn sts | 1973 | | Sunken plaza at Chase Tower | 65, 66 |
| Fisher, Judge, Senior Apartments | 5821 N Broadway | 2011 | | | 155 |
| For the Young at Heart | Lincoln Park Zoo, in Children's Zoo | 1988 | | Lincoln Park | 35 |
| Fountain Figure, Crane Girl | Van Buren St & Lake Shore Dr | 1908 | 1964 | Grant Park near Buckingham | 108–10 |
| Fountain Figure, Dove Girl | Harrison St & Columbus Dr | 1908 | 1964 | Grant Park near Buckingham | 108–10 |
| Fountain Figure, Fisher Boy | Van Buren St & Columbus Dr | 1908 | 1964 | Grant Park near Buckingham | 108–10 |
| Fountain Figure, Turtle Boy | Harrison St & Lake Shore Dr | 1908 | 1964 | Grant Park near Buckingham | 108–10 |
| Fountain Girl (aka Temperance, Willard) | East of History Museum | 1893 | 2007 | Lincoln Park | 20–21 |
| 400 North LaSalle Condominiums | 400 N LaSalle St | 2003 | | | 8 |

| Name | Location | Built | Moved, Rebuilt, or Replaced | Notes | Page No. |
|---|---|---|---|---|---|
| Freedom | Clark & Wisconsin sts | 2003 | | | 80 |
| Fuller Park | 331 W 45th St | 1912 | 1993 | Fuller Park | 105–6 |
| Garfield Boulevard | 5500 S Western Ave | 1998 | | | 115 |
| Garfield Park Conservatory | 300 N Central Park Ave | 1998 | | Garfield Park | 98–99 |
| Garland Court | Garland Ct & Randolph St | ca 2000 | | West of Chicago Cultural Center | 123 |
| Gateway Plaza | Peterson & Lincoln aves | 2000 | | Legion Park | 86–88 |
| Gold Star Families Memorial and Park | 1411 Museum Campus Dr | 2006 | | Gold Star Families Memorial and Park | 88–89 |
| Great Lakes, Fountain of the | 221 S Michigan Ave | 1913 | 1963 | South Garden at Art Institute | 47–51 |
| Gurgoyle | Damen Ave & Schiller St | 1895 | 2002 | Wicker Park | 24–25 |
| Hancock, John, Center | 875 N Michigan Ave | 1989 | | | 66–67 |
| Harris Bank | 111 W Monroe St | 1975 | | | 71, 73 |
| Heald Square | Wacker Dr & Wabash Ave | 2003 | | Behind statues of Washington et al | 79 |
| Hughes, Langston, Elementary School | 240 W 104th St | 2009 | | | 155 |
| Humane Society, Illinois | Chicago & Michigan aves, NE corner | 1890–1910 | | | 30–31 |
| Humane Society, Illinois | 811 N Tower Ct | 1890–1910 | | Jane Byrne Plaza | 31 |
| In Celebration of the 200th Anniversary of the Founding of the Republic (aka Noguchi) | 130 S Columbus Dr | 1976 | | Grant Park | 103–4 |
| Independence Square (aka Fourth of July) | Douglas & Independence blvds | 1902 | | Not functional | 18–20 |
| Jacob and the Angel II | 55th St & Lake Park Ave | 1962 | | Shopping center plaza | 79–80 |
| Kempf Plaza (aka Lincoln Square, Giddings Plaza) | Lincoln Ave & Giddings St | 1999 | | | 116–17 |
| Lakeshore East (two identical) | Benton Pl & Field Blvd | 2005 | | In park at Lakeshore East | 91–92 |

| Name | Location | Built | Moved, Rebuilt, or Replaced | Notes | Page No. |
|---|---|---|---|---|---|
| Lawson, Victor, Memorial | Chicago River at 400 W Madison St | 1929 | | Not functional | 137, 138 |
| Lincoln Central Park | Lincoln & Dickens aves | 2000 | | Lincoln Central Park | 117–19 |
| Lion | Lincoln Park Zoo, west of lion house | 2006 | | Lincoln Park | 35 |
| Man with Fish | Shedd Aquarium, SW corner | 2001 | | Museum Campus | 90, 91 |
| McCormick Place Lakeside Center Terrace | Lakeside Terrace, facing lakefront | 1990s | | East side of McCormick Place | 84, 85 |
| McCormick Square | 2301 S. Martin Luther King Dr | 1990s | | West entrance to McCormick Place | 85 |
| McCormick, Robert | Dearborn & Walton sts | 1890 | 1999 | Washington Square Park | 25, 27, 28 |
| Memorial Water Wall | Soldier Field, McFetridge Dr entrance | 2003 | | Museum Campus | 89, 90 |
| Mid-North Triangle Park | Clark St & Belden Ave | 1998 | | Mid-North Triangle Park | 119, 120 |
| Millennium Monument (aka Peristyle) | 100 E Randolph St | 1917 | 2003 | Millennium Park, replaced Peristyle | 110, 111 |
| Mist | 932 W Monroe St | 2010 | | Mary Bartelme Park | 155–57 |
| Moroccan American Friendship | Conservatory Dr & Fulton Blvd | 2003 | | Inside Garfield Park Conservatory | 98–101 |
| Nature's Friends | Hudson Ave & Menomonee St | 2001 | | | 82, 83, 85 |
| New City | 1515 N Halsted St | 2015 | | Mall courtyard | 80 |
| Nichols Park | 1330 E 53rd St | 1992 | | Nichols Park | 95 |
| Niesen, William | West of Cannon Dr, near ball fields | 1955 | | Lincoln Park | 34 |
| North Center Senior Campus (two similar) | Oakley & Belle Plaine aves | 2008 | | Gene Schulter Park | 101, 102 |
| Northcutt, Jim, Memorial Drinking | 2521 N Stockton Dr | 1989 | | Lincoln Park | 38, 39 |

| Name | Location | Built | Moved, Rebuilt, or Replaced | Notes | Page No. |
|---|---|---|---|---|---|
| Northern Trust | Monroe & Wells sts, NE corner | 1969 | | | vi–vii |
| Olive Park (five similar) | 600 E Ohio St | 1965 | | Milton Lee Olive Park, not functional | 103, 105 |
| Peaches Memorial | 5730 N Clark St | 1998 | | | 126–27 |
| Perez, Manuel, Plaza | 4345 W 26th St | 1980 | | Not functional | 160 |
| Pioneer Court | 433 N Michigan Ave | 1965 | 1990s | Replaced earlier fountain | 131–33 |
| Polk Bros. Park | 600 E Grand Ave, west of Navy Pier | 2016 | | Polk Bros. Park, replaced earlier fountain | 139–41 |
| Portage Park | Irving Park Rd & Central Ave | ca 1935 | 2002 | Portage Park, not functional | 124 |
| Printers Row Park | 700 S Dearborn St | 1998 | | Printers Row Park | 120–22 |
| Prudential Plaza (two similar) | 181 N Beaubien Ct | 1990 | | | 66 |
| Richman, Phil | 1350 E 57th St | 1998 | | Bixler Park | 123–24 |
| Roosevelt Collection | 150 W Roosevelt Rd | 2012 | | | 80 |
| Rosenberg, Joseph | 1128 S Michigan Ave | 1893 | | Grant Park | 17–18 |
| San Marco II | 440 S LaSalle St | 1986 | | One Financial Plaza | 73–75 |
| Seward Park | Division & Orleans sts | 2000 | | Seward Park | 88 |
| Shit | 1003 N Wolcott Ave | 2005 | | | 7–8 |
| 63rd Street Beach House | Lakefront Path & 63rd St | 1919 | 1999 | Jackson Park, operates sporadically | 157 |
| Skyspace (two different) | Halsted St & Roosevelt Rd | 2006 | | Neal Plaza, Univ Illinois Chicago | 82 |
| South Garden (aka Dan Kiley) | 221 S Michigan Ave | 1962 | | South Garden at Art Institute | 51–52 |
| Spinning Water | 1355 E 55th St | 1968 | | Nichols Park | 94–95 |
| Stearns Quarry | 27th & Halsted sts | 2009 | | Palmisano Park | 106–7 |
| Storks at Play (aka Eli Bates) | 2221 N Stockton Dr | 1887 | | Lincoln Park | 14–15 |
| Sun Yat-sen Park | 251 W 24th Pl | 1976 | | Sun Yat-sen Park, not functional | 124–25 |

| Name | Location | Built | Moved, Rebuilt, or Replaced | Notes | Page No. |
|---|---|---|---|---|---|
| Tange, Kenzo | 515 N State St | 1990 | | | 71 |
| Time, Fountain of | Midway Plaisance & Payne Dr | 1922 | | Washington Park | 52–56 |
| Turtle | 1255 N Astor St | 1991 | | Goudy Square Park | 34–35 |
| Vernon Park Place | 1080 W Vernon Park Pl | 1999 | | Vernon Park Place | 116 |
| Viennese Drinking | Pearson St, east of Michigan Ave | 1998 | | | 34 |
| Vietnam Veterans Memorial, Chicago | Riverwalk, west of Wabash Ave | 1982 | 2005 | | 77–79 |
| Wallach, David | Lakefront Path, Promontory Pt | 1939 | | Burnham Park | 33 |
| Waller–Midway Plaza | 5700 W Midway Park | 2001 | | Cul-de-sac on Midway Park | 116 |
| Water Cannon | McClurg Ct & River Dr | 1989 | | Part of Centennial Fountain | 56–59 |
| World War II Memorial Drinking | 6500 S Racine Ave | 1945 | | Ogden Park | 33–34 |
| World War II Memorial Drinking | 2400 E 105th St | 1947 | | Trumbull Park | 33–34 |

# NOTES

These notes are designed to help readers find more information about Chicago's fountains and to explore new topics. In addition, they give credit where credit is due.

Overall, I provide a note when I quote or paraphrase someone and neither cite the publication in the text nor mention there that the quote comes from an interview by the author. (All interviews were conducted in 2014 and 2015.) In a few cases, I provide a note for a particular fact or figure that must be substantiated. Also, I provide a note when I cite the opinion of another.

The costs of various fountains were taken from press reports and converted into today's dollars using an inflation-calculating tool provided by the U.S. government at http://data.bls.gov/cgi-bin/cpicalc.pl.

I do not provide a note (or explanation in the text) for information about or references to general Chicago history—such as who Daniel Burnham was, how Aaron Montgomery Ward fought for a "forever open, clear and free" lakefront," how the Daleys ruled Chicago, and why the World's Columbian Exposition was important. Many readers will be familiar with such topics. Furthermore, information about these subjects is readily available. Space is at a premium in this book, so readers will either have to know such information or look it up.

See the readers guide at the end of this book for bibliographic information on all the sources cited in these notes—and for many additional resources to consult.

## Introduction

1 "How about griffins?": Scott Howell, interview by author.

1 "my favorite project, a work of the heart": Jane Byrne, *My Chicago*, p. 354.

2 "It was pretty easy to pull off this prank": Charlie Wojciechowski, interview by author.

4 "Can the reward go to anyone?": Harry Romanoff, audio recording.

5 "Chicago is what it is": John David Mooney, interview by author.

5 "Public spaces are the fabric": Ernest Wong, interview by author.

6 "Plensa wanted to restore": Keith Patrick, *Jaume Plensa: The Crown Fountain*, p. 74.

6 "The cops chased us": Diane Joy Schmidt, interview by author.

6 "Perhaps I did it for fun": Schmidt and Fitzsimmons, *The Chicago Exhibition*, p. 3.

7 "I hoped it would motivate dog owners": Jerzy Kenar, interview by author.

8 "whatever materials were around": Marcus Ober, interview by author.

8 "I'm thinking of coloring ours": Diana Breting, interview by author.

9 "Better living through chemistry": Michael Klaus, interview by author.

## 1. First Fountains

13 "bubble over with pride": Nancy Moffett, *Sun-Times*, Dec. 25, 1999.

13 "The fountain was derelict": Edward Windhorst, interview by author.

15 "For sheer dexterity": Ira Bach and Mary Lackritz Gray, *A Guide to Chicago's Public Sculpture*, p. 141.

15 "copper fig leaves prepared by Mr. St. Gaudens": James Riedy, *Chicago Sculpture*, p. 46.

16  "not of the postmortem character" and "the bestowment": *Tribune*, Dec. 27, 1892.

16  "a free barnyard": *Tribune*, July 18, 1894.

16  "every man who visited": *Tribune*, July 18, 1894.

16  "unbearable nuisance": *Tribune*, Dec. 17, 1894.

16  "an affront to Catholics": *Kentucky Irish American*, Aug. 22, 1908, published in Louisville, Ky. Accessed in August 2014 in the archives of the Special Collections and Preservation Division of the Harold Washington Library Center, Chicago Public Library.

16  "The incident will serve": *Tribune*, Aug. 5, 1908.

17  "in memory of many dry afternoons": *Tribune*, June 18, 1976.

18  "out of deference to public taste": *Chicago Times*, Oct. 6, 1893.

19  "We're not here for mere pleasure": *Interocean*, July 5, 1902.

19  "When the flags": *Chronicle*, July 5, 1902.

19  "one of the prettiest": *Record Herald*, July 5, 1902.

20  "While other parts": *American*, Oct. 10, 1902.

20  "The completely derelict condition": John Vinci and Stephen Christy, *Inventory and Evaluation of the Historic Parks in the City of Chicago*.

20  "Stop! No way": *Sun-Times*, Aug. 26, 1988.

20  "Consider them a gift": *Sun-Times*, Aug. 26, 1988.

20  "The boulevard fountains": Terry Tatum, interview by author.

20  "the representative of the young teetotalers": *Tribune*, April 29, 1895.

22  "She came to me": *Sun-Times*, Sept. 13, 2006.

22  "a pound of letters": *Tribune*, Aug. 22, 1958.

25  "This fountain is more": Public Building Commission of Chicago, http://www.pbcchicago.com/content/projects/project_detail.asp?pID=FP-39.

28  "The murmur of falling water": Patrons of Washington Square Park, *Washington Square Park Renovation*.

## 2. Drinking Fountains

29  Fountains in London, England: Marilyn Symmes, *Fountains Splash and Spectacle*, pp. 46–47; and Leslie Coburn, "The Water Question," p. 4.

29  One of Chicago's first: Coburn, "The Water Question," p. 4.

30  The society had sprinkled: Coburn, "The Water Question," p. 9.

31  "At one time": Charles Gasperik, interview by author.

31  "Their erection": Coburn, "The Water Question," p. 11.

31  "plain and inartistic": *American*, Nov. 13, 1911.

31  "It's everywhere conceded": *Tribune*, May 9, 1909.

32  "One of the shames": *Chicago Post*, Nov., 27, 1905.

32  "artistically pleasing as well as": *Tribune*, Oct. 9, 1908.

32  During the Depression: Leslie Coburn, "The Water Question," p. 19.

33  "stamped with fancy": *Tribune*, Sept. 24, 1950.

34  "My work": Hans Muhr, plaque attached to his water sculpture *Drama*, https://www.flickr.com/photos/catscape/162726741.

38  "sprinkling the sand": *New York Times*, Oct. 10, 1922.

38  "The angel-like figure": Chicago Park District superintendent George Donoghue to Miss Joanne Sholts, March 26, 1959.

39  "Everyone who drinks": *Sun-Times*, June 28, 1989.

## 3. Iconic Fountains

41  You might not have known: This information about Buckingham Fountain was derived from a variety of sources, but much of it can be found at

the Chicago Park District's website, http://www
.chicagoparkdistrict.com/parks/clarence-f
-buckingham-memorial-fountain/.

43  "because the British": *Rebeat Magazine*, November 20, 2014. Interview by Rick Simmons

43  "forever open, clear and free": a phrase from the legal precedent and the legislation protecting Grant Park from development that was championed by Aaron Ward Montgomery.

44  "certain of their color combinations": *New York Times*, May 15, 1932.

45  Parker Hall III: Recounted by business acquaintance, Philip Halpern, interview by author.

45  "the lyric of the lake": *Tribune*, Sept. 24, 1927.

45  "Look, Lester": Timothy Gilford, *Millennium Park: Creating a Landmark*, p. 290.

47  "by the singer as much as the song": Keith Patrick, *Jaume Plensa: The Crown Fountain*, p. 84.

47  "These faces represent": Jaume Plensa during a public presentation at the Art Institute of Chicago, June 16, 2014.

47  "The fountain is an homage": Plensa at the Art Institute of Chicago, June 16, 2014.

47  Plensa has declined: Plensa at the Art Institute of Chicago, June 16, 2014.

47  "Burnham was sorry": Lynn Allyn Young, *Beautiful Dreamer*, p. 30.

48  "I cannot think of art": Lorado Taft, University of Chicago Faculty, https://www.lib.uchicago .edu/projects/centcat/fac/facch19_01.html.

51  "The relocation of": James Riedy, *Chicago Sculpture,* p. 12.

51  "The re-siting showed": James Krohe Jr., "Reading: Exterior Decoration."

51  Critics say Art Institute: Jeff Huebner, "Hearts of Stone"; James Krohe Jr., "Reading: Exterior Decoration"; and James Riedy, *Chicago Sculpture,* p. 8.

52  "He led a challenge": *Tribune*, Feb. 26, 2004.

54  "a masterpiece": Ira Bach and Mary Lackritz Gray, *Guide to Chicago's Public Sculpture*, p. 252.

54  "a row of false teeth": Timothy Garvey, *Public Sculptor*, p. 173.

54  "an atrocity": Garvey, *Public Sculptor*, p. 164.

55  "The answer had been": Andrzej Dajnowski, interview by author.

56  He'd like to cover it: Dajnowski, interview by author.

56  "I thought of the figure": *Monumental News Magazine*, February 1921.

56  "two spindly water pipes": Edward Hungerford, *Inland Architecture Magazine*, Spring 1960.

58  Critics asked how the district: *Tribune*, Oct. 9, 1988.

58  "public art at its best": Metropolitan Sanitary District of Greater Chicago, press release, Feb. 3, 1988.

58  "'Okay,' Daley said": Jonathan Alter, interview by author.

58  "A fellow commissioner": Alter, interview by author.

58  "The fountain gave her": Alter, interview by author.

58  "It was an injustice": Alter, interview by author.

58  "'Tut! Tut! What a waste'": John Holden, interview by author.

59  "I wanted to symbolize": *Architectural Record*, March, 1990.

59  Lohan said he wanted: Dirk Lohan, interview by author.

## 4. Plaza Fountains

62  Harry Bertoia said wind: Ira Bach and Mary Lackritz Gray, *Chicago's Public Sculpture*, p. 43.

65  "wade into the pool": *Tribune*, June 23, 1975.

65  "color, better seating": *Tribune*, Sept. 7, 1986.

65  "the architectural equivalent": *Tribune*, Oct. 5, 1992.

65 "I also heard": Mike Lyons, interview by author.

66 "a fountain that dances": *Sun-Times*, July 5, 1981.

73 "life into a very cold material": *Tribune*, Dec. 21, 1986.

74 "sculptor's diploma": *Tribune*, Dec. 21, 1986.

77 a nod to the octagonal shape: Edward Windhorst, interview by author.

77 "Therefore, the relatively small": Windhorst, interview by author.

77 "We've forgotten about this war": *Tribune*, Nov. 12, 1982.

77 "hallowed ground": *Chicago Reader*, July 24, 2003.

77 "No public official": *Sun-Times*, May 30, 2014.

78 "The city is treating": *Chicago Reader*, July 24, 2003

78 "more visible": *Tribune*, Nov. 6, 2005.

78 "employed the [fountain's]": *Tribune*, Nov. 6, 2005.

80 "instant supplier of peace": *Tribune*, Oct. 22, 2010.

82 "Why was there a rush?": *Gazette*, Oct. 1, 1998.

81 "DiMaggio was America's first": George Randazzo, interview by author.

82 "We held an open competition": Judith Kirshner, interview by author.

82 "I love that it's open": Kirshner, interview by author.

82 "our ability to spread our wings": Gary Lee Price, http://garyleeprice.com/bronze-garden-statues /natures-friends.

83 the melodies "will impart": Price, http: //garyleeprice.com/bronze-garden-statues /natures-friends.

85 "sculpture to inspire": Price, http://garyleeprice .com/about-gary-lee-price.

85 "I hope I can assist": Price, http://garyleeprice .com/about-gary-lee-price.

85 "When the city said": Vi Daley, interview by author.

## 5. Park and Parkway Fountains

86 "ushered in a new era": *Inside*, July 21, 1999.

86 "vaguely Arts and Crafts": Edward Windhorst, interview by author.

86 "When I pointed that out": Windhorst, interview by author.

88 "virtual total obedience": Windhorst, interview by author.

89 "Getting the screens just right": Joe Petry, interview by author.

89 "With many solemn events": Philip Cline, interview by author.

89 "When we have an event": Cline, interview by author.

89 "because it acts": Joe Petry, interview by author.

89 "He knew I love to garden": Jerry Migely, interview by author.

89 "I knew some of the officers": Migely, interview by author.

89–90 "Originally, the sculpture": Anna Koh Varilla, interview by author.

91 "By omitting gestures": Stephan Balkenhol, Shedd Aquarium press release, Sept. 19, 2001.

91 "bizarre": CBS Chicago, http://chicago .cbslocal.com/top-lists/best-bizarre-statues -or-public-art-in-chicago.

91 "The sculpture raises": CBS Chicago, http://chicago.cbslocal.com/top-lists/best -bizarre-statues-or-public-art-in-chicago.

91 "figures are going to grab": Ted Beattie, Shedd Aquarium newsletter, September 1998.

91 "the crescendo of the park": Magellan Development Group, http://www.magellandevelopment .com/lakeshore-east/park/.

91 "Many people moved": Ernest Wong, interview by author.

92 "giving them texture": Wong, interview by author.

92 "making it less likely": Wong, interview by author.

92 "Can you believe it?": *Sun-Times*, Jan. 7, 2000.

92 "The balls are like a natural spring": Jerzy Kenar, interview by author.

94 "The fountain is a symbol": Rev. Michael Pfleger, interview by author.

94 "welding shop": *Hyde Park Progress*, http://hydeparkprogress.blogspot.com/2007_09_01_archive.html, Sept. 28, 2007.

95 "the community served by a park": Hyde Park Historical Society newsletter, September 1990.

95 believes a three-foot-long vertical section: Stephanie Franklin, interview by author.

98 "a catalyst for encouraging": *Sun-Times*, Oct. 20, 1997.

99 "It took intervention": Andrew Tinich, interview by author.

99 "this West Side gem": Lisa Roberts, interview by author.

99 "They became an exhibit": Roberts, interview by author.

99 "It was fascinating": Andrew Tinich, interview by author.

101 "Art has no price": Abdelkamel Lahlou, interview by author.

101 "The fountain makes": Lisa Roberts, interview by author.

101 his creation would symbolically connect: *Tribune*, Aug. 17, 2003

102 "a galloping effect": Omri Amrany, interview by author.

102 "We let the Levins'": Amrany, interview by author.

105 "Connors has gone": *Architecture Chicago Plus*, http://arcchicago.blogspot.com/2013/08/mcplazas-privatizing-chicagos-orphan.html.

105 "remained a 'foreboding paved space'": Chicago Park District, http://www.chicagoparkdistrict.com/parks/fuller-park/fountain/.

107 "Hundreds of millions": *Tribune*, May 8, 2008.

107 "The head's horizontal ribbing": Hana Ishikawa, interview by author.

107 "Water is handled": Ishikawa, interview by author.

## 6. Fountain Frenzy

113 "Public fountains add beauty": Public Building Commission press release, April 11, 2001.

113 "positively bubbles with good sense": *Tribune*, July 17, 1997.

114 "the fountains that bloom": *Tribune*, May 14, 2000.

115 "homogenize the city": *Tribune*, July 17, 1997.

115 "a fine example": John Vinci and Stephen Christy, *Inventory and Evaluation of the Historic Parks in the City of Chicago*.

116 how long the last fountain: Jan Strzalka, interview by author.

116 "with craft": Windhorst, interview by author.

116 "clearly intended as a way": Edward Windhorst, interview by author.

116 "The fountain was located here": Windhorst, interview by author.

116 "This fountain offers": Windhorst, interview by author.

116 "It's the poster child": John O'Neal, interview by author.

117 "is a nineteenth-century neighborhood": Edward Windhorst, interview by author.

117 "side effect": Kevin Carroll, interview by author.

117 "unloved" by the community: Edward Windhorst, interview by author.

119 "It had sunken areas": Windhorst, interview by author.

120 "Out of admiration for his father": Windhorst, interview by author.

120 "A fountain does not work well": Windhorst, interview by author.

120 "Naturally, we said yes": Mary Ivory, interview by author.

120 "That made us feel": Ivory, interview by author.

120 "It looked like something that belonged": Ivory, interview by author.

121 "We picked the three most prominent colors": Edward Windhorst, interview by author.

123 "Why are we giving up": *Hyde Park Herald*, July 22, 1998.

124 "That fountain is little more": Windhorst, interview by author.

125 "Polish-baiting": *Chicago Reader*, Nov. 19, 1998.

126 "Chicago is an October sort of city": Goodreads, https://www.goodreads.com/quotes/446381 -chicago-is-an-october-sort-of-city-even-in -spring.

126 "It was important to help": Mary Ann Smith, interview by author.

126 "Peaches would cheer us on": Smith, interview by author.

127 "Peaches was a wonderful": Robert Levy, interview by author.

## 7. Forgotten Fountains

128 extensive photo archives: These images are available through the Chicago History Museum's Research Center, http://chicagohistory.org /research.

128 Buffalo Fountain: press reports, including *Tribune*, Jan. 12, 1941; and *Tribune*, March 2, 1941.

129 "to forward the beautification of the city": *Tribune*, Sept. 10, 1908.

130 "set like a jewel": *Tribune*, Sept. 10, 1908.

131 "the friendly darkness of night": *New York Times*, June 24, 1899.

131 "talk of the town": *Tribune*, June 17, 1899.

131 "The nymph is not": *Tribune*, June 17, 1899.

131 "not in any sense objectionable": *Tribune*, June 17, 1899.

131 "Preachers, or some of them": *New York Times*, June 24, 1899.

131 "practically ruined": *Boston Evening Transcript*, July 17, 1899.

131 he hoped the fountain could be rebuilt in "imperishable bronze": the *Sketch*, June 12, 1899.

133 "ever-changing shades": *Tribune*, March 21, 1890.

133–34 "The projection of strong electric light": John Moses and Joseph Kirkland, *Aboriginal to Metropolitan*, p. 512.

134 "public spectacles": *Tribune*, Aug. 22, 1890.

134 "Thousands dropped nickels": *Tribune*, Aug. 15, 1892.

134 "playfully dubbed": Jacob Kaplan, Daniel Pogorzelski, Rob Reid, and Elisa Addlesperger, *Avondale and Chicago's Polish Village*, p. 2.

137 "no other installation": *Terrazzo Esplanade*, National Terrazzo and Mosaic Association, Chicago, 1933.

137 the work was in a "deplorable" condition: Letter from Joseph Chamberlain, director, Adler Planetarium, Oct. 28, 1968.

137 "The Planetarium's installation": Richard Bruns, interview by author.

137 "glistening magic carpet": *Terrazzo Esplanade*, National Terrazzo and Mosaic Association, Chicago, 1933.

137 "Their beauty will be massive": *New York Times*, March 3, 1928.

137 "Watch out[,] Buckingham Fountain": *Tribune*, Sept. 1, 1995.

137 "explodes, with a dozen plumes": *Tribune*, Aug. 24, 1997.

141 "No charity for Charitas": *Sun-Times*, Nov. 12, 2003.

142 no religious or liturgical significance: Rev. Daniel Flens, an assistant to Cardinal George, interview by author.

## 8. City of Fountains

145 "Times change": GuideStar, City of Fountains Foundation Report, May 9, 2016.

147 "that shape young lives": Roy Inman, *The City of Fountains*, p. 50.

149    "intentionally detract": Sherry Piland and Ellen Uguccioni, *Fountains of Kansas City: A History and Love Affair*, p. 173.

151    "When people argue": Mark McHenry, interview by author.

151    "Kansas City's unique": Heidi Downer, interview by author.

## 9. Creative Fountains, Past and Future

152    "make no little plans": Daniel Burnham, quoted in Encyclopedia of Chicago, http://www.encyclopedia.chicagohistory.org/pages/2396.html.

154    "with the heavens as a dome": *Tribune*, May 16, 1908.

154    "an outdoor collection": *Examiner*, Feb. 1, 1913.

154    "entirely a celebration of water": John David Mooney, interview by author.

155    "Fountains promote rest": Mooney, interview by author.

155    "This system teaches kids": Hana Ishikawa, interview by author.

155    "I'm glad community members": Ishikawa, interview by author.

155    "The traditional concept of a fountain": Ishikawa, interview by author.

157    "Traditional, classical designs": Joe Petry, interview by author.

160    "local Mexican-American vets": *Tribune*, Nov. 6, 1992.

160    "electric iceberg": *Popular Mechanics*, April 1913.

160    "The remarkable beauty": *Popular Mechanics*, April 1913.

162    "These fountains": *Tribune*, April 20, 1964.

162    "providing a spectacular view": *Tribune*, April 20, 1964.

162    "For a fountain to be successful": John David Mooney, interview by author.

162    "There's no downside": Bruce Verink, interview by author

# READERS GUIDE

Besides books, articles, and reports, this list includes sections for periodicals; websites, blogs, and newsletters; and book club discussion questions.

## Books, Articles, and Reports

Apel, Melanie Ann. *Lincoln Park Chicago*. Arcadia Publishing, Charleston, S.C., 2002.

August, Krista. *Giants in the Park: A Guide to Portrait Statues in Chicago's Lincoln Park*. Lincoln Park Press, Chicago, 2015.

Bach, Ira, and Mary Lackritz Gray. *A Guide to Chicago's Public Sculpture*. University of Chicago Press, Chicago, 1983.

Ball, Philip. *Life's Matrix: A Biography of Water*. Farrar, Straus, and Giroux, New York, 1999.

Byrne, Jane. *My Chicago*. Northwestern University Press, Evanston, Ill., 2003.

Campbell, Craig. *Water in Landscape Architecture*. Van Nostrand Reinhold, New York, 1978.

Catrambone, Kathy, and Ellen Shubart. *Taylor Street: Chicago's Little Italy*. Arcadia Publishing, Charleston, S.C., 2007.

Chappell, Sally Kitt. *Chicago's Urban Nature*. University of Chicago Press, Chicago, 2007.

Chicago Park District. *Principal Monuments, Memorials, Fountains, etc. in the Chicago Park District*. Chicago, 1937.

Coburn, Leslie. "The Water Question." *Chicago History* 38, no. 1 (Spring 2012): 4–21.

Commission on Chicago Landmarks. *Buckingham Fountain, Final Report to the Commission*. Chicago, 2000.

———. *Drake Fountain, Preliminary Summary of Information Submitted to the Commission*. Chicago, 2003.

Coorens, Elaine. *Wicker Park*. Old Wicker Park Committee, Chicago, 2003.

Cremin, Dennis. *Grant Park: The Evolution of Chicago's Front Yard*. Southern Illinois University Press, Carbondale, 2013.

Davis, Susan O'Connor. *Chicago's Historic Hyde Park*. University of Chicago Press, Chicago, 2013.

Department of Cultural Affairs and Special Events. *The Chicago Public Art Guide*. City of Chicago, 2004.

Department of Cultural Affairs, City of Chicago. *Loop Sculpture Guide*. Chicago, 1993.

Fishman, Charles. *The Big Thirst*. Free Press, New York, 2011.

Franch, John. *Robber Baron: The Life of Charles Tyson Yerkes*. University of Illinois Press, Urbana, 2006.

Garvey, Timothy. *Public Sculptor: Lorado Taft and the Beautification of Chicago*. University of Illinois Press, Urbana, 1988.

Gilford, Timothy. *Millennium Park: Creating a Landmark*. University of Chicago Press, Chicago, 2006.

Gordon, Ron, and John Paulett. *Printers Row Chicago*. Arcadia Publishing, Charleston, S.C., 2003.

Graf, John. *Chicago's Parks*. Arcadia Publishing, Charleston, S.C., 2000.

Graf, John, and Steve Skorpad. *Chicago's Monuments, Markers, and Memorials*. Arcadia Publishing, Charleston, S.C., 2002.

Hopwood, Rosalind. *Fountains and Water Features*. Francis Lincoln, Ltd., Publishers, London, 2009.

Huebner, Jeff. "Hearts of Stone." *Chicago Reader*, July 10, 1997.

Inman, Roy. *The City of Fountains: Kansas City's Legacy of Beauty and Motion*. Kansas City Star Books, Kansas City, Mo., 2012.

Kaplan, Jacob, Daniel Pogorzelski, Rob Reid, and Elisa Addlesperger. *Avondale and Chicago's Polish Village*. Arcadia Publishing, Charleston, S.C., 2014.

Krehl, Donald. *Monumental Chicago*. lulu.com, 2011.

Krohe, James, Jr. "Reading: Exterior Decoration." *Chicago Reader*, Aug. 11, 1988.

Lincoln Park Commissioners. *Report of the Commissioners and a History of Lincoln Park*. Chicago, 1899.

Maloney, Cathy Jean. *Chicago Gardens: The Early History*. University of Chicago Press, Chicago, 2008.

Moses, John, and Joseph Kirkland. *Aboriginal to Metropolitan: History of Chicago*. Munsell and Company, Chicago, 1895.

Pacyga, Dominic, and Ellen Skerrett. *Chicago: City of Neighborhoods*. Loyola University Press, Chicago, 1986.

Patrick, Keith. *Jaume Plensa: The Crown Fountain*. Hatje Cantz, Berlin, 2008.

Patrons of Washington Square Park. *Washington Square Park Renovation*. Chicago, 1997.

Piland, Sherry, and Ellen Uguccioni. *Fountains of Kansas City: A History and Love Affair*. City of Fountains Foundation, Kansas City, Mo., 1985.

Riedy, James. *Chicago Sculpture*. University of Illinois Press, Urbana, 1981.

Schechter, Harold. *The Mad Sculptor*. Houghton Mifflin Harcourt, New York, 2014.

Schmidt, Diane Joy, and Michele Fitzsimmons. *The Chicago Exhibition*. Melrose Publishing Co., Los Angeles, 1985.

Sinkevitch, Alice, editor. *American Institute of Architects Guide to Chicago*. University of Illinois Press, Urbana, 2014.

Smith, Carl. *City Water, City Life*. University of Chicago Press, Chicago, 2013.

*Souvenir of Lincoln Park: An Illustrated and Descriptive Guide*. Illinois Engraving Company, Chicago, 1896.

Sullivan, Karin Horgan. *Chicago's 50 Best Places to Find Peace and Quiet*. Universe Publishing, New York, 2005.

Symmes, Marilyn, editor. *Fountains Splash and Spectacle*. Rizzoli International Books, New York, 1998.

Tuan, Yi-Fu. *Dominance and Affection*. Yale University Press, New Haven, Conn., 1984.

Vinci, John, and Stephen Christy. *Inventory and Evaluation of the Historic Parks in the City of Chicago*. Chicago Park District, Department of Planning, 1981–82.

Weller, Allen. "Lorado Taft, the Ferguson Fund, and the Advent of Modernism." In *The Old Guard and the Avant-Garde: Modernism in Chicago, 1910–1940*, edited by Sue Ann Prince. University of Chicago Press, Chicago, 1990.

Whyte, William. *The Social Life of Small Urban Spaces*. Project for Public Spaces, New York, 2001.

Woodhouse, Sharon. *A Native's Guide to Chicago*. Lake Claremont Press, Chicago, 1996.

Worley, William. *The Plaza, First and Always*. Addax Publishing Group, Lenexa, Kans., 1997.

Young, Lynn Allyn. *Beautiful Dreamer: The Completed Works and Unfulfilled Plans of Sculptor Lorado Taft*. Quality Books, Oregon, Ill., 2012.

## Periodicals

*American Architect, Architectural Record, Atlantic Cities/ City Lab, Chicago Magazine, Chicago Reader, Crain's Chicago Business, Inland Architecture Magazine, Inside, Monumental News Magazine, New York Times, Realty and Building, Inc./* the *Economist, Sculpture Review*, and the *Sketch*.

Chicago newspapers, including *American, Chronicle, Commerce, Daily News, Daily Southtown, Examiner, Gazette, Herald-Examiner, Interocean, Morning News, Record Herald, Sun-Times*, and *Tribune*.

## Websites, Blogs, and Newsletters

Architecture Chicago Plus: www.arcchicago.blogspot .com.

Ask Geoffrey Baer at Chicago Tonight, WTTW TV: http://chicagotonight.wttw.com.

Chicago Architecture Info: www.chicagoarchitecture .info.

Chicago Collections Consortium: www.explore
   .chicagocollections.org.
Chicago Design Slinger: chicagodesignslinger.blogspot
   .com.
Chicago History Museum, Electronic Encyclopedia of
   Chicago: www.encyclopedia.chicagohistory.org.
Chicago History Museum's online research: http:
   //libguides.chicagohistory.org/research.
Chicago Maps: www.chicagoinmaps.com.
Chicago Park District (Artworks and Monuments):
   www.chicagoparkdistrict.com/facilities
   /artworks-monuments.
Emporis, a building directory, plus: www.emporis.com
   /city/101030/chicago-il-usa.
Hidden Truths (The Chicago City Cemetery and
   Lincoln Park): www.hiddentruths.northwestern
   .edu.
*Hyde Park Historical Society Newsletter*
*Hyde Park Progress*: http://hydeparkprogress.blogspot
   .com.
*Public Art in Chicago* (Jyoti Srivastava's blog): www
   .publicartinchicago.com.
Romanoff, Harry. Audio recording. https://www
   .dropbox.com/s/1jw5f7iczg2myka/Harry
   _Romanoff_3_3_1969.wav?dl=0.
*Streetsblog Chicago*: http://chi.streetsblog.org.

## Book Club Discussion Questions

1. Did *Chicago's Fabulous Fountains* make you feel differently about fountains in general and Chicago's fountains in particular?

2. Were you surprised at the number and variety of Chicago's fountains?

3. What specific fountains struck you as the most memorable or significant, attractive or appealing?

4. Does the author make his case that fountains can be a window to learning more about art, architecture, history, politics, ethnic identity, and cultural forces?

5. What did you learn from reading this book that you found most interesting?

6. Did the book broaden your perspective about fountains, water, plazas, parks, cityscapes, street life, or public art?

7. Which fountains in this book are you most eager to visit or learn more about?

8. Do Chicago's outdoor public fountains deserve more respect and support?

9. As pieces of public art, do outdoor fountains warrant historical preservation? If so, why have only two fountains been designated as protected Chicago Landmarks?

10. Would you like to see more fountains in Chicago? And would you like to see the existing fountains turned on earlier in the spring and left running longer in the fall?

11. Does this book motivate you to do anything . . . visit fountains, learn about them, "adopt" one, raise money for their preservation, write a letter on their behalf to a newspaper or lawmaker, support the building of more fountains, et cetera?

12. How could Chicago better utilize and celebrate its fountains?

# PHOTO CREDITS

# INDEX

Page numbers in **boldface type** indicate illustrations.

**Greg Borzo**, a native of Chicago, is an award-winning writer who has worked for the Field Museum of Natural History, the American Medical Association, Business Word, and the University of Chicago, where he currently freelances. Borzo has written four other books: *Chicago Cable Cars*; *RAGBRAI: America's Favorite Bicycle Ride*; *Where to Bike Chicago: Best Biking in City and Suburbs*; and *The Chicago "L."* He gives presentations and conducts tours about the "L," biking, history, Chicago's cable cars, and Chicago's fountains for the Chicago History Museum, Chicago Cycling Club, Forgotten Chicago, libraries, clubs, and other organizations.